EYES (_

TO THE WORLD

memories of travel in wool

by Karen D. Miller

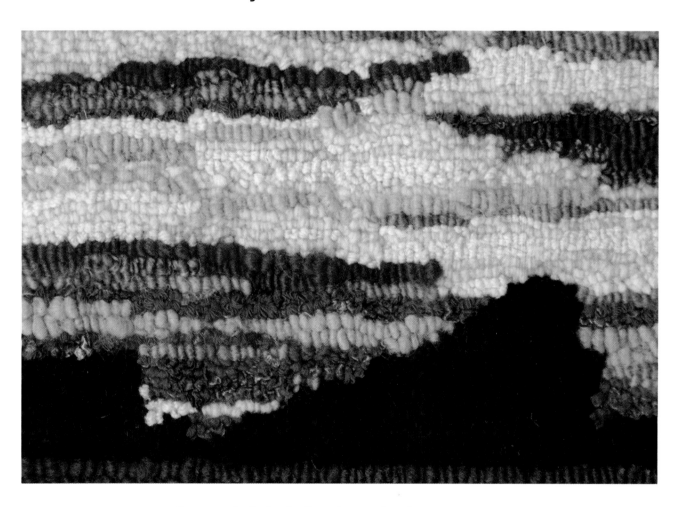

Sunset on the Rock, 7" x 5", wool yarn and wool roving on rug warp.
Designed and hooked by Karen D. Miller,
Ottawa, Ontario, Canada, 2014.

Presented by

Graphic design by Matt Paulson
Front cover: *She Will Move Mountains*. Designed and hooked by Karen D. Miller.

Printed in the United States of America
10 9 8 7 6 5 4 3 2 1

Landscape photography by Karen D. Miller
Rug photography by the artist unless otherwise noted
Cataloging-in-Publication Data
Library of Congress Control Number: 2019951132

ISBN 978-1-945550-41-6

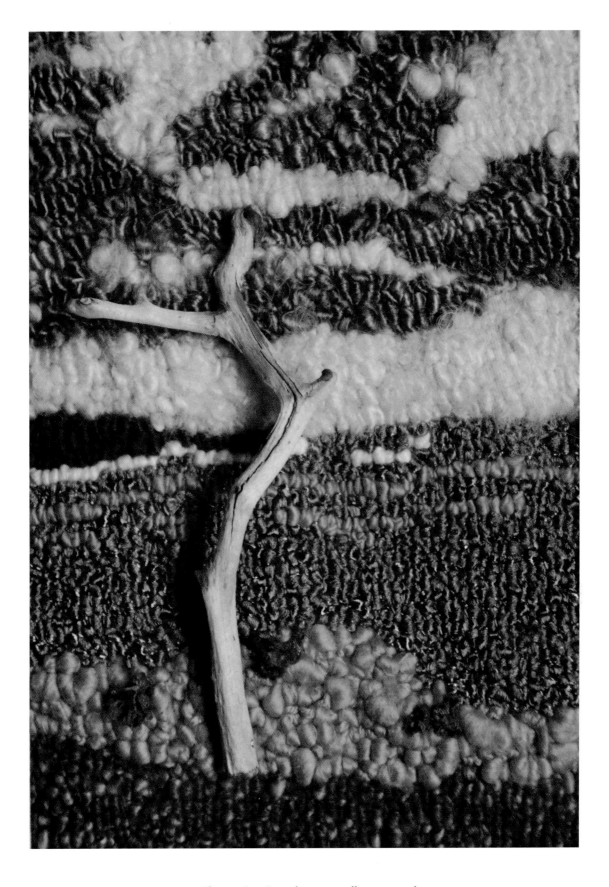

Lewisporte Shore, 5" x 7", *wool yarn, metallic yarn, wool roving, sari silk ribbon, and driftwood on rug warp. Designed and hooked by Karen D. Miller, Ottawa, Ontario, Canada, 2015.*

ACKNOWLEDGMENTS

"There is so much in the world for all of us if only we have the eyes to see it, and the heart to love it, and the hand to gather it to ourselves." – L.M. Montgomery

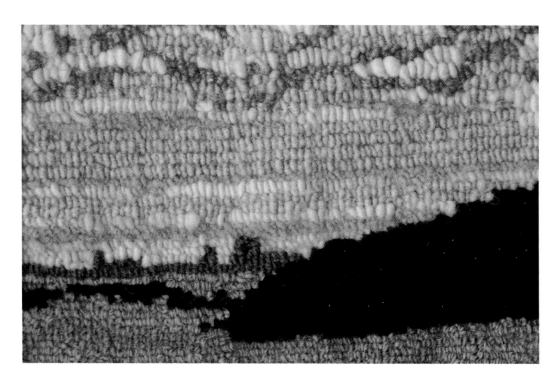

Icebergs on the Horizon, 7" x 5", wool yarn and acrylic yarn on rug warp. Designed and hooked by Karen D. Miller, Ottawa, Ontario, Canada, 2014.

I feel so fortunate to have three amazing travel partners with whom to tour the world and to voyage through life. My husband, Daniel, has truly been my partner in this project and I couldn't have done it without him. My kids, Kadyn and Peyton, are a constant source of inspiration to me. Seeing the world through their eyes is a tremendous gift. I love each and every one of the adventures that the four of us take together.

My parents, who never failed to take us on a family vacation every year when we were kids, instilled in me a love of travel for which I will always be grateful. And thank you to my sister, Kirsten, for moving to one of the most beautiful places and giving us an open invitation to come and visit.

Thank you to Debra Smith and Ampry Publishing for their support in the making of this book. And of course, a huge thank you to all of the artists who have allowed me to use their work and for sharing their thoughts, inspiration, and processes with me. This book is so much richer for having all of you in it.

A NOTE ON TERMINOLOGY

The reader may notice that I refer to what I do as "hooked fibre art" or "hooking" rather than "rug hooking." I do this to reinforce that what we know as "rug hooking" is just one of the many ways in which artists use fibre as an artistic medium. Given the common challenges we all face, working with the same materials and the wonderful opportunities that exist for mixing techniques, I choose to view myself as a part of a large community of like-minded and supportive fibre artists.

TABLE OF CONTENTS

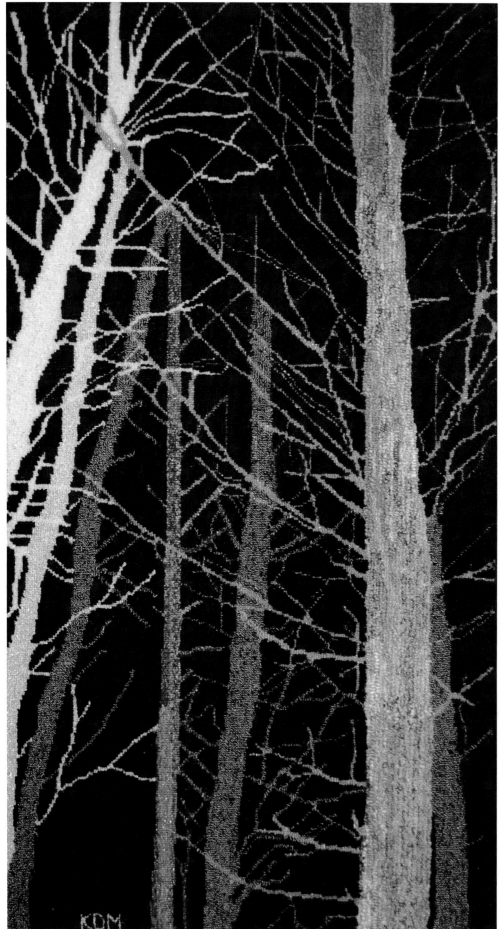

Ghost Trees, *17" x 32", wool and metallic yarn, sari silk ribbon on rug warp. Designed and hooked by Karen D. Miller, Ottawa, Ontario, Canada, 2014.*

THE ARTIST IN ALL OF US

Ten years ago, I began making hooked fibre art. Now you are holding my book. Looking back, it seems as though my journey as a fibre artist has been that amazingly and inexplicably fast. It has helped, though, that I have known what this book would be about almost from the very first exhibition of my work. I sat under a tent in a city dog park for a whole day, making not a single sale and passing out only a handful of business cards, but I didn't care because I was so proud to have done it. I had mustered up the courage not only to make my own creations, but to hang them for all to see in amongst aisles and aisles of other artists' tents. People encouraged me. Artists whom I respected acknowledged me. Nobody laughed.

Why is it that we don't try? I've thought a great deal over the last ten years about why it took me so long to try my hand at expressing myself. As a teacher, I see many students who are too tentative to try what is right in front of them waiting to be grasped, and too quick with excuses to not allow their own talent to blossom. I sympathize, because

for years that was me, too. I was put off by misconceptions about what art is, and who artists are, and what it really takes to be one. I didn't realize that art is just having something to say and the courage to try to say it. It turned out that there was an artist in me. And if there is an artist in me, then there is certainly an artist in you. **There is an artist in all of us, if you only wish to try and to grow.**

This book is about trying to fill a blank backing with your own ideas. I hope that you find the work inspiring and beautiful. Most of all I hope you see something you like and, whether you are an experienced artist or not, I hope that it gives you the courage to pull out that idea you've been harbouring. I hope that it inspires you to reach for your hook or your paints or your pencils or your pastels and share your ideas with the world.

As for me, that first show in the dog park turned out to be a stepping stone in my journey, and the experience gave me the confidence to dream bigger. You should, too. **There is nothing to be afraid of, and nothing to wait for.**

Monkshood at Cape Onion, *7" x 5", wool yarn, acrylic yarn, and metallic yarn on rug warp. Designed and hooked by Karen D. Miller, Ottawa, Ontario, Canada, 2014.*

Gros Morne Scenic Route (in progress), 7" x 5", wool yarns and cotton yarn on rug warp. Designed and hooked by Karen D. Miller, Ottawa, Ontario, Canada, 2015.

The Sisterhood of Travel and Art

Travel is a state of mind; it is a curiosity about the world and the people "out there," in the realm beyond the comfortable familiarity of home. We've all travelled, even if we've never left home. Maybe you've been fortunate and you've been able to travel around the world to see it at its most extraordinary. Maybe you have found a place that you love and that you return to every chance that you get. Maybe you've never left home at all, but you read and you watch and you imagine. I think travel is just a state of mind. We travel every time that we leave the everyday behind and allow ourselves to view our surroundings with an openness to wonder. Travel, whether it is real or virtual, confronts us with new environments and forces us to re-examine old assumptions. It encourages us to be curious, and curiosity is the first requirement in art.

I have been fortunate enough to have traveled, if not around the world, then at least to places so strange to me that they felt like new worlds altogether. Travel for me is escape. It is freedom, however brief, from the everyday. For one day, or two days, or two weeks, no matter where we go, I am freed from the drudgery of school lunches, to-do lists that never end, and holding together a family that flies apart into all directions every morning, day after day after day. When we travel, even buying groceries is a delight because we are all together with nowhere else to be and not another care in the world. We can take the time to wonder what *svinka* might be and why the box of *apfelsinu* has an orange on the front rather than an apple. The kids laugh with their dad about silly things because he's not miles away in his mind, and we love each other because we have the time to be the quirky bunch that we really are. We have no idea what is happening in the news and, for the most part, we don't care. We are together and we are happily lost in our own petty concerns, like identifying who ate the last *kleinur* and whether we should go get another bag now or later when the rain passes.

And travel, for me, is also about adventure. That isn't to say I'm an outdoors type looking to spend a week camping on a glacier or hiking for days with nothing to eat but the food on my back. I'm not. The adventure I love is the disorienting feeling of standing in the middle of strange landscapes or walking past weird street signs. I relish the feeling of being "the visitor" and the isolation that comes from being adrift in a sea of incomprehensible languages. It awakens an alertness in me. I notice even mundane things that I would ignore at home. It is change that I seek, no matter how small, because it enlivens me. I start taking pictures, and I start to imagine things I want to do to capture these moments and make them last forever. For the first few years of my art career, that was how almost all of my ideas were born.

I tend to fall in love with places. I didn't really discover this until later in life, so my husband and I spent many years travelling to new places each holiday and treating the experience as a "once in a lifetime" event. Looking back, I can easily understand why this approach didn't awaken the artist in me. It was always too much, too fast, and usually too exhausting. Italy is, I'm sure, a fantastic place, but seeing it by backpacking to a new city every day or two for two weeks in the midst of an historic heat wave was never going to do it justice.

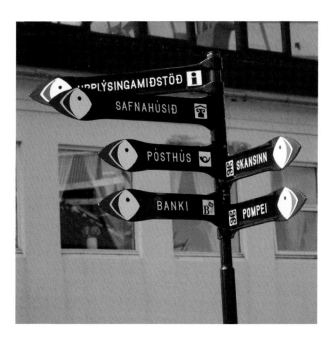

These puffin-decorated direction signs found on Heimaey, in Vestmannaeyjar, Iceland, made us smile when we were far from home.

Years later, I can recall that we were in Rome and Tuscany and down the Adriatic Coast, but with the exception of a bizarre memory involving the Italian word for a towel, I mostly remember always being very thirsty. I have a fantastic memory of the Coliseum; the gift shop had an air conditioner that my husband and I stood underneath for as long as was politely possible. Our hotel room in Florence had an air conditioner with a "max" button that was denoted by a strongman flexing his muscles. We ate *gelato* and we learned to see cities in the evening when it was cooler. But the wondrous details of these places mostly escaped me. It wasn't until we slowed down in Venice that I really started to observe what was around me, but unfortunately, that was right at the end of our trip.

We visited Greece, too, and my husband dragged us through a hike in the summer heat with no water, and the cruise itinerary kept us moving past islands so quickly that they began to blur. We visited Great Britain and Ireland on a rail pass and saved on taxis by walking through parts of towns that we should not have. We saw London by foot with the wrong shoes, and thence to town after town, day after day, feet covered in blisters, never stopping until we had completed the grand circuit that we had planned out over a map so that we would "see it all." In the end, I understand now, we actually saw little at all.

Thank goodness our children were born. Thanks to them, we discovered a way to travel that I wish we'd discovered years before. We learned to pick a home base with a kitchen for a week at a time, to rent cars, to shop at the grocery stores and, possibly most importantly for us, to retreat up the globe to the northern latitudes and remote locations that we enjoyed. Instead of chasing passport stamps and iconic photographs, we sought escape. Instead of arriving at Athens airport and finding it so crammed that we had to carry our luggage over our heads to navigate the crowds, we arrived at Vágar in the tiny Faroe Islands to complete silence. Even our car rental counter was closed, and we had to call for someone to come to the airport to give us our keys. Yes, even remote travel is not without its problems.

It was exactly at this point that I awoke as an artist. I had picked up a couple of hooking kits on a stop in Chéticamp, Nova Scotia, a couple of years before but hooking hadn't really grabbed me. I had finished the projects and found the method interesting, but not compellingly so. I was still cross-stitching then, but that for me meant
completing patterns that other artists had designed and packaged. It was just a relaxing hobby that I kept up all through my university studies and into my first career. I never would have called myself an artist. The idea had never even occurred to me. I had never had even the slightest curiosity about either artists or their art. I appreciated the genius of the great musical composers and played an instrument, but again, it never occurred to me to compose anything myself. I would have dismissed you out of hand if you had suggested to me that there was an artist within me.

St. Pauls, *7" x 5", wool yarn, acrylic yarn, and novelty yarn on rug warp. Designed and hooked by Karen D. Miller, Ottawa, Ontario, Canada, 2013.*

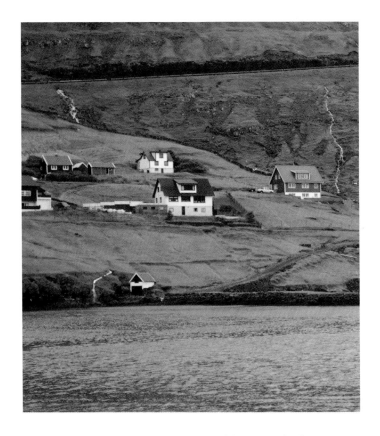

Bright greens, the signature colour of the Faroese landscape

And yet, that is exactly what I realized when I set foot in Iceland for the first time. Iceland before the 2008 financial crisis was different than it is now, of course, but even today the "other-worldliness" jars you immediately upon landing. **It is a land that forces you to observe and to be in awe.** It is a place that forced me to want to keep hold of my feelings. Looking at and sharing photographs wasn't enough because no matter how many I had taken, they never seemed to capture what I remembered. The colours in my mind were more vibrant, the shades subtler, and the emptiness wider. Photographs couldn't capture the freshness of the wind or the sponginess of the carpets of moss. No photograph seemed able to capture the ridiculousness of a puffin. So I set my mind to capturing it artistically. Maybe it seems a bit odd that I didn't use cross-stitching since I had so many years of experience with it, but the truth is that I never even considered it. The experience was so different that somehow it made sense that the way forward was to use a different method too. I hooked a scene, and then two, and I was in a whole new world. I've never cross-stitched again.

Since then, we have travelled several times to Iceland and to places along the Atlantic coast of Canada in search of that feeling of being at the edge of the world. In Fogo, Newfoundland, I was able to climb up to one of the proverbial four corners of

the Earth and look out over seaside cliffs to the empty horizon. It was exactly the feeling that I seek. Sometimes these scenes are striking, such as when waves are crashing against fantastical rock formations like the Elephant of Bell Island or the jagged black spires of South Iceland. Often, however, the camera can struggle to make anything appealing out of the expanses of sea sloshing around low headlands under monotonous skies. It seems to miss all of the subtlety that I see in the cool landscapes of greens-to-blues and browns-to-yellows, with perhaps a burnt red thrown in. Such places will offer up a splash of colour for you to grasp at, perhaps purple flowers or a red building, but I want you to feel the shivers that I felt when I stood in the wind at those spots. There is always wind by the sea. That is why I like the twisted, stunted, and often dead trees of the Atlantic shorelines. Their grasping branches and stripped bark are a record of all of the winds and storms of their lifetimes. Grasses are useful, too, when the wind gusts print their patterns on the fields, or clouds when they race in strings across the sky. Sunlight is tricky when it plays with the clouds. My favourite effect of all has to be standing in a spot of sunshine while all around is gloom. **Anywhere can give the feeling of being at the edge of the world.**

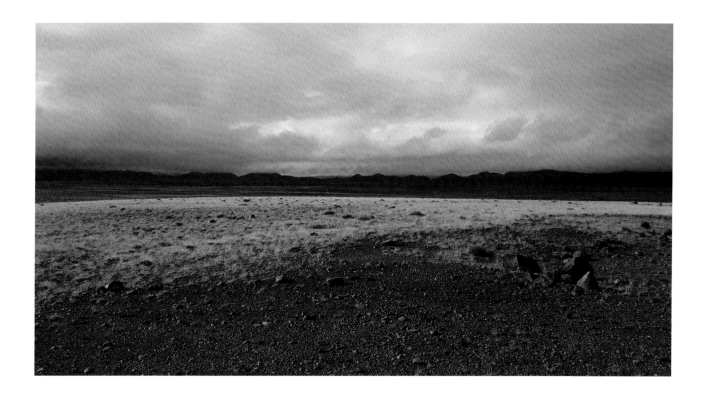

A glimpse of the interior of Iceland. I was eager to capture the colour combinations that I saw as I knew that they were uniquely Icelandic and I would not encounter them anywhere else.

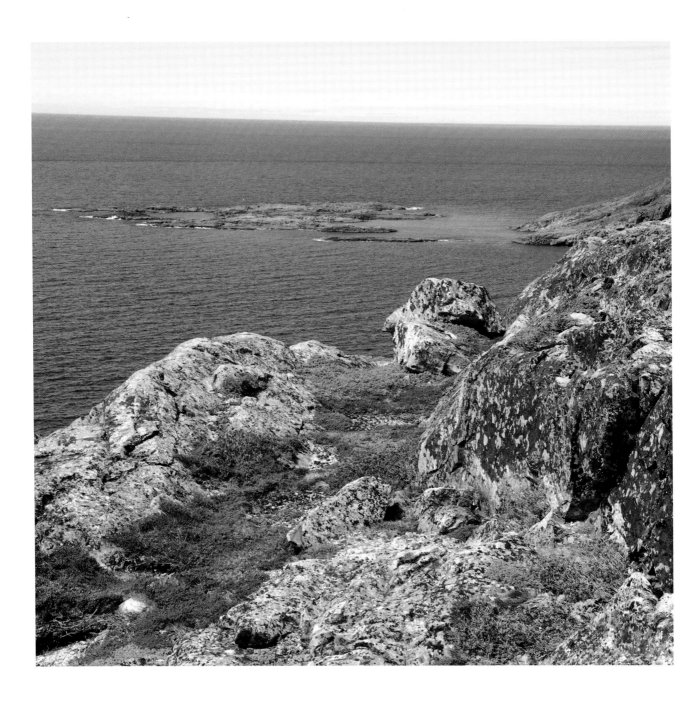

A view from the top of the Brimstone Head Trail on Fogo Island,
Newfoundland, one of the proverbial four corners of the earth.

I originally conceived of this book as a way to share my own experiences with using travel to inspire my art. When I teach, I encourage my students to explore, which means thinking unconventionally and pushing against the boundaries that hold them back. Everything is easier with examples, of course, and so I began with the idea of documenting in detail how I work and how I think. However, artistic expression is, by its very nature, individual. Everyone has a different vision, everyone has different methods, and every one of them is perfectly valid. Writing about myself only made me more curious about how others see the same things that I do, or why they look to different things than I do, and especially how some of them arrive in places that I will always struggle to imagine. How an artist develops a plan for a piece from nothing more than an idea in her mind's eye is, to me, an often-overlooked element of the artistic process. It is quite separate from the process by which the artist uses her technical skill to execute that plan. For example, it is one thing to study a painter's masterful use of short brush strokes and a light colour palette to create the impression of a shimmery sky. But how did that painter know that a shimmery sky was what she was after? When does she use it, and when does she avoid it, and why?

Gros Morne at Twilight, 7" x 5", wool yarn and acrylic yarn
on rug warp. Designed and hooked by Karen D. Miller,
Ottawa, Ontario, Canada, 2015.

In the world of fibre artists, I find that the "why?" is often the more vexing question than the "how?" We tend to be a technically accomplished crowd, often with decades of experience in producing wonderfully detailed work. Creating original works that reflect our personal stories, however, is an added element that is intimidating to some. That is why I am so glad that in the end, more than 31 artists agreed to share their original travel art with me for this project, and several provided me with examples of their thought processes. These artists all began with a blank backing, conceived an idea, planned it, and executed it entirely unaided. Each piece that they shared is pure self-expression. I hope that everyone who reads this book will see or read something that will resonate with them and lead them to make new art to share with us all.

Drawing Inspiration from Art

What is it that I want to tell the world through my art? It is the first, and perhaps most vexing, question that all artists face, and the single question that separates artists from crafters. And do I have anything original to say? The good news is that the answer to the second question, at least, is clear. We all have our own perspective on life. We all live experiences that will resonate with somebody and be new to somebody else. Your own perspective is what will define you as an artist, and how you select and tell your stories in your art will be your artistic fingerprint. This unique fingerprint will be evident in everything that you do.

Being clear about what you are trying to achieve is the first step in any successful artistic endeavour and necessarily involves a certain amount of introspection, especially at the beginning of your career. I suggest to my students that it is critical to forget what you work with, whether it is wool or thread, hook or needle. How you make your art is unimportant. The important thing is to determine what it is that most excites you about making art, and there can be no boundaries on this process. It could be that you are drawn to specific combinations of colour, or that you are fascinated by an intriguing idea or subject, or that you find certain compositions mesmerizing. Look at as many different styles as you can. That means looking at styles that you like and, perhaps as importantly, styles that you don't particularly like. Try to understand why you like something by identifying specifically what it is that attracts you. Just as importantly, identify what exactly it is about certain styles or effects that you don't like.

Study the work of other fibre artists. This includes the important influence of role models whose style and achievements you respect and wish to emulate. Studying other fibre artists is the typical first step in examining a broader range of artistic styles because their work demonstrates, in practical terms, both the opportunities and the limitations that you will encounter when expressing yourself in fibre. At the same time,

though, no matter how passionate we are about fibre, we should also never lose sight of the fact that fibre artists form only a small portion of the visual arts community. There is so much more to see.

Painting is probably by far the most accessible of the visual art forms. Painters of all styles have filled galleries and museums in almost every city and town in the world and have been the subject of many thousands of books about their inspirations, their work, and critical analyses of their techniques. The advantage of this for fibre artists is that painters and their critics have documented hundreds of years of lessons learned about the possibilities of colour, light, and composition. These are the tools of all visual artists, and lessons learned about them in paint are just as valid in fibre. Making a point of scanning artists' gallery shows and other compilations of their work for anything that catches your eye is bound to be a lucrative use of your time.

It is important not to limit yourself. **Be open minded to all art forms and what they can teach you.** Sketch artists, photographers, architects, sculptors, carvers, installation artists, folk artists, musicians, or writers can all trigger an idea about how to express yourself in your own medium. After all, poets and painters have enjoyed a notably symbiotic relationship over the centuries, so there is no reason it can't work for you, too. In fact, later in the book we'll see an example of how Liz Alpert Fay drew inspiration from the written word. Inspiration can come from anything, from internationally acclaimed multimillion-dollar architectural competitions to repurposed trash.

Writing this book gave me a wonderful opportunity to test my ideas about artistic influences in the fibre art world. I asked each of the fibre artists who contributed to this book about their own artistic influences. From the 31 responses, I was able to compile a list of over 60 different names of artists, groups, and movements, many of which were new to me. Some influences were mentioned by multiple artists, but the large majority were a mixture of local artists that made for a very diffuse word cloud.

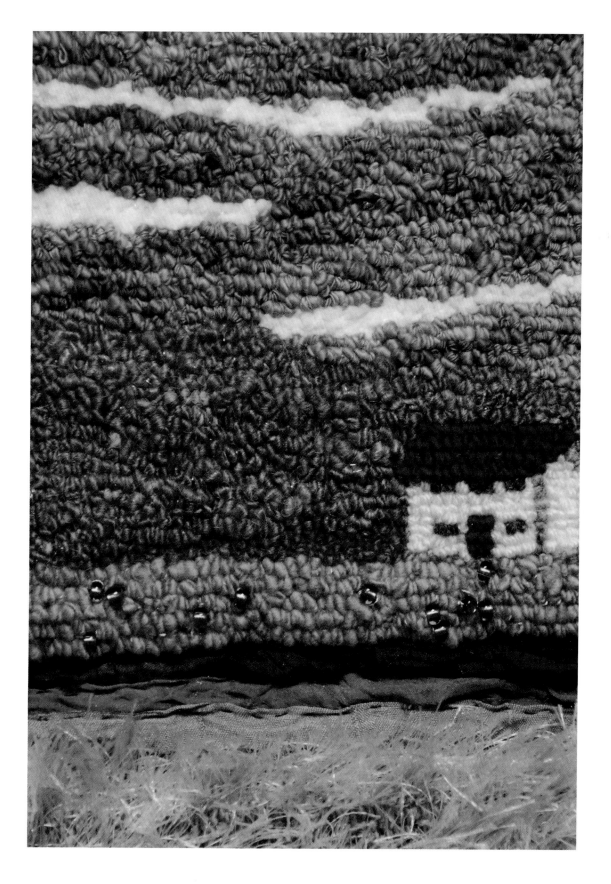

***Tilting**, 5" x 7", wool yarn, novelty yarn, sari silk ribbon, and beads on rug warp. Designed and hooked by Karen D. Miller, Ottawa, Ontario, Canada, 2013.*

Wallwork Waldheims Brown Kahn **Monet**
Renoir Irving Katz Wright
Group of Seven
Impressionism Squires
Goudie
Carr Sloane Rye Lapointe O'Keeffe Wright
Thorburn Montgomerie
Van Gogh Neel American Folk Art
Botticelli Colville Walsh-Best
Roy Fitzpatrick Kenney Shirran
Colpitts **Cezanne** Landseer Scarpa Bateman
Michelangelo **El Anatsui** Edye Eaton Martin
White COBRA Zerebeski Calder
Williams Boyd **Thomson** Patterson Reid
Milne Chagall
Baas Becking Singh Young Craig
von Sneidern Hayden Ajzenkol Matisse Klimt Meier
Canadian West Coast First Nations Harrison McDowell
Stegg Fallert

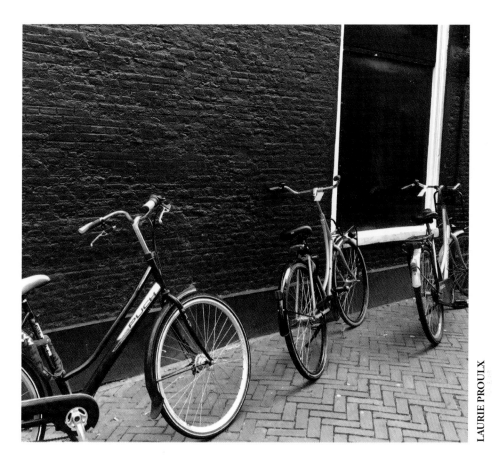

Travel magically turns everyday sights into artistic inspiration,
like these herringbones and circles in Leiden, Netherlands.

The first observation I would make about this word cloud is that while these artists acknowledged drawing inspiration from other fibre artists, they confirmed that the vast majority of their inspiration came from other media. It shows that the majority of these artists chose fibre because it is a medium that suits their message, not just because they have perfected the skill of using it. In fact, many of these artists are also comfortable in other media, whether photography, painting, pottery, or sculpture. Artists like Melissa McKay, Christine Walker Bird, and Lori LaBerge may even paint a picture of their subjects before they hook them.

The second observation is that over two-thirds of all of the names given were of painters, groups of painters, or painting movements. This isn't at all surprising, of course, but it is useful confirmation for new fibre artists of the value of studying the painters all around us. The influence of Impressionism, and Monet in particular, was pronounced. The link between fibre art and Impressionism seems well established, but I was surprised at how strong it was in this group.

My third observation is about the range of non-painting influences. To say that it was wider than I thought it would be is an understatement. I wasn't surprised to see influences such as folk art, wood carving, ceramics, and even

sculpture and installation art. I was, however, surprised that architecture was mentioned, and mentioned multiple times. I had also never heard of wood fibre art as a technique. It was a reminder to me that even as I strive to be open-minded to all influences in my art and in my teaching, the world of artistic expression is probably more astonishingly diverse than I will ever be able to fully comprehend. I can't imagine being without exposure to these exciting and talented artists, though. When I picked up hundreds of lobster claw bands on an Atlantic Canadian beach with only a vague idea of what I wanted to do with them, I was definitely channeling ideas I had seen from this category of non-painting influences.

My final, and somewhat sad, observation is to note the multiple mentions made of the important influence of high school art teachers in establishing a lifelong interest in the arts. Certainly, where I come from, public school cuts in the arts mean that fewer children are being introduced to art as part of their education. **It just means that the responsibility falls to us, as artists, to assume the role of guides to the world of the arts for our own children and their friends.**

ART PRIMER: THE GATEWAY ARTISTS

There are at least three ways the work of other fibre artists can offer you practical guidance in your own artistic journey. At least initially, every artist needs an example of what fibre art can do and how far it can be taken. Doris Eaton, for example, is one of the accomplished masters of the traditional techniques that form the foundation we all stand upon today. Several artists in recent years, such as Deanne Fitzpatrick, have sought to popularize fibre art, either to revive what they perceived to be a dwindling art form or simply to share their passion for what they do. One of the most useful things that these people do is challenge the rules, break them, and encourage you to do the same. Finally, many artists, such as Laura Kenney, have stretched and pulled fibre art in wonderful new ways, limited only by their own imaginations and often without regard to how anybody did anything before them. Many of these artists are featured in this book.

ART PRIMER: NEO-IMPRESSIONISM, POST-IMPRESSIONISM, FAUVISM, AND FIBRE ART

Monet and the Impressionists were the most frequently cited influences among the contributors to this book. I think this reflects the pioneering influence that the Impressionists had on the study of light in nature, and particularly in the development of *plein air* techniques that I discuss extensively later in this book. However, I would suggest Neo-Impressionism and Post-Impressionism as first avenues for the fibre artist beginning to explore how her techniques can be used for her own expression.

Fibre artists deal with the constraint that they cannot mix strands of fibre in their work with the same ease that painters can mix pigments on their palette. Fibre can be dyed any colour, but once it is incorporated into the work, the space that that fibre occupies can only be that single colour. Wool cannot be blended in the same manner as paints. Fibre artists have developed techniques to address this constraint, such as dyeing wool fabric, cutting it into strips and then hooking the strips in the same order that they were cut. This ensures that the final result will maintain the exact appearance that was achieved on the fabric when it was whole. But far more often the fibre artist is dealing with separate colours.

Neo-Impressionist painters such as Georges Seurat and Paul Signac worked on the principle that the separation of colour is actually an advantage rather than a limitation. They believed that separate applications of pigment made paintings more vibrant than is possible with mixed colours. This approach to colour has direct application to the fibre

artist's challenge. The Neo-Impressionist school took two forms. In Divisionism, the artist placed separate, individual strokes of pigment. Look to Signac's *The Port of Rotterdam* (1907) or *The Port of St. Tropez* (1901-1902) for examples in the travel theme, or Plinio Nomellini's *Sea of Genoa* (1891). In Pointillism, the artist placed individual dots of pigment on the camvas. Signac's *The Red Buoy* (1895), *Grand Canal (Venice)* (1905), and *Entrance to the Port of Marseilles* (1911) are all examples of Pointillism, as well as portraying a great deal of travel. Several of the works of Henri-Edmond Cross, such as *The Beach at St. Clair* (1901), are also examples.

Post-Impressionist painters blurred the precise separation of colour that characterized the Neo-Impressionist painters but still applied bright, unblended colours with thick, defined brush strokes. Paul Gauguin, Paul Cézanne and Vincent van Gogh are all considered examples of Post-Impressionism, with whose work we are all well familiar.

The brief Fauvism movement of the early 1900s was a Post-Impressionist school, worth highlighting for their explicit objective of capturing their feelings with colour. They were willing to alter anything to achieve that end, including changing the colours they saw and the conventional rules about composition and representation of form. Look to Othon Friesz's *Paysage (Le Bec de l'Aigle, La Ciotat)* (1907), Maurice de Vlaminck's *The River Seine at Chatou* (1906) and Andre Derain's *Effects of Sun on the Water* (1905) for examples.

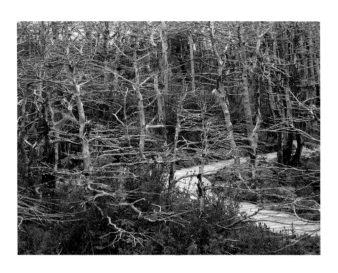

Post-Impressionism
Pratt O'Keeffe
Kjarval Fauvism
Carmichael Harris
McCavour Thomson
Van Gogh Carr

Your own artistic influences will most likely be more focussed than this representative cloud. As an example of what this could look like for you, I present my own cloud.

Wind-stripped trees at The Arches Provincial Park, Newfoundland, Canada, that inspired some of my more complicated themes of strength in weakness.

Tom Thomson looms largest in my influences, with my favourite works of his being *Fire-Swept Hills* (1915), *Thunderhead* (1912), *Sunset* (1916), and *Northern Lights* (1915), if I had to pick only four. As he does in his work, I try to accurately capture the detail of what I am actually seeing and unveil the colour that you might not be expecting. I prefer the use of deep, cooler colours such as strong blues, greens, or browns that are reminiscent of the earth and sky as opposed to either pastels or the brighter, warmer colours. When I look at Thomson's works, done deep in the Canadian boreal forests near my own home, I hear and feel what he must have felt when he was standing alone with his paints, miles from any other living soul. I can hear the wind in the trees and the waves splashing against the shores of the lakes. I can feel the constant movement of leaves and water in the wind through his use of rough and raw brushstrokes. I try to capture similar "edge of the world" feelings from my travels around the North Atlantic. I am also drawn to Thomson-like ymbols of stubborn strength and mulish endurance, like the stunted and wind-twisted trunks of solitary coastal trees or lonely outcrops of rock surrounded by frothing seas. Even in my sunniest scenes, I want you to feel the cool and crisp touch of the winds that always blow there.

Emily Carr, Georgia O'Keeffe, Vincent van Gogh, and of course Tom Thomson, all feature in my word cloud for their choice and use of colour. In much of her work, especially her forest pieces, Carr makes exquisite use of green, which has long been my favourite colour. In his wheatfield pieces, van Gogh juxtaposed a darkened blue sky against golden fields of grass and green trees. These combinations are almost electrically attractive together. In central Iceland, I took many similar photographs of golden fields in front of distant mountains that were rendered deep blue by the dark skies of a passing storm. And in some of O'Keeffe's works, like *Pool in the Woods, Lake George* (1922)

and *From the Lake, No. 1* (1924), I feel like we would have been fighting for the same colours on the palette had we ever had the chance to paint together. I think sometimes that I have an affinity for less popular, perhaps less striking, colours than the norm, but O'Keeffe reminds me that the cool side of the palette can look fantastic, too.

Carr and an Icelandic artist named Jóhannes Sveinsson Kjarval feature on my artist cloud for their unconventional choice of subjects. Carr was not afraid to make the individual trees of a forest her subject, for example, when others might have considered them unremarkable and used them at most as background. I feel strongly about giving the overlooked a second glance and seeing the remarkable where others might not necessarily think to look. Kjarval fascinates me for his dogged determination to see beauty in the mundane. See, for example, *Lava at Bessastadir* (1954). I would guess that few things could appear less noteworthy to an Icelander than a lava rock in the middle of a lava field. The country is, after all, covered in both from end to end. Kjarval sat in the same spot and painted the same rock in the same field over and over again and showed not only that it was beautiful, but also that its beauty changed through the days and through the seasons. It was a revolutionary concept at that time and in that place, and I can't help but feel a kinship when I walk into the woods in Canada and take pictures of things like lichen and fungi.

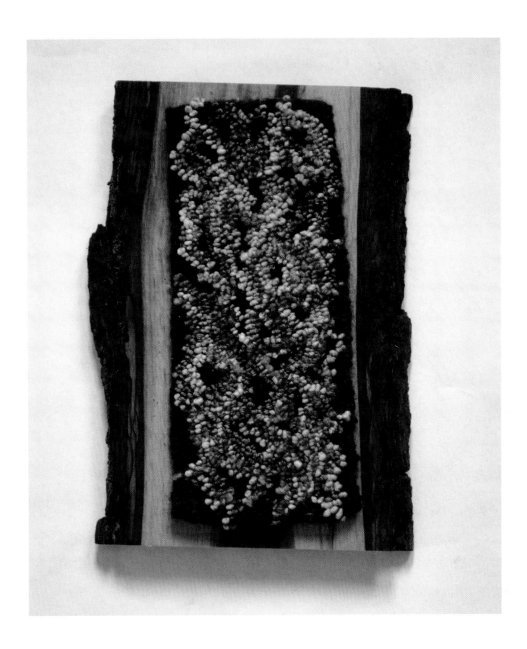

Underfoot II, 8½" x 13", wool yarn, acrylic yarn, and cotton
yarn on hand-woven backing on live edge walnut frame.
Designed, woven, and hooked by Karen D. Miller,
Ottawa, Ontario, Canada, 2018.

Finally, Fauvism, the fibre artist Amanda McCavour, and Mary Pratt all occupy what I call the aspirational part of my cloud, together with O'Keeffe. I can't point to anything that I have done yet that reflects their influence, but they represent directions in which I wish to go. Pratt represents a departure from the natural world for me, towards more familiar subjects closer to home, but still quite in keeping with my curiosity about the overlooked and the mundane. *Jelly Shelf* (1999), *Cod Fillets on Tin Foil* (1974), and *Supper Table* (1969) all represent for me Pratt's ability to see the art in her everyday life. In a somewhat complementary vein, O'Keeffe represents for me a more efficient art, focusing less on the compositional details and relying more on the effective use of colour and colour combinations to suggest meaning.

Amanda McCavour inspires me with the delicacy of her thread work. Hooking is typically considered complete when the backing is completely filled and concealed. This results in a heavier, substantive final look and feel. McCavour's work sews thread across space, pulling empty space and background light and colour into her compositions. I have experimented with similar effects in hooking, beginning with *Suspension* (p. 128), but I have a long way to go to achieve the delicacy that McCavour achieves in *Neon Bloom* (2014) or *Neon Clouds* (2016).

Fauvism for me is a liberating and personally expressive approach to art, perhaps best expressed by de Vlaminck when he said, "I try to paint with my heart and my guts without worrying about style." I find that fibre art is conducive to this kind of experimentation, which is why I smiled when Laura Salamy shared with me her similar feeling that "it was the first time that I could go ahead and do what I felt, all the rules be damned." The Fauvists encourage me to let go of reality when it is binding me rather than inspiring me, and let my heart guide my hand.

I would encourage everyone to every now and then think about who your influences are and how they impact your art. I suggest repeating the exercise because your influences are as dynamic as you are and it will change continuously as you evolve as an artist. As I write these words, there is no doubt that my own cloud will have changed by the time you read them. However, I find that thinking about my work in this way helps me to identify complementary, related avenues in seemingly disparate influences, and to understand what gaps I am filling when I stumble across new revelations. I hope it proves just as useful for you.

Waiting on Shore, 7" x 5", wool yarn, acrylic yarn, metallic yarn, and baker's twine on rug warp. Designed and hooked by Karen D. Miller, Ottawa, Ontario, Canada, 2014.

"Hand-cut fiber will give you more of a Monet effect, while using machine cut will give a Van Gogh quality. Tom Thomson is easily interpreted by using fluffy, full yarns and natural rovings." – Melanie Perron

Toronto, Canada

The Art Gallery of Ontario in Toronto, Canada, hosted a special exhibition of Georgia O'Keeffe's work. For me, seeing this exhibition once again proved that attending a properly curated exhibition of an artist's life work is more insightful that reading any books. A proper exhibition allows the artist to speak directly to you, as she intended.

Reykjavik, Iceland

The Listasafn Íslands (National Gallery of Iceland), Reykjavik, Iceland. An exhibition of the sounds of the country's waterfalls appealing against sacrificing Iceland's natural beauty for development seems only more poignant now, years later in the tourist boom. Finding the hidden pockets of Iceland's art elsewhere was more fun, though, such as the modern Icelandic art at Listasafn Árnesinga in Hveragerði, or the throwback to Kjarval's time in the bar at the Hótel Holt in Reykjavik.

NYC, USA

Metropolitan Museum of Art, New York. I went to see their van Goghs, and was almost overwhelmed when confronted by the artistic heritage of virtually the entire world assembled all in one place. Not since Florence had I seen such a rich collection, but back then I wasn't really looking.

Reykjavik, Iceland

Kjarvalsstaðir, Reykjavik, Iceland. A little gem, just for me, where in wandering the rooms filled with his work, I confirmed that Jóhannes Kjarval really is one of my muses.

2 REALISM AND THE POWER OF OBSERVATION

What more logical place is there to begin as an artist than by documenting our strange and inspiring surroundings as we see them? We are already well accustomed to the idea of making visual diaries of our travels. After all, we buy postcards and prints and take photographs and videos so that we can better remember the fantastic things we've seen and share our wonder with our friends. Capturing those memories with our own hands is just the next step. **I already loved to travel, and when I finally sought an inspiration for my art, my album of travel photos was my first and most obvious resource.**

I began my journey in the visual arts trying to accurately capture the forms and the colours that I saw. Shouldn't drawing what is right in front of us be child's play? After all, isn't drawing something we encourage our children to do, and don't we cover our fridges with their handiwork? Shouldn't I, a grown adult, with a pencil and an eraser and some paints, be able to make a reasonable picture of a sunset I have seen a hundred or more times in my life? The truth is that most of us will find that we can't, and the danger then is that we will get frustrated, put our pencils back into the drawer and say those fateful words, "I'm not an artist."

In fact, we are right to be in awe of the fairground sketch artist who can take our likeness in a handful of practiced lines across a fresh page. Capturing detail exactly as you see it is a skill, and like any skill it requires a great deal of practice: first to learn and eventually to master. However, focusing on how to capture a detail actually skips the prior, and often overlooked, step of noticing the detail in the first place. This, too, takes practice, especially these days when we have every portable electronic excuse not to pay any heed to our immediate surroundings. There is probably no better time to practice than when travelling. After all, if you are travelling for pleasure, noticing your surroundings is the whole point. Observation should be the purpose of your days, especially if you are travelling to see something you are curious about. If we're travelling for relaxation and escape, or even for business, the change in our daily environment will destabilize us just enough that we pay more attention than usual. Such observation is fertile ground for art.

How many times have you heard an artist suggest that an idea "just hit them" or "jumped out at them"? Don't be fooled. This suggestion does a disservice to the skill they put into the identification and framing of their idea; they were not passive. Effective observation is active concentration combined with an awareness of what you are looking for. An artist is somebody who studies her surroundings looking for appealing colours and

> "I'm not interested in replicating something exactly, but I want to have a reminder to trigger or expand on an idea and have it morph into something else."
> – Tracy Jamar

compositions in the world around her. The more practiced she is, the less obvious the effort she will have to expend. It can appear almost subconscious, but this combination of concentration and self-awareness is always the same.

ART PRIMER: IS REALISM REALLY ART?

Is capturing just what you see really art? Realism is a recognized movement in the art world, characterized as the close observation and accurate capture of the details that we see in the world around us. As a movement, it also includes the practices of journalism, which seeks to state the facts as they are known, and photography, which permits the precise and complete mechanical capture of "what the eye sees."

The power of Realism is that it is inclusive. It captures the details of our lives from our own perspectives, whomever we may be and whatever reality we may live. While we all recognize the world of the wealthy and the royally born that was almost exclusively depicted in some of the other art movements, it was Realism that brought the rest of the world into art. When you capture even the most mundane details of your life in your art to share with the world, your piece is an example of Realism and, yes, it is art.

Realism
Abstraction
Expressionism
Impressionism

Travel is an ideal time to practice observation because at least one half of the challenge is taken care of: It is easier to concentrate when there are lots of different things to look at. It does, however, emphasize the importance of the second component of active observation: What should you look at? It isn't enough simply to be curious, because the volume of things to look at, and the pace at which they appear to you, can quickly become overwhelming. This is the problem that I had in Italy. I had never given any serious consideration to what it was that I was trying to see, and so I spent a lot of my already very hurried time looking at things that, though famous, I was still years from realizing I actually had little interest in. If I were to return, I would look for such different things, like the colours, shapes, textures, and patterns of the region.

Part of the solution is to think about what you like. This sounds obvious, and it is, but it saves a lot of time to be clear about it. Perhaps it can be a particular colour, or a combination of colours. For example, I love the golden colour of grass in the sunlight set against the deep blue of a stormy sky. I prefer my colours strong, whatever colours they may be, and I don't care at all for pastels. So even before considering subject matter, it is scarcely surprising that I found little of interest to me in the sunbleached off-whites and sand-beiges of the ruins of Ephesus, Turkey. You want to maintain an open mind, of course, since that is the point of travelling, but some balance is necessary. For example, when she travels, Jean Ottosen makes a point of seeking out the local textile work, art work, and architecture to understand what the locals find beautiful or noteworthy about their own home as a starting point for her own exploration. This is a wonderful example of an active observation technique in practice. However you choose to approach things, techniques like this will protect the originality of your own artistic expression.

Tulip (Fireworks), 5" x 7", wool yarn and acrylic yarn on linen. Designed and hooked by Karen D. Miller, Ottawa, Ontario, Canada, 2016.

One of my favourite techniques to develop my powers of observation is to take every opportunity to travel closer to home. Not only can you do it more frequently, but you can revisit places that interest you and look at the same subject in different ways. The idea is still to get away from the everyday, but the differences are far fewer than with a more exotic trip. This more controlled environment allows you to more easily identify and focus on the differences that truly matter and consider more deeply how you would go about capturing them. Such practice makes observation more natural to me so that I don't need to study my surroundings so closely to recognize what interests me. I practice on my walks, on our day trips, on our weekend getaways, and when we go camping—and I have made art from all of them.

The next six pieces are all examples of art made from what I consider to be local travel. Kathy Taylor's *The Laurie E, Georgian Bay* is a fishing boat passing a favourite family vacation spot on Georgian Bay in Ontario. Everything about the Laurie E should have served to make it unremarkable. In Kathy's telling, the boat is so well known to everybody in her area of the bay that it serves as a morning alarm clock for many throughout the season. However, Kathy noticed it the day that she, too, was out on the water with her camera, and she was struck by the birds milling about in the air looking for a free meal. Her portrayal of the complicated, mottled complexion of reflections and dark bands in the water is both astonishingly accurate and effective in giving her piece very convincing depth. Altogether, *The Laurie E, Georgian Bay* is a wonderful example of observing details right in front of you and remembering not to ignore the everyday.

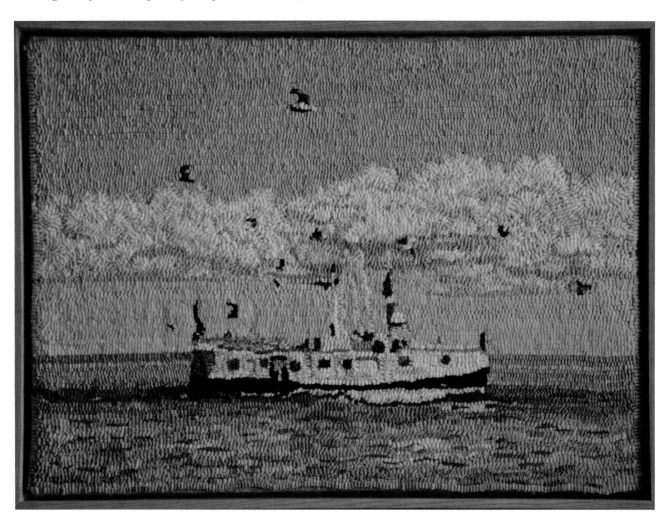

The Laurie E, Georgian Bay, 22" x 16", various cuts of hand-dyed wool fabric on linen. Designed and hooked by Kathy Taylor, Toronto, Ontario, Canada, 2016.

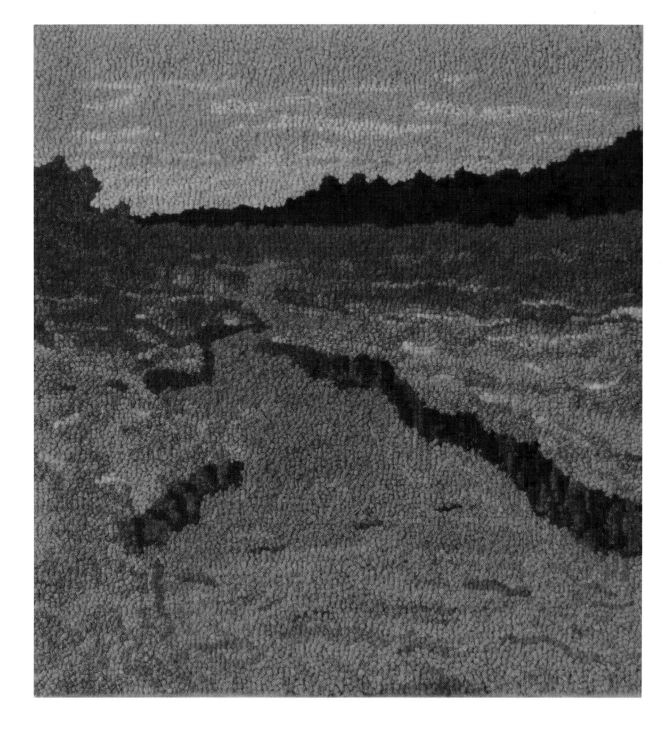

Along Breakwater Trail, *16" x 17", #3-cut wool on linen.*
Designed and hooked by John Flournoy, Lewes,
Delaware, USA, 2015.

It was the colours of *Along Breakwater Trail* that first caught my attention. You may already recognize the blues and greens that I quite enjoy, and the inclusion of the water certainly piqued my curiosity. John Flournoy explained to me that the scene is of a favourite bicycle trail in the coastal region of Delaware. He took a photo of this view from a bridge over the marsh one morning, before everyone else arrived, when it was still peaceful and he could hear the grasses rustling in the breeze. I teach my students to be aware of the beauty of things they may be inured to. This piece is an example of what you might find as you recognize your surroundings for what they are instead of merely a backdrop to the rest of your life. When that happens, the uniqueness of the elements of the scene stand out to you as they never have before.

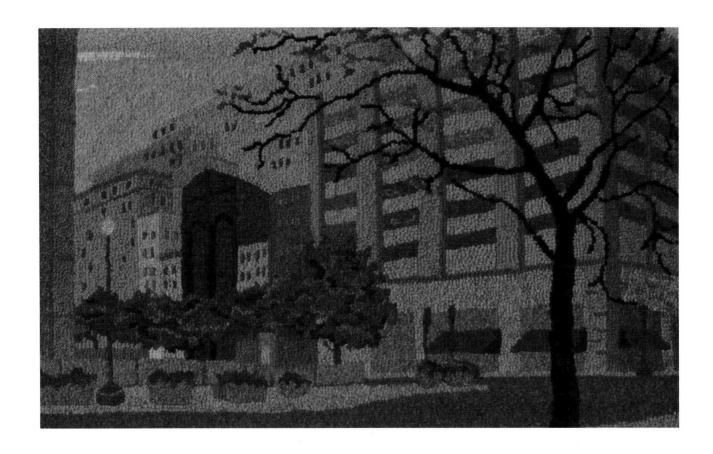

Downtown Washington DC, 31" x 15", #3-cut wool on linen.
Designed and hooked by John Flournoy,
Lewes, Delaware, USA, 2007.

Downtown Washington DC, also by John Flournoy, demonstrates the control over your image that is possible when you are travelling locally. Photography is an important part of John's process, and later in the book we will see an example of a piece that he composed by selecting usable components from different photographs of the same scene. In this piece, however, he worked with a single photograph because he was able to visit his scene at the time of his choosing to get the image that he wanted. Since he knew this area of the city well, he knew that there would be no people or traffic about if he went early on a Sunday. As a result, his image emphasizes the contrast between old and new architecture and between the concrete cityscape and the tree, as he intended. There are two things I especially appreciate about this portrayal of Washington. The first is that by staying honest to the muted colours and resisting the temptation to apply the veneer of false polish that others apply to idealize their cityscapes, John makes the city look and feel lived in—and almost as though it could be a street corner that I have stood on in my own city. Second, John's disciplined adherence to the rules of perspective, both in his lines and in his use of his colour values, creates enough depth that I feel like if I could only strain my neck forward, I could actually peek down the street to the left.

Exploring the Lake is my own local study piece. For several summers, we joined the rest of our extended eastern Ontario family for a gathering at a family cottage. Part of the tradition was canoeing on the lake, which I always enjoyed because it was so quiet that you could hear the frogs and watch the birds and see the occasional beaver or muskrat. On this particular trip, I noticed this odd rock at the point of an island that we often circled. I loved the unexpected geometry of the rock in amongst the random disorganization of the forest, and the water that mirrored the shoreline so completely that it itself all but disappeared. The rock had always been there, in plain sight across the lake from the cottage, but I had never noticed it before. Every year afterwards, of course, I couldn't help but notice it.

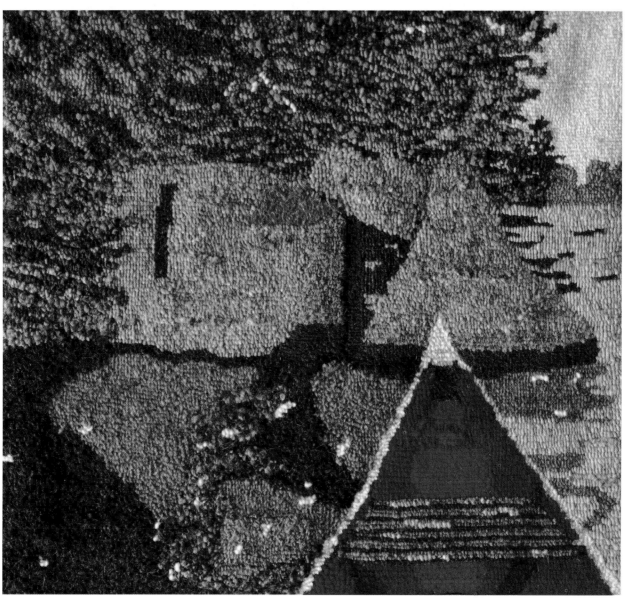

DANIEL MACDONALD

Exploring the Lake, *17" x 19½", wool, acrylic, and novelty yarns and wool roving on burlap. Designed and hooked by Karen D. Miller, Ottawa, Ontario, Canada, 2011.*

I love this example of seeing, or in this case feeling, what was right in front of you all along through the concept of travel in your own backyard. I had approached Judith Lilley about this piece because I liked her approach to what I guessed was a classic summer vacation theme, and her use of lovely blues. Imagine my delight, then, when she explained that she is the woman in the image and she is running into the water by her home on the south shore of the estuary of the St. Lawrence River in Québec. She had moved to the village eighteen years before and never swum in the river, thinking it to be glacially cold. It was a neighbour who taught her that the river is wonderful just before full tide on a sunny day, and this piece depicts her enthusiasm all the rest of that summer to catch up on eighteen missed years and drop everything and jump in whatever chance she got.

Observation is also what enables an artist to find a unique take on a familiar subject and portray it in a new light. This is an important skill, as anybody who has been subjected to looking at somebody else's picture of the same famous tower from the same corner of the street as everyone else can attest. Consider, for example, Central Park in New York City. I've been to it, I've seen it in the same movies and television shows that everyone else has, and I recognized it instantly in Gunda Gamble's Gates at Central Park. Yet, and this intrigued me, I'd never seen it like this before. The scene is of The Gates exhibition by Christo and Jeanne-Claude in 2005, consisting of over 7,500 gates of saffron-coloured fabric hung over the pathways of the park. Gunda happened to visit on the day of a fresh snowfall, which transformed the city and the park. Without question, the scene of the exhibition is unique, since it only lasted for two weeks and was never repeated, and even the inclusion of the snowfall is less common in portrayals of Central Park. However, it was Gunda's treatment of the skyline of New York that most drew my attention. She has muted and blurred one of the most iconic skylines in the world behind a foggy sky, creating a relatively unusual feeling of New York. It is anything but a typical memory of New York, and yet just as instantly recognizable.

Into the Sea: A Celebration of Summer, 12" x 14", #6- and 8-cut recycled wool, yarn, sari silk, and wool roving on linen. Designed and hooked by Judith Lilley, Kamouraska, Québec, Canada, 2016.

Gates of Central Park, 22" x 19", #3-cut wool on rug warp. Designed and hooked by Gunda Gamble, Ariss, Ontario, Canada, 2010.

Observation by Photography

No discussion of observational techniques would be complete without a discussion of photography. I asked all of the contributors to this book to tell me about their approaches to observing the world around them and all of them confirmed that photography is a useful tool. Some of them use it quite extensively. For example, Jean Ottosen mentioned returning from a holiday to South Korea with 1,900 photographs, and Trish Johnson, who has a background in photography, says she is never without her camera. Almost everyone mentioned carrying a camera or a mobile phone and using it frequently. With today's cameras being cheaper, smaller, easier to use, more functional, and with larger memory capacity every year, there is no reason anymore not to carry one and photograph at will. This describes me as well. Clearly, visual artists find that photography is an important tool for observation.

All the advantages aside, however, too much reliance on the easy accessibility of photography will be detrimental to your artistic process. We have all seen the extreme situation of tourists walking quickly down a main boulevard or through a museum, their heads turned to the left and their video cameras pointing to the right. Or worse, all of us have stood behind the tourist who never lowers his mobile to look at the view with his own eyes. The idea here is that since data storage is cheap and travel is expensive, you should maximize the amount of "stuff" that you see, and it is better to see something quickly and photograph it to study later than to lose time appreciating it now and therefore miss seeing something else altogether. Of course, the problem with harvesting information like this is that it is passive observation. By the time later comes, you are out of the moment. In fact, by moving so quickly, or looking exclusively through the lens of your camera, you likely didn't experience any moment at all. By definition, therefore, your active observation will be delayed and very likely incomplete. This is not conducive to making good art.

Using photography well is simply a matter of understanding how it can be used to support your active observation of a subject. The object is to take photos that begin the process of developing your composition and contain memory aids for the important details. To demonstrate these concepts, it is useful to recall how artists used photography when a film had 24 exposures and took up to a week to develop. For many artists in those days, the delay between taking the exposure and receiving the developed photo was far too long, so they used more immediate methods of capturing important elements of what they saw, such as journals and sketchbooks. They used journals to write down their impressions at the time that they experienced them, which is to say either immediately or as soon as possible afterwards. Contemporaneous impressions are easy to document accurately when they are fresh, but can be difficult to recollect later after they have been altered, perhaps subconsciously, by further reflection or the incorporation of other people's opinions.

"Often, I find the image that remains in my mind is better than the actual photograph." – Liz Alpert Fay

These contemporaneous impressions often contain the spark that gives the final piece both its originality and its vitality. Journals were also useful for identifying necessary details about the scene, such as notable colours or feelings, and for storing potentially useful souvenirs of the moment, such as maps or other specimens. As such, journals were very effective memory aids. I will return to this idea in the next section.

With the advent of personal photography, artists were freed from the necessity of sketching on the spot. In an essay by author Sarah Fillmore in the book *Mary Pratt*, leading Canadian artist Mary Pratt described the impact of film photography on her working process like this: "The camera was my instrument of liberation. Now that I no longer had to paint on the run, I would pay each gut reaction its proper homage. I could paint anything that appealed to me . . . I could use the slide to establish the drawing and concentrate on the light, and the content and the symbolism." The essential point is that photography saves the artist a significant amount of labour but does not in any way alter the process of composing and producing a piece of art. That can only take place in the artist's mind. In an online interview with the National Art Gallery of Canada, Mary Pratt also spoke about the process of reviewing and rejecting her own photos: "It gets sent off to Toronto or wherever to be processed, and then when all of these slides come back, I've forgotten that first jab, that first jab of enthusiasm. So I spread them out on a light board to have a look at them, to see if there's anything there that I remember. Is there anything that's going to make me feel like that again? Sometimes there

isn't; sometimes it was just a total waste of time."

Trish Johnson offered three advantages for the visual artist of practising photography. First, taking and studying your photographs will make you more observant of the variations in the quality of light at different times of day, times of the year, and in different weather conditions.

This certainly resonates with me as I have long noticed—and been drawn to—the warmer feel of the late afternoon summer sun than the crisp sun of morning. I am also intrigued by the challenges posed by low light when portraying threatening skies.

The photograph is a step in the artistic process, but it is still up to the artist to determine if there is a viable idea in the image.

The same photo of tulips, in colour and in black and white. In the black-and-white photo on the right, you can see that by taking colour out of the equation, the eye is better able to focus on the lights and darks in the photo, otherwise known as the values.

Secondly, although nowadays it is more common as a function in photo-editing software, experimenting with black-and-white photography is still an effective way of learning the importance of contrast and value before adding the challenge of colour. I enjoyed my own black and white phase for exactly this reason. Without having to worry about colours, I found that I enjoyed making compositions that depended upon contrast and value changes for their impact so much that I still look for similar opportunities in my colour compositions today. In addition, transferring a photo into black and white is extremely useful in revealing the values and shading required in your composition. By removing the distraction of colour, these elements are made much clearer. In fact, when working from a photo, I will often additionally print out a black-and-white version to have on hand should I have trouble distinguishing the values in a specific section of the image.

Thirdly, photography allows you to begin the process of composing while you are still on the scene, whether by altering angles to change your perspective on the subject or increasing the focal length to magnify and crop your image. Several of the other contributing artists agreed on this point, and it is the single greatest advantage of photography that I use on an everyday basis. I will take several photographs of any scene, trying different focal lengths and angles as the situations seem to suggest. With regard to angles, I will experiment with the balance of a composition by taking photos with the subject in different off-centre placements. There is also ample opportunity to change the context of an image in sometimes surprising ways by shooting from either above or below. Regarding focal length, several other artists also noted that zooming in tight to a subject is a reliable method of removing extraneous detail. The same technique can even completely transform the image, such as when focusing on a vibrantly coloured and fantastically contoured fungus under your feet instead of the decrepit trunk on the forest floor that it is growing on. I will take photographs of any specific details that strike me as being important to use as memory aids in my studio work.

It is readily apparent that this approach to photography can quickly yield a large number of photographs, only a few of which will ever become art. This has certainly been my experience, and others mentioned the same phenomenon. Jean Ottosen reported that she trimmed her 1900 photos from her holiday down to 100 that contained interesting ideas, and then down to 17 that she judged worthy of working with further. Only a handful, she said, will be hooked. I have experienced similar ratios. Further, I have struggled with the accumulation of years of photographs from various holidays, day trips, and life. I have made it a practice to save my most promising photos in a dedicated folder and, in addition, regularly print them and store them in a box in my studio. I do this so that I have easy and rapid access to them whenever I want to go back and find a particular photo, or I just want to browse for inspiration. Oftentimes, I will use a photo years after it was taken for a completely new idea.

If you have many photos printed for future use, there is a high likelihood that some will become misfiled, lost, or forgotten. Is losing photographs a problem? Of course not. In Liz Alpert Fay's words, "Often I find the image that remains in my mind is better than the actual photograph." What she is identifying, as Mary Pratt did, is that even the best photograph is no more than a reminder of an idea that you had. Interestingly, I thought it was another artist, Judith Lilley, who captured best why Liz Alpert Fay is right when she pointed out that the obvious problem with photographs is that they are too perfect, saying, "My memory is certainly selective, leaving out the uninteresting parts of the image." And Brigitte Webb corroborates them both: "When recording scenes or places in photographs, one captures the moment as it is viewed whilst for me in rug hooking it is an impression of my feelings, personal images, recalling its essence and trying to interpret that." So as long as you keep hold of your ideas, you haven't lost anything at all.

This returns me to the usefulness of journals, diaries, and sketchbooks. Given that their explicit purpose is to be a vehicle for preserving and developing your own ideas, they are the perfect complement to a large archive of photographs. Even if you have what you think is the perfect photograph, I think it bears recalling Tracy Jamar's observation at the opening of this chapter about not wanting to simply replicate the subject. **Replication is impossible with hooking anyway. Even if that is our goal, we have to make choices about what details to omit, and in doing so we begin to reveal our interpretation of the subject.** As soon as we begin to do that, we are venturing past the photograph itself.

Observation by Sketchbook

Even if you take hundreds of photographs, think for a moment about all of the extra-visual elements that you capture in your art. It could be who you were with at the time, your reasons for taking the trip, or an appreciation for what somebody close to you would think of that place or experience. An image could be there only for the instant that we observed it, too quickly come and gone to be photographed. It could be notable because of how we were feeling at that moment rather than what we saw. All of these factors are as much a part of the memory and the idea as the photograph. And since the image may be meaningless without them, they are just as important to record, whether by sketch or by word. **However you choose to capture your own thinking and ideas that complement your photographs, the most important thing is that you do it.**

There are many ways to capture this extra-visual information. The classic approach, of course, is the sketchbook, and with good reason. Unfortunately, the idea of using a sketchbook also often elicits a horrified response: "But I can't draw!" However, this misses the point. The sketchbook is nothing more than a completely flexible tool for capturing thoughts. You can draw in it, paint in it, colour in it, sandwich objects between its pages, glue things into it, write in it, and even cut and fold its pages. **There are no prizes for the best sketchbook. So don't worry.** And if your sketchbook is a mess that only makes sense to you, that is exactly the point. The value of keeping a sketchbook is that it forces you to be an active observer of composition and important details. After all, you have to observe a line before you can draw it, and with a world of detail to choose from, what you choose to draw will reveal what you feel to be the most important elements of your forthcoming composition. There is no such thing as the "right" sketch, and no two artists will draw the same sketch, even if they are sitting right beside each other.

There are other options, of course, and with today's technology, there are even more than ever before. Journals and notebooks, blogs, social media, scrapbooks, and even boxes of mementos are all ways in which we capture what we are thinking and why we are moved by something. **When choosing which tool you are going to use, the only relevant criterion is whether you are comfortable enough with it to use it consistently.** Just as a writer is no closer to completing a novel after buying a fancy desk, you are no further ahead simply for having expensive photo editing software or a fancy set of watercolour paints. My own preference is to annotate my photographs, most prolifically in my myriad of scrapbooks. I scrapbook everything about my family in annual books, I build scrapbooks of each of our trips, and I used to relish challenges like taking photographs of everything going on in our lives over a particular week. I mix my photographs with tags and cards noting the peculiar stories and oddities of life, and souvenirs of all of our family events, big and small.

"Look, observe, and look again. Photograph, sketch, take notes, anything that helps focus your observation." – Gail Nichols

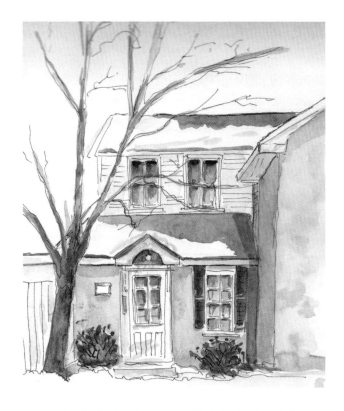

Sketch of Moodie Cottage, *Christine Walker Bird, Belleville, Ontario, Canada, 2017.*

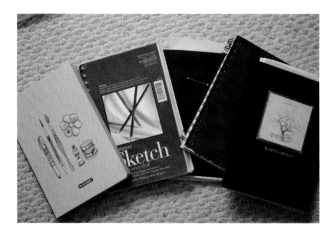

Having a number of sketchbooks means always having one close at hand when you need one.

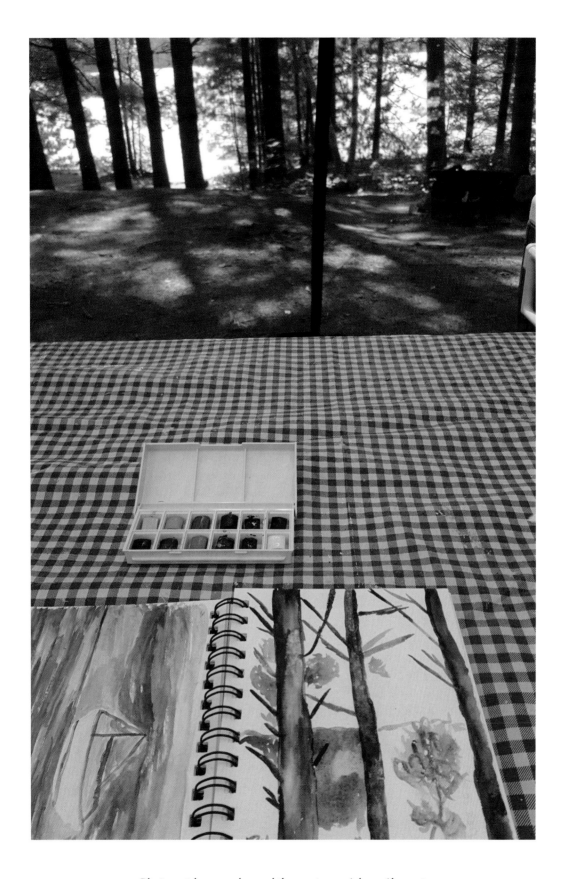

Playing with watercolours while camping at Achray, Algonquin Park. I am no expert at drawing and painting, but there is value in practicing these skills and getting down colours and impressions while in the moment.

Trish Johnson took this approach a step further and combined her photos and diary entries from a vacation to Grand Manan into a quilted journal that is now a piece of fibre art in itself.

Many artists use sketchbooks. The general idea is to identify and quickly capture in words or a sketch what it was that you liked about a place. If you have spent a great deal of time setting up the perfect shot of exactly what you want, perhaps this is unnecessary, but my own experience, shared by virtually all of the other contributors to this book, is that that rarely happens. Even the best photograph is only a reminder of what you loved about what you saw, especially when you are travelling. Since travel photography is done in real life, and in real time, most images will be taken from too close or too far, quite probably at the wrong time of day for the light or in the wrong weather, with extraneous objects or people, or even missing the very thing that fleetingly caught your attention.

Postcards from Grand Manan, 5" x 7" x 2", machine-pieced
and quilted. Designed and created by Trish Johnson,
Toronto, Ontario, Canada, 2007.

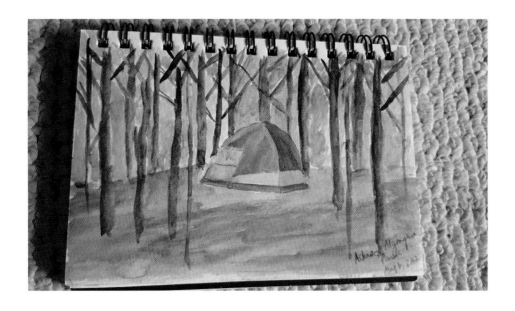

*A page from my sketchbook. Quick marks on the page and letting
go of perfection helps me to remember the feeling
and colours better than any photo.*

For example, I find photographs are generally poor at capturing the true magnificence of huge natural features like canyons, grasslands, mountains, or glaciers. I find children and wildlife equally impossible to catch in the correct pose, or any pose at all, and often end up being a blur. I find that both nature and cities are, in general, messy and unattractively unkempt if you look at them too precisely, as the camera lens does. **The great advantage of the sketchbook over the camera, therefore, and the great value to you as an artist in developing the habit of using one, is that it is a device for capturing what you see rather than precisely what is there.**

Earlier, I mentioned the fairground sketch artist. I could also have referred to the street artists who lay in wait around the tourist traps offering to do your portrait or your caricature. What these artists do exceptionally well is quickly strip any face down to only the essential features that make it recognizable. They replicate these features quickly and accurately in only a handful of bold strokes. They aggressively scribble and blur their lines but they scarcely ever pause, and I've never seen them erase. They only have a few minutes of your time to work with, so economy and efficiency are paramount. These two concepts are a useful guide in how to best use your own sketchbook.

As an extreme example, Susan Feller made the sketch on this page while stuck in traffic traveling a mountain road on the way to Greenville, South Carolina. You could call this sketching technique many things, like bare or parsimonious, but I would discourage you from describing it as "simple." Although Susan only used two lines in her sketch, she did so because she understood her subject well enough to know that two lines were all that she needed. I know she was correct because I, too, spent hours stuck in traffic on a road through the White Mountains in New Hampshire in the fall leaf-peeping season. It is a strange feeling, really, being in a traffic jam in the middle of the countryside. We are all accustomed to being at a standstill surrounded by all the noise and flash of urban life, but being bumper to bumper on a hairpin turn in a valley overlooking miles of nothing but featureless hills and trees is peculiar. Although the reasons we were stalled may have differed, Susan's two lines still capture the hairpin turns of the road and the absurdity of there being nothing else around. The emptiness of the page is just as important as the lines that Susan did draw, and the simple lines she used were chosen well.

At the other end of the spectrum, one could say, there is the sketchbook of Christine Walker Bird. I call this extreme because if I could paint like Christine does in her sketchbook, I would happily try to sell them as finished pieces. While anybody can express themselves, it is equally true that artists who are technically accomplished in another medium, such as drawing or painting, have a tremendous advantage in that they are able to accurately translate what they see in their mind's eye to the page. They have the technical capability to reliably and accurately portray what they see, and to portray what they imagine.

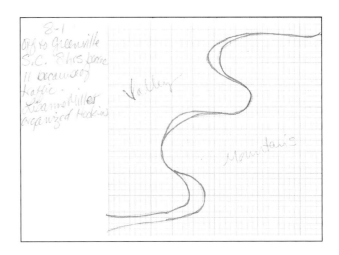

Year Study: "Traveling"- Journal Entry for August 1st, *Susan L. Feller, Augusta, West Virginia, USA, 2014.*

This is an important skill. While there are accurate tools and techniques for overcoming the inability to draw or paint, such as tracing paper and photo projectors, there are fewer options when capturing one's own imagination. Several of the other artists in this book mentioned their formal training in drawing or painting and how it increased their technical understanding of form, light, and colour. One great value of the sketchbook, therefore, is in the practice. **The sketchbook is simply a device to practice art for the pleasure of making art without the pressure of needing to complete a perfected piece.** It is a place for experimentation, doodling, trial and error, and practice that you simply cannot do with fibre art. Fibre art simply takes too long to execute to be experimental. A single hooking takes months to complete, which is just too much time to evaluate if an idea or a technique is going to work. Naturally, my favourite time to sit and play at art is when I am traveling, surrounded by inspiration and freed from my deadlines and other tasks.

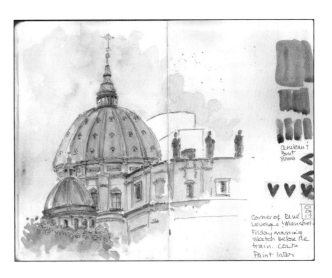

Sketch of Marie-Reine-du-Monde in Montreal, *Christine Walker Bird, Belleville, Ontario, Canada, 2017.*

My last example of a visual sketchbook, and a technique that is unsurprisingly closer to my own heart, is that of Monika Kinner-Whalen. In this example, Monika has cut out and pasted in several garden pictures from older magazines. An artist might do this for many reasons. She might wish to use it as a practice study for sketching, as a model for a piece, as a souvenir and a reminder of something else entirely, or to prompt a new train of thought. This is a fantastic technique for trying out new colour combinations to see if they work, before committing to a piece of art.

In general, I'm far more comfortable writing than drawing, and so I have always had a predilection towards writing diaries and travel logs. When I was younger, I liked to write down my impressions of the day in a structured, daily travel diary that covered everything from the things I'd seen to the weird things that happened. Recently, however, as I have grown as an artist, I have been gravitating towards more of a messy combination of a scrapbook and a journal. Parenthood certainly helped me to embrace this more rapid and unstructured approach. I write down not just my impressions, but also the seemingly random thoughts triggered by things that I see. When I am wrestling with a larger idea, I find that inspiration often comes without warning, and at the oddest times. **I carry my journal with me on my travels because I have learned that my mind is particularly active when I am immersed in strange environments, or even if I am just separated from the everyday for a day or two.** I have begun to use a more conventional sketchbook, but it will probably be a long while before I am as comfortable with it as I am with the written word.

Susan Feller's journal contains a second entry that demonstrates the use of written notes in conjunction with a sketch. The sketch is more detailed this time, showing an outline drawing of her own foot and some surrounding detail. The notes, however, describe a wonderful view that we cannot see, of vultures riding on thermals and a river in a gorge. As the viewer, we wish that perhaps we could share the view, too, and Susan offers the hope that this will happen in the future when she returns. However, the point of the sketch is not where Susan is, but rather where she is going. The sketch is about her journey along the Appalachian Trail, and her ambition to complete it all. The notes are efficient reminders of the beauties to be seen along the Trail, perhaps pointing her to photographs that she may have taken that day.

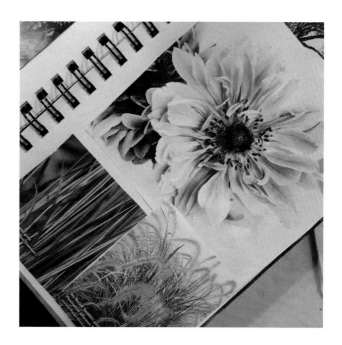

The sketchbook of Monika Kinner-Whalen,
Saskatoon, Saskatchewan, Canada, 2018. A scrapbook-like approach to gathering and preserving ideas

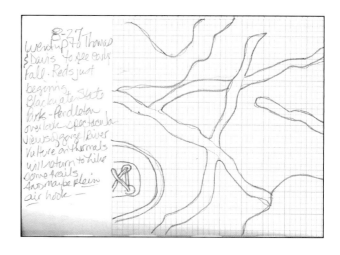

Year Study: "Blackwater State Park Trail"- Journal Entry for August 27th, Susan L. Feller, Augusta, West Virginia, USA, 2014.

My process is to take photographs first and make my notes or sketches later. Most other artists described a similar process. An interesting counterexample was Tracy Jamar, who offers a compelling reason for reversing this order. Tracy suggests that you should write down what it was that made you notice the scene first, and only then take the photograph. This is interesting to me because this order clearly establishes that the photograph is only a reminder of your own impression or memory rather than being the substance of the memory itself. Given this approach, it is unsurprising that Tracy travels with a diary in which she records her thoughts and emotions. In my own experience, these can seem so strong as to be unforgettable at the time, but are actually surprisingly ephemeral. By the end of even a two-week trip full of new adventures and experiences, I often feel as though I actually arrived months before. One of my favourite pastimes on the last evening of a trip, in fact, is to go through my journal and remind my family of all of the things that we'd all already forgotten.

Other artists also pointed out the importance of recording more technical information, like details about the light, colours of important elements such as the sky, the weather, and the time of year. I think this is important even if you also take a photograph. Most of my own photographs disappoint me, sometimes for failing to capture the grandeur, but most often for failing to catch the colours that struck me. Instead of the bold colours of van Gogh in Provence, I am left with the uninspiring dreariness of Canada in spring snowmelt. The translucent glow of water in sunshine and the fire of a sunset are other common examples where I find that the camera routinely underachieves. By taking notes, however, I am able to use these poor photographs as guides with which to recreate my memory.

A brilliant sunset on Fogo Island, Newfoundland, Canada. While the camera was able to capture the colours of the sunset, it did not capture them nearly as vividly as I remembered them being. Using my photo only as a guideline, I accentuated the colours in my hooked piece below in order to more accurately depict my memory.

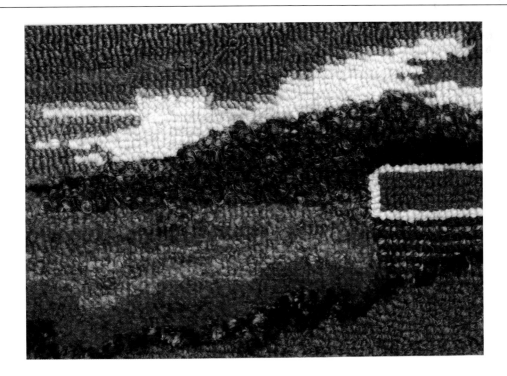

Fogo Sunset, 7" x 5", wool yarn and acrylic yarn on rug warp.
Designed and hooked by Karen D. Miller,
Ottawa, Ontario, Canada, 2013.

A last theme to touch on is the idea of self-awareness, which different artists mentioned in different ways, and which resonated with me. These artists suggested that knowing yourself is an important first step in understanding the world around you. I agree and truly believe that our art is a reflection of something about ourselves. Even simply by virtue of showing something to the world that we took the time to make, we are saying something about what impresses us, or scares us, or inspires us. Your sketchbook or your journal allows you to explore your feelings about different subjects. Of all of the pictures you will take on your travels and of all of the ideas you will have, as a fibre artist

only a few, at best, will become art. Those will be the ideas that captivate you the most. Working with ideas in your sketchbook or journal is an excellent start to the process of panning through your hundreds of ideas to identify only the most interesting nuggets. For me, writing is still the more personal process, and so it is in the writing about my ideas that I truly confirm which ones resonate most with me, and why. If I can't be bothered to even begin to write about something, no matter how otherwise spectacular it might seem, I know I will not wish to spend weeks or months in my studio with it.

LESSONS IN PERSPECTIVES

Earlier, I observed that there is no such thing as a "right" sketch, and that no two artists will make the same depiction, even if they are sitting beside each other. Ideally, I could have shown you two pieces of the same place, by different artists, to demonstrate this point. The closest I can come to that is the different perspectives on the Swallow's Tail headland in New Brunswick by myself and Trish Johnson, which you can find on page 63. Similarly, three other pairs of artists visited similar enough places that I think it worthwhile to highlight their different approaches side by side. If ever you were inclined to set down your hook because your idea "has already been done," this should help to dispel that notion.

The first example is of the province of Saskatchewan in Canada. *Prairie Icon* emphasizes the colours of the prairies

and gives as much prominence to the sky as it does to the grain elevator. Shelly Nicolle-Phillips is drawing a comparison between her home in the prairies and her roots in the Canadian Maritimes. She sees a parallel between the grain elevators that are being torn down in many rural communities in Saskatchewan and the lighthouses that are being decommissioned and converted or demolished in Atlantic Canada. For her, both grain elevators and lighthouses are beacons to their communities, and a reminder of the open, rural world that she embraces each time she escapes from the city. Finally, she designed her sky to represent what she calls the living, and ever-changing, prairie sky, and also the changing world that challenges the existence of these small communities.

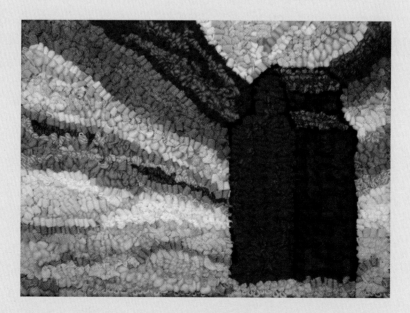

***Prairie Icon**, 13" x 9½", #8-cut wool, jersey, wool roving, wool yarn, and sari silk on burlap. Designed and hooked by Shelly Nicolle-Phillips, Regina, Saskatchewan, Canada, 2013.*

Prairie Rug #1, *3" x 2", various yarns and quilting cottons on burlap. Designed and hooked by Monika Kinner-Whalen, Saskatoon, Saskatchewan, Canada, 2013.*

Monika Kinner-Whalen's collection of Prairie Rug pieces are as much an example of an observational technique as a perspective on Saskatchewan. They make use of striking local colours rather than any particular detail.

Prairie Rug #2, *7" x 5", various yarns and quilting cottons on burlap. Designed and hooked by Monika Kinner-Whalen, Saskatoon, Saskatchewan, Canada, 2013.*

Prairie Rug #3, *7" x 4", various yarns and quilting cottons on burlap. Designed and hooked by Monika Kinner-Whalen, Saskatoon, Saskatchewan, Canada, 2013.*

Monika's inspiration came from her childhood, when she used to look out the back window of the family car as they travelled through the countryside. She has no photos from those days to work from. Instead, she just remembers the bands of colour that whizzed past her, and builds them row by row in her work.

As a second example, in the Netherlands, Christine Walker Bird chose a bright and cheery view of Amsterdam that is a quite-literal representation of how the city made her feel. At that time in her life, she was volunteering in unstable and impoverished areas of rural Kenya, and Amsterdam was her stopover on her trips home. She made no attempt to show a specific area of the city, but instead chose to show the enduring permanence and beauty of colourful houses lined up along a canal to share her impression of a great city built on a landscape of water.

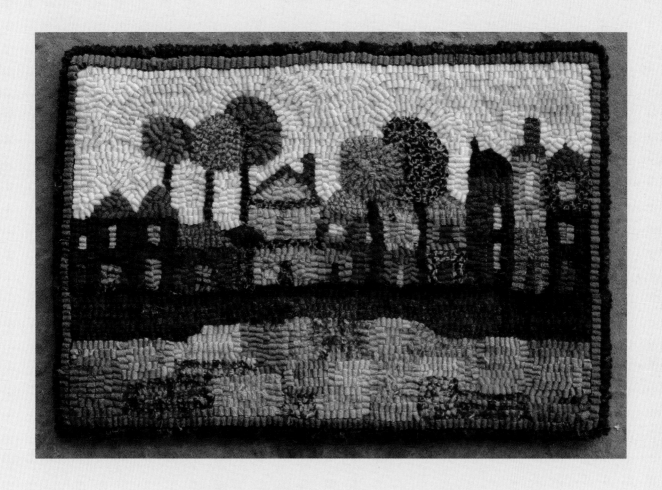

Houses by the Canal, 14" x 9½", #5-cut hand-dyed wool on linen. Designed and hooked by Christine Walker Bird, Belleville, Ontario, Canada, 2017.

Gail Nichols has two very different portrayals of her travels in the Netherlands. As distinct from Christine Walker Bird, Gail selected very specific, very unconventional details that she knew would not be recognizable to anyone and abstracted them so that they simply stand alone in their own beauty. *Waterbus Naar Kinderdijk* is an abstraction of the rope marks on a bollard on the waterbus from Rotterdam to Kinderdijk, collaged together with some other images of light playing across the ferry's painted surfaces to make the final image. As she observed to me, there is something about being in a place where you don't understand what is being said or written that makes you more observant of your surroundings.

Waterbus Naar Kinderdijk, 55" x 30", new and recycled fabric strips on polyester. Designed and hooked by Gail Nichols, Braidwood, New South Wales, Australia, 2016.

Logistics, *35" x 55", new and recycled fabric on hessian. Designed and hooked by Gail Nichols, Braidwood, New South Wales, Australia, 2017.*

Logistics was inspired by a trip to a highly advanced flower auction and international distribution centre in Aalsmeer, near Amsterdam. Flowers that have been auctioned onsite and online are continuously dispatched into a chaos of carts and electric vehicles to begin their journeys around the globe. Gail was so mesmerized that she stayed and watched from an elevated walkway for hours. What particularly caught Gail's attention, though, was the possibilities of the pavement markings that guided the movements of the vehicles, which she then combined into the plan for this piece.

Swaledale View, 10" x 16", hand spun wool yarns and fabric on hessian. Designed and hooked by Anne Shaw Hewitt, Reeth, North Yorkshire, United Kingdom, 2015.

In this third and final example of how different artists take different perspectives on similar subjects, Anne Shaw Hewitt shares her view of Swaledale in the Yorkshire Dales of England. Anne passes Swaledale every day on her commute to work, and she returns frequently to walk her dog and take photos for inspiration for all of her fibre art, including spinning, hooking, and weaving. For this piece, *Swaledale View*, she worked from a photo but intriguingly, she also let the colours she had on hand in her fabric and yarn show her the way.

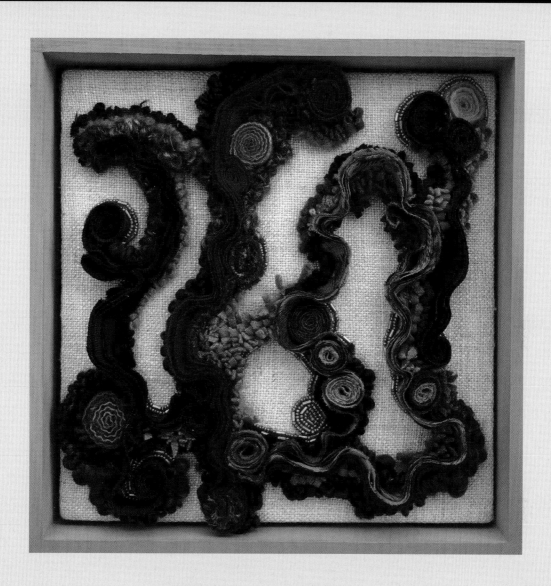

Wandering, *9" x 9" x 3", antique wool shawl remnants, wool, yarn and glass beads on linen. Designed and hooked, bias shirred, coiled, and beaded by Tracy Jamar, New York, New York, USA, 2011.*

Tracy Jamar was on a trip in the Cotswolds when she was unexpectedly held over for an extra day due to the weather. With the extra time, she was able to wander over the hills and see sights that she would otherwise have missed, including these sheared hedgerows that criss-cross the dales. By leaving the backing bare in between her hedgerows, she further emphasizes their height.

The Marriage of Travel and Art: *Plein Air*

The ultimate act of active observation, of course, is to take out all of the intermediate steps altogether and just do it directly. This means no photography, no sketching, no journaling, and no other memory aids. There is a long tradition of practising art on site, called *plein air*. The primary advantage is that being on site enables the artist to capture aspects of the composition as they change, most particularly changes in light. The secondary advantage, of course, is that if you are travelling, you are in fantastic new locations that you want to capture in some form anyway. This chapter will provide examples from artists who have undertaken *plein air* fibre art both in their travels and closer to home. I hope that their techniques and insights will be helpful as you begin incorporating *plein air* art into your own journeys.

Of course, the primary advantages of *plein air* translate exceptionally poorly to the realities of the fibre artist. First and foremost, fibre art takes a long time, meaning that subtle changes in light will come and go while you are concentrating on your piece. Even slow changes, such as the direction of the shadows, may very well change faster than you will be able to capture them. Secondly, and no less critically, the fibre artist possesses no means of mixing or dyeing colours while away from the studio, or even accessing colours that she did not bring along with her. As well, the equipment and supplies are bulky and unwieldy and poorly suited to anything but a relatively flat location where you can sit for a

"*Plein air* work . . . is a chance to use the senses. Sight, hearing, touch, and smell can all help give life to a work." – Lori LaBerge

long period. Finally, there is the minor but somewhat amusing fact that it seems to be very difficult to keep rain from wool no matter how tightly covered the bin, so inevitably everything smells of wet sheep.

However, there are still definite advantages to hooking *en plein air*. Above all, it is fun. **Fun and enjoyment is something that every artist deserves, and you are no exception.** Secondly, it is undeniable that the longer you spend in a location, the more you have the opportunity to appreciate its subtleties and develop a real feel for it. Such enjoyment and understanding can only be powerfully positive influences on your art. They are well worth the minor inconvenience of a little bit more planning and some adaptation of your studio methods, especially if you are already travelling anyway. In addition, several contributors to this book consider *plein air* work to have strengthened their powers of observation, particularly with respect to different light conditions, colours and textures. They identified that pieces they did *en plein air* were more vibrant for having accurately understood the interaction between light and the

DANIEL MACDONALD

Hooking en plein air *in Îles de la Madeleine, Québec, Canada*

colours of the piece, had more depth, and reinforced their positive memories of their subjects. Maybe the only advantage I didn't agree with was the idea that being *en plein air* frees the artists from the distractions of home, but that is probably only because I haven't yet ever travelled and done *plein air* work without my children.

SETTING UP

The single most important part of setting up to do *plein air* work is picking the right place to sit. Where you sit determines what you will produce in your session, so both the composition and the light must be right. Since the original inspiration for *plein air* was the quality of light, consider this point first. Susan Feller advises that you first identify the shadows in the scene, then the shapes of the objects that are creating those shadows, and finally the colours in the scene. Shadows are important to identify first because they give the value contrasts necessary to produce depth and to distinguish forms from one another. Secondly, shadows change as the light moves, so they need to be captured while they are where you want them. By contrast, objects stay the same, so you have time to capture them later. Ideally, the best time of day to work *en plein air* is in the morning or the late afternoon during the spring and summer, as this is when shadows will be most pronounced. During the winter, the sun is always lower in the sky, so time of day is not as important. You should never select a location where the sun is either right in front of you or right behind you; this will affect the quality of the shadows, which will in turn weaken the contrast in values.

Composition is a critical component of any art, but it is even more so *en plein air* because it also determines where you put your chair and, in my case, park your family. With all of the supplies required for fibre art, the placement of your chair is not a decision that is easily modified. Further, if you are travelling, you likely will not have your usual amount of time to spend at a scene. For these reasons, you must make the correct decision quickly. When you make an incorrect decision, as I learned recently, there is no choice but to start over.

ART PRIMER: THE ORIGINS OF *PLEIN AIR*

Painters have long practiced the technique of making art *en plein air*. *Plein air* art is done on location, usually rapidly so as to capture quickly changing aspects such as light or movement. It was popularized in the nineteenth century by the Barbizon School and other French Impressionist painters, namely Claude Monet, Camille Pisarro and Pierre-Auguste Renoir. Monet, especially, painted many pieces in the *plein air* style, as he believed that the outdoors could be captured best while the artist was on location to react to the inevitable changes in light and environment. Vincent van Gogh also favoured the approach, writing in a letter to French painter Emile Bernard in 1888 that "while still working directly on site, I try to capture the essential in my drawing—then I fill in the spaces, defining them with outlines, some expressed, some not, but in every case felt." The Group of Seven, Tom Thomson and Emily Carr also brought their painting supplies with them into the woods in order to better capture the essence of the Canadian landscape.

LORI LABERGE

Lori LaBerge's set up when embarking en plein air *work.*

We were at a campsite at Achray in Algonquin Provincial Park in Ontario, Canada, which we love because it has a beautiful beach and fronts onto one of the most famous lakes in Canadian art, where Tom Thomson painted *The Jack Pine*. I was eager to capture my happy memories *en plein air*, despite the unusual challenges of keeping campfire smoke and sticky marshmallow fingers out of my yarn. I set myself up on a lawn chair on the beach while the kids splashed in the lake beside me. I quickly sketched out my scene and began hooking. It was not too long, unfortunately, before I realized that I had no focal point and my scene was irretrievably boring. In this case, necessity really was the mother of invention. I flipped over my backing, turned my chair in the other direction, and used the view of the beach fading out to a narrow, rocky point in the water. After the false start, this was the view that became *Achray, Algonquin Park*.

Sometimes a composition can be triggered by an artist's attraction to the colours and story in a scene. This was the case with Patricia Winans's piece *Tide Is In*. While on vacation in Seal Cove, Grand Manan, New Brunswick, she was struck by the weathered boards of the old wharf. She was equally interested in the story implied by the dory anchored out in the water, awaiting the return of the fishermen on the high tide. Her composition is a combination of the colours and this story.

Achray, Algonquin Park, 5" x 5", wool yarn on linen.
Designed and hooked by Karen D. Miller, Ottawa,
Ontario, Canada, 2017.

ART PRIMER: VALUE

Value refers to the relative lightness or darkness of a colour. Variation in colour value is what gives depth and definition to your image. *Depth*, or perspective, is creating the illusion of three dimensional space or shapes in your two-dimensional work. It is achieved by using variation in values to simulate shading. *Definition* is the distinction between the elements of your composition. Variation in values is useful in delineating the boundaries between objects and other features to make their individual forms readily recognizable.

Think of black-and-white photographs as taking an X-ray of your subject. By stripping away the surface colours, the underlying value variations are more apparent (see p. 26 for an example). Sketching with only black pencils is another way to practice identifying values. You can alter the surface colours as you experiment, but you will always need enough contrast in your colour values to make your image recognizable and give it depth. As a guide for my students, I suggest at least three values of every colour within a composition to give yourself enough flexibility to work with.

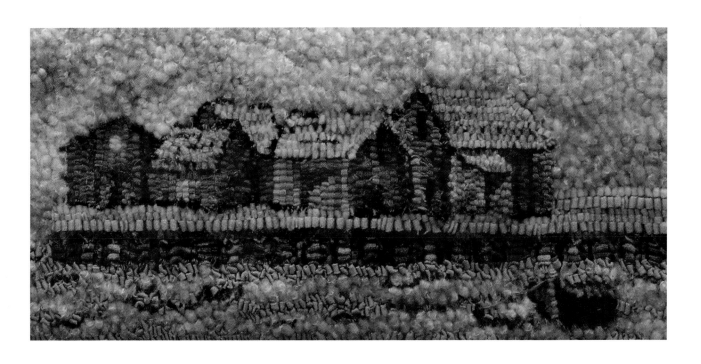

Tide Is In, *15" x 6", #3-, 4-, and 5-cut wool, polyester fabric, and linen thread on linen. Designed and hooked by Patricia Winans, Riverview, New Brunswick, Canada, 2015.*

Pure *Plein Air*

The original inspiration for *plein air* was to more accurately capture the reality around you. The fundamental contradiction between observing a rapidly changing environment and capturing it with the slow techniques and constrained palette of fibre art necessitates compromises in your approach. I will discuss three compromises here that will increase your chances of capturing the effects that you wish: advance scouting of your location, visiting your location over multiple days, and reducing the size of your piece.

ADVANCE LOCATION SCOUTING

The most obvious way to identify the colours you will need to bring and the time you will need for hooking is to scout your location in advance. This enables you to take whatever notes and photos you need to accurately gauge the likely colours and values you expect to use, and in what quantities, so that you can assemble the correct palette.

This process is most practical when you are not travelling far and have easy access to your studio. For example, Lori LaBerge and Susan Feller both have large properties that they frequently walk through with an eye to selecting locations for their art. They are able to identify the colours that they will need and return to the location well equipped to capture the scene in the manner that they want and not in the way that their materials dictate.

Similarly, Patricia Winans was able to scout the location for her piece *Petitcodiac River Marsh* because it is a spot close to her home where she often walks her dog. On the day that she chose her location, she did a quick sketch and wrote in a rough plan for the colours that she would need for a finished piece. She then returned to the location the next day at approximately the same time so that she would have similar light conditions, and began hooking. Patricia often scouts her locations because it expedites and simplifies her process. Knowing the colours she wishes to use, she can often forego sketching altogether and instead draw her design straight on her backing material while she is on-site. In this way, she maximizes her time actually spent hooking.

Ytri-Vik, Iceland, *5" x 5", wool yarn on linen. Designed and hooked by Karen D. Miller, Ottawa, Ontario, Canada, 2016.*

The ability to scout is much more limited, and often impossible, when you are travelling farther afield. I was fortunate enough to be able to return to Iceland several times, but it isn't always the case that you will be able to travel back to a place you have been before. Even if you do visit a place again, you don't necessarily know precisely what scene you will be doing, and this introduces considerable variability into your potential palette. Especially if you are travelling by air, luggage constraints can severely limit the amount of materials you can bring. This was my situation with my piece *Ytri-Vik, Iceland*. I had long known that I wanted to try a *plein air* approach in Iceland, but I could only bring a very small canvas bag with a handful of mini-skeins of yarn in various shades that I thought I would need. Thanks to my previous trip to the same area of Iceland, however, I had the great advantage of knowing the distinctive colour palette of the region to guide my choices. I also tried to pack variegated yarns that gave me a greater mix of shades and values so that I could cover more colours with just one skein. When I arrived and selected my scene, I compounded my advantage by keeping my subject simple and focussing instead on the overall mood and feel of the place so that my colours didn't have to be perfectly accurate.

Petitcodiac River Marsh, 12" x 8", #3-cut wool, silk
ribbon, and wool yarn on linen. Designed and hooked by
Patricia Winans, Riverview, New Brunswick, Canada, 2013.

MULTIPLE VISITS

A second technique for *plein air* is to visit your location as many times as is necessary over the course of multiple days at the same time of day to maximize the amount of time you have with your subject in similar light conditions. This technique also allows you to modify your colour palette with each visit, if you have access to your studio or a store. This approach is not feasible if you are travelling around and frequently changing locations, obviously, but it works if you are in the habit of staying in the same location for several days, as we are.

When working on my piece *House on the Point* (p. 49), I had the advantage of having access to the scene for a full week, and so when the light changed, I could return to it the next day at the same time and continue on. Similarly, Jean Ottosen visited Grasslands National Park in Saskatchewan, Canada, with the express intention of finding a location in which to do some *plein air* hooking. She happened upon the scene for her piece *The Barn-Study* from the window of the building where she was staying, and so it was straightforward for her to work over a period of two afternoons, at approximately the same time of day, in order to get consistent light effects to complete her work.

Visiting locations multiple times is most practical when they are close to your studio. Susan Feller likes to look close to home for her *plein air* subjects, and *Paw Paw and Light* is of one of the trees on her property. The proximity of her chosen subject enabled her to observe it in all seasons and at various times of the day in different lights. Using the information from her observations, she decided to set her composition in the fall as the leaves were changing and beginning to fall off the paw paw tree. Hearing and seeing the leaves rustling in the breeze swayed her to fill the frame with a close-up of the leaves.

Paw Paw and Light, 7" x 5", #6-cut wool on linen, mounted on cotton and framed. Designed and hooked by Susan L. Feller, Augusta, West Virginia, USA, 2014.

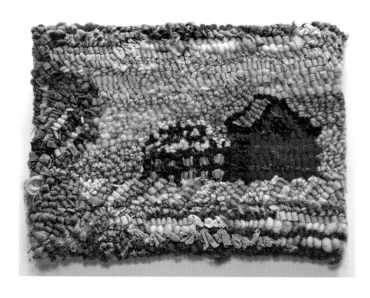

The Barn-Study, 9" x 6¾", #6-cut wool, silk fabric and yarn, roving, and mohair locks on linen. Designed and hooked by Jean Ottosen, Regina, Saskatchewan, Canada, 2014.

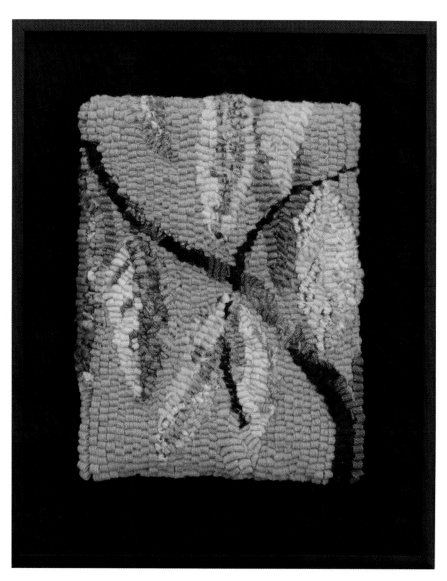

SMALL SIZE

My preferred strategy for balancing the need for speed against the slow technique of hooking is to keep my *plein air* pieces small, usually either 5" x 5" or 5" x 7", but no larger. This size gives me plenty of space in which to explore ideas and concepts without having to commit a lot of time to it. This approach allows me to capture the light and colours before they change, and makes my investment of my time manageable since my family usually doesn't allow me to just sit in one location in peace for any length of time. Besides, when we travel, my main focus is on spending time together and having adventures, so putting a lot of my time during daylight hours into creating a piece of art is not usually my first priority. I prefer to treat my *plein air* pieces as small, low detail snapshots from a moment in time in my travels.

COMBINED APPROACHES

My first attempt at *plein air* fibre art used a combination of all of these approaches. I had been to Îles de la Madeleine, Québec, before, so I was familiar with the general scenery and colour scheme, and I knew that it would be a great place to try out this technique. For *House on the Point*, I chose a landscape scene that I could see from the cottage that we had rented right on the beach. This enabled me to work on the piece over several days, which I was happy to do since I had a comfortable chair to work from. I kept my composition small, simple, and with very little detail. At that time, I had already been making a series of Newfoundland-inspired postcard-sized pieces based on photographs that I had taken on my travels to that province, so this felt like an extension of that work.

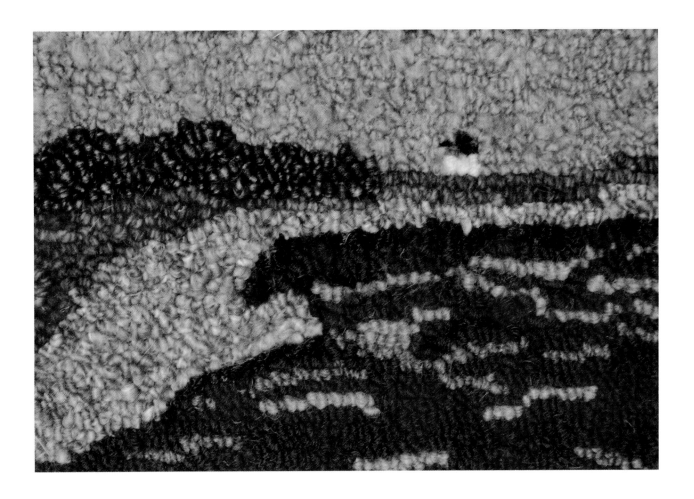

House on the Point, *7" x 5", wool yarn on linen. Designed and hooked by Karen D. Miller, Ottawa, Ontario, Canada, 2015.*

The unexpected limitation of this piece, and what made it a true *plein air* challenge, was that the yarn supply I had been expecting to be able to find on the island turned out not to exist. There was a very limited supply available, and most of the yarns available on the island were more suited for knitting bright clothing. The stores didn't have any of the earthy tones required for any landscape work. This limited me to what I had been able to carry with me, which fortunately was enough for my needs because of my knowledge from previous trips.

Modified *Plein Air*

Since you are working in the real world under time constraints when *en plein air*, quite often the direction of the light and the direction you need for your composition will not be aligned. This can be either because of some shortcoming in the scene or your lack of time to either find the perfect spot or wait for the perfect moment. These constraints suggest the need for alternative approaches. For example, Lori LaBerge acknowledges these realities when she suggests that, if necessary, you can make a location work for you by making modifications.

Add what you need to your scene, or subtract what you don't, to make it work. At first glance, this seems heretical. After all, why do *plein air* at all if not to capture exactly what you see? In fact, however, there is no more need for slavish devotion to detail in the field than there is in the studio. And once you are liberated from the assumption that *plein air* must be realism, it can be even more fun. Just as in the studio, you can modify colours or composition as you wish. You can return indoors, or even put aside your fibre altogether and pick up your pencil or your paints. I will treat each of these approaches in turn.

MODIFYING COLOUR

As I noted before, the greatest limitation of *plein air* in fibre art is in your colour choice. This is counterintuitive for a visual artist, so what if you refused to allow your colour palette to dictate your choice of subject or techniques? This approach isn't unknown to fibre artists, even in studio. After all, artists have long been using the hit-or-miss technique to use random leftover colours. As we also saw earlier, Anne Shaw Hewitt also let herself be guided by her available materials when completing *Swaledale View* as a full studio piece.

If falsifying colour is an acceptable practice in studio, there is no reason not to consider it in the field. And if you are open to the idea of falsifying colour, then it restores to you complete control over your palette and allows you to focus on what is possibly more important than your choice of colours, which is your choice of values. Values are what enable you to shade, giving depth to your piece, and to delineate, thereby distinguishing between the elements of your composition. It is therefore more important to bring a variety of values for each colour you bring than to attempt

to pack a sample of every colour in the colour wheel. In my experience, when working with my smaller pieces, I need no more than three values of a colour in order to give it the appropriate depth and delineation. Taking this approach helps with the practical consideration of keeping the amount of supplies manageable while not constraining my artistic possibilities.

INDOOR *PLEIN AIR*

It was Jean Ottosen who reminded me of the most obvious disadvantage of *plein air* work, and it has nothing to do with either fibre or slow techniques. In a word, it is the mosquitoes. When she mentioned it, I was reminded that it took me three attempts to visit the spot where Tom Thomson painted *The Jack Pine* because the first two times, I didn't have enough insect repellent and I ended up fleeing the woods. I have often wondered how the Group of Seven managed to paint anything at all in the Canadian forests without either mixing mosquitoes and flies into their paint, going mad, or both. The other disadvantages are similarly obvious, being all of the many forms of weather that make sitting in a chair in the open decidedly unpleasant.

The solution, obviously, is to go indoors. Of course, this may appear to be an oxymoron since there is nothing at all "open air" about sitting inside. However, there are at least a couple of approaches that preserve the *plein air* approach without needing to be outside. The first was already demonstrated by Jean's earlier piece, *The Barn-Study* (p. 48), as she found her subject outside a window of the building she was staying in. It was far more comfortable than sitting amongst the insects, and she was still able to study the light on her subject. I took the same approach with my piece *Ytri Vik, Iceland* because I had no wish to blow away, freeze, or both, and I could see what I wanted just fine out my cottage window. Susan Feller did the same thing when making her piece *South View*, the title of which refers to the view of three large trees from her own house. To compose the piece, she was even able to move from one window to another within her home. The variation of height and the perspective that brought is something that she wouldn't have gotten from standing outside.

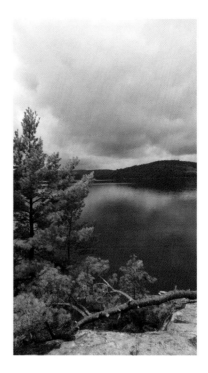

The location of Tom Thomson's painting The Jack Pine *at Achray in Algonquin Park, Ontario, 2016. The actual tree is no longer there—but the bugs are.*

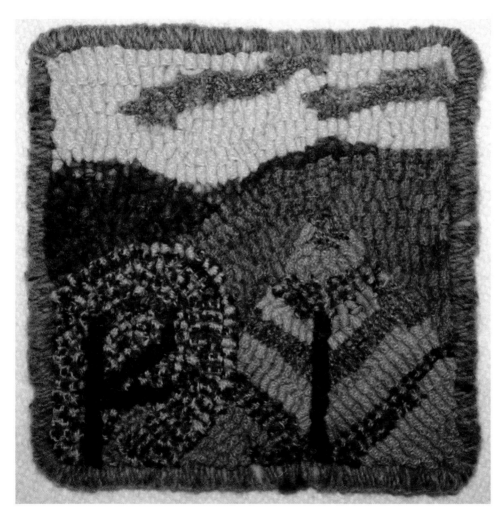

South View, *5" x 5", #6-cut wool on linen. Designed and hooked by Susan L. Feller, Augusta, West Virginia, USA, 2014.*

The second approach is to bring the outdoors inside. I took this approach when making my piece *Seashell II* in Îles de la Madeleine, Québec. Every day of our vacation, my family and I would scour the beach, collecting whatever interesting and unusual shells we could find. Each evening we brought all of our shells up to our cottage to sort them into three piles: ones we would keep, ones my daughter and I would use for our evening watercolour sessions, and ones we would return to the beach. My son found a great shell that was still completely intact and showed a fabulous mix of orange and purplish-grey hues. Since the subject was obviously portable, I simply brought it inside to guide my hooking. Whenever I needed to confirm a colour, I took the shell outside again to examine it in the right light.

USING OTHER ACTIVE OBSERVATION TECHNIQUES

Despite all of these adaptations to the *plein air* approach, it is still inescapable that light changes rapidly and, especially if you are travelling, there may be no avoiding the fact that you simply just do not have enough time. The question then is how to most efficiently use the limited amount of time that you have on-site. There are at least two approaches.

The first is to abandon any idea of making a complete piece during your session and instead focus on preparing for later studio work. For example, map out your backing markings on a piece of paper using watercolours, pastels, pencil crayons, or even markers. Whatever method you use, make markings that match the colours that you are seeing in each area of the scene in front of you so that you can later match them to your yarn or wool colours. You can either complete the work in studio or return to your location with your materials.

Another approach is to use your limited time to make a small *plein air* work as the study for a future, more de-tailed studio work. This is usually a small, lightly detailed piece whose purpose is to capture colour and values and their interrelationships. The details are deferred to the full work when it is completed in studio. As an example of this latter approach, Lori LaBerge used a study to develop her piece *Nesting* (pages 54-55). Her subject was a hornet's nest hanging in the upper section of a pine tree at the edge of a clearing on her property. She decided to hook a small 7" x 5" piece based on this scene while she was on location, and she named this piece *Nesting Study*.

My kids are amazing at spotting and collecting beach prizes from the sea.

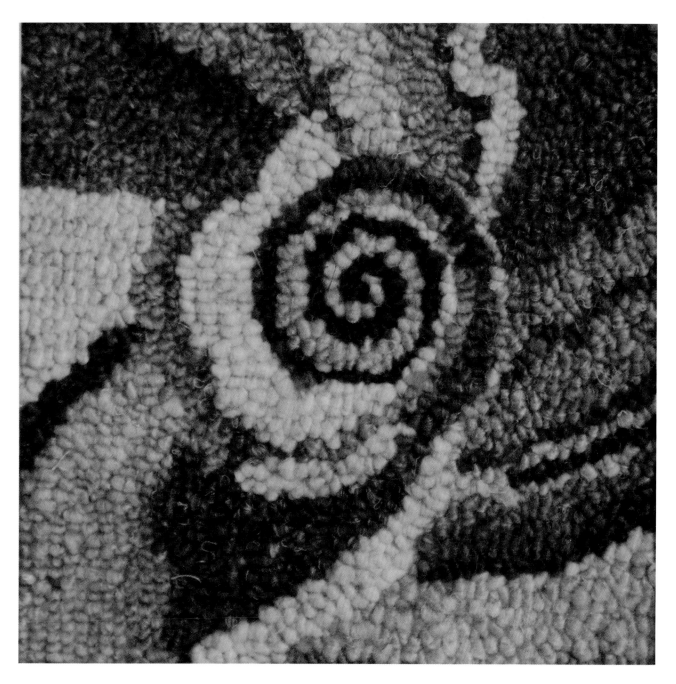

Seashell II, *5" x 5", wool yarn on linen.*
Designed and hooked by Karen D. Miller,
Ottawa, Ontario, Canada, 2017.

Plein Air Hooking: Nesting Study

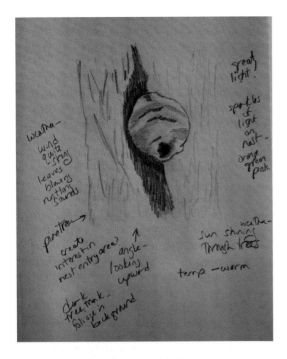

Sketch for Nesting Study, *Lori LaBerge, Spruce Pine, North Carolina, USA, 2015*

Lori took detailed notes on the weather conditions, light, and temperature from that day. In particular, this helped her to remember that the light conditions were "...compelling with tints of pink, green, and orange."

Comparing the final piece with the original study shows how faithfully she was able to rely upon her first impressions to complete her work.

Nesting Study, *7" x 5", #4-cut hand-dyed wool on linen. Designed and hooked by Lori LaBerge, Spruce Pine, North Carolina, USA, 2015.*

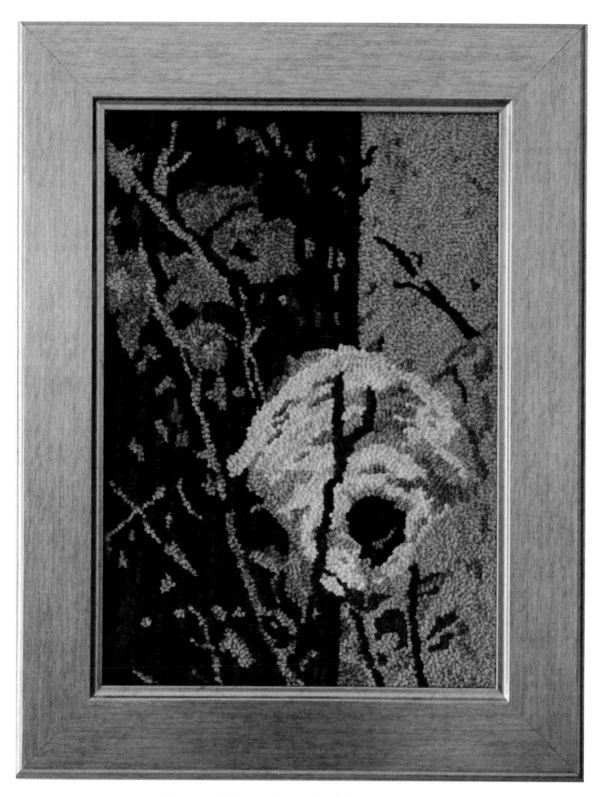

Nesting, *14½" x 19½", #4-cut hand-dyed wool on linen.*
Designed and hooked by Lori LaBerge, Spruce Pine,
North Carolina, USA, 2015.

Watercolour sketch of Tree on Weslemkoon Lake,
Christine Walker Bird, Belleville, Ontario, Canada. 2016.

The other effective use of limited time is to forego fibre altogether in the field and rely upon the use of other media, such as watercolours, acrylics, oils, pencils, or anything else. While there are no rules, most *plein air* artists I corresponded with cautioned against the use of photography. There is a place for photography in *plein air*, but only as a reference when working on details from the scene. It should not be used for identifying the shadowing, lighting, or colour of your piece since this will inhibit your own observations of these elements. Many artists actually choose not to take a photograph of their *plein air* location just so that they cannot inadvertently rely too heavily upon it.

Christine Walker Bird uses watercolours to do her *plein air* impressions for her studio work. *Northern Lake* is based on a tree that she saw near her cottage north of Belleville, Ontario,

Canada, while out kayaking. In particular, it was the way in which the tree was clinging to the granite shoreline that caught her eye and seemed to her to be symbolic of the beauty and resilience of the north itself.

Christine uses watercolours instead of simply taking a photo because she finds painting outdoors a more immersive experience that enables her to represent the feel of the wind, the sounds of the air, and the play of the light that surrounds her as she focusses on her paintbrush. Watercolour paints run into each other in a fluid, spontaneous way, and she tries to convey a similar feeling in her hooked art. Painting *en plein air* also enables her to alter the placement of the different elements of the scene to find the best composition.

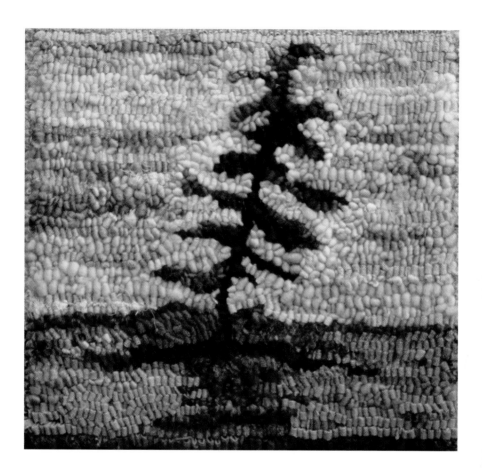

__Northern Lake,__ 10" x 10", #5- and 6-cut wool and wool yarn on linen. Designed and hooked by Christine Walker Bird, Belleville, Ontario, Canada, 2017.

Once again, comparing the *plein air* watercolour with the final studio piece, it is clear how much Christine was able to rely upon her depiction of her first impressions to guide her studio work. There are some differences, but there are many more, and more important, similarities.

The risk with all of these approaches is that the more work is done in studio, the higher the likelihood that the work will lose the sense of immediacy and spontaneity that the artist felt while on location. This challenge is neither new nor specific to fibre art. Tom Thomson, one example that I am familiar with, did hundreds of *plein air* oil paintings, often on wood panels, but only a small number of those ever became larger studies back in his Toronto studio. He much preferred creating art with rapid brushstrokes on location when all of his senses were alive to the scene directly in front of him.

Patricia Winans's perspective on using other media reveals the single greatest reason I can think of for working *en plein air* with fibre. In her experience, her watercolour paints dry far too fast outside, so she must move very quickly to capture the effects that she is seeking. For her—and I could not agree more—the positive consequence of working with a slow medium like fibre is quite simply that it is relaxing. Sometimes the simple things are the most important.

3 TRAVEL AND ART IN MY LIFE

Four places have come to mean more to me than most in my art: Grand Manan, an island in the Bay of Fundy off New Brunswick; Îles de la Madeleine, in the Gulf of St. Lawrence; Iceland and the Faroe Islands; and, of course, Newfoundland. One of these places has recently become a very popular international destination, but the others are not so familiar. Before I go through how these places have influenced me, however, I'll begin with three examples of art in travel that I failed to see at the time.

Before 2008 I was not an artist. I didn't look at the world the way an artist does, even when I was looking at some of the most beautiful places that the world has to offer. This wasn't just because I hadn't found my calling yet; I wasn't even trying to capture anything artistically before 2008, let alone failing at it.

Venice is a place that has justifiably inspired libraries full of art books. I wrote a journal full of amusing anecdotes as we travelled through Italy—both what we liked and what we didn't care for, and I liked Venice a great deal. Yet somehow, nothing compelled me to take down what I saw. Looking back, it is one place that I would one day like to "do over" for the colours and the sights that only are possible there. There was one shop that we just peeked inside, alongside a canal, beside one of the arched footbridges that are normal there. The sun shone between the buildings at just the right angle so that the reflections from the canal played through the shop windows and illuminated the walls with living, dancing patterns. The canal water glowed green in the sunlight and washed up against the stone steps to ancient buildings. My husband said how much he would love one day to canoe the city, at least away from the main canals where the waterbuses prowl. It delights me to think what art such an adventure could yield.

DANIEL MACDONALD

Along the Grand Canal in Venice, Italy

Greece was our honeymoon, and even all these years later I can still look back and see what a visual feast it was. I saw, but was unmoved by, the incandescent blue of the sunlit waters off Mykonos. I appreciated the Acropolis, but not how I would today. It is only now that I realize that I don't care for ancient sites for what they were; I care about how they exist today. When I look at pictures of statues and sculptures and friezes and buildings, I wish they weren't so often cleaned to look "as they were." There is a certain grace in the past that I wish we could be more respectful of, and cherish rather than sterilize. When little plants and lichens grow into the crevices of old walls and between the folds of sculptures made long ago, it bridges them from their time to ours. If I ever return, this is what I will look for.

Even with hindsight, I cannot explain how I did not see Scotland. I even spent part of my childhood there, visiting family. Perhaps that was the problem: in seeing it as part of home, I didn't see it as remarkable in any way. And perhaps, too, my family is right that my affinity for the rugged lands of the North Atlantic is no accident. Is it possible for something to be both home and an otherworldly escape? Is it possible to be alone at the edge of the world in the very place where your own roots lie? As I write this, the Highlands have begun to call me, so I know I am going to find out.

As we turn now to the places that have most inspired my art so far, I encourage you to think as well of the places you have already been and the places you will go, and what they might have to inspire you. Find what you love and look for it wherever you are.

DANIEL MACDONALD

The stunning beauty of Santorini, Greece

DANIEL MACDONALD

Greyfriar's Bobby, Edinburgh, Scotland

GRAND MANAN
NEW BRUNSWICK, CANADA

In 2011, we had a little problem. We knew we were going to eastern Canada again because we love to be near the ocean, but through our trips over the years we had covered everything that we thought we wanted to see. My solution was Grand Manan, the largest of the Fundy Islands, located in the Bay of Fundy off the south shore of New Brunswick.

It was lovely. The island is even smaller than the map suggests on account of its inhabitants largely being strung along one side and congregated in primarily two communities. Being a fan of the Group of Seven, I already knew that Arthur Lismer had visited the island in 1931 and done two paintings of the fishermen's boats and fishing stages in the southern community of Seal Cove. Perhaps the greatest testament to the power of his painting is that when we visited Seal Cove ourselves and walked around its stages in the fog, it actually felt strangely familiar to me. We searched for tiny sand dollars and bright sea glass on the little beach when the tide was out, and our daughter gathered seagull feathers and ran ahead flapping her wings, pretending to fly. We tried dulse seaweed, because it seemed to be the thing to do, and we walked on the sea bottom under the wooden wharves in nearby White Head Island because you could and because it was so weird.

Halfway through our stay, the fizzling remnants of a hurricane shut down the ferries for over a day, and so we went up to the lighthouse at Swallowtail and watched our daughter laugh as she got blown down in the grass.

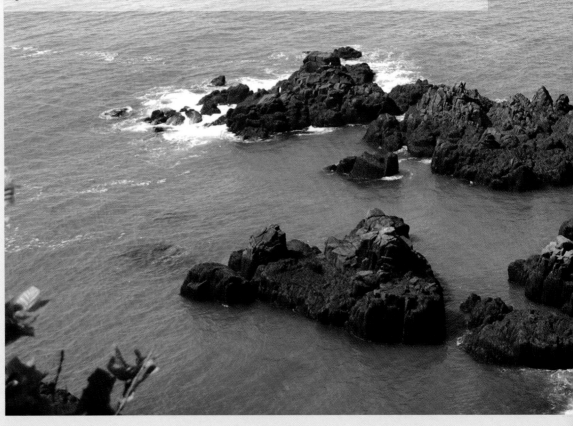

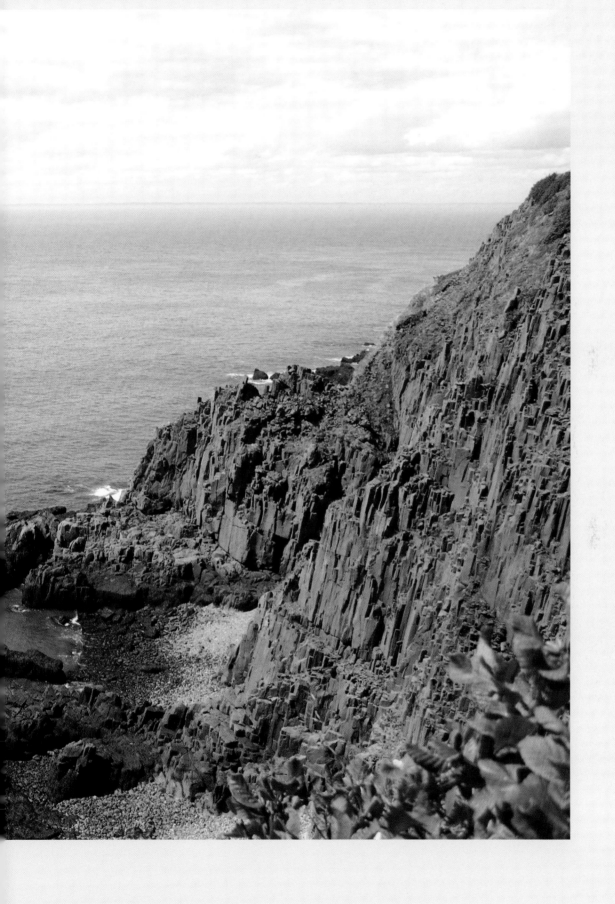

I originally approached Trish Johnson about her work *Douglas at Swallowtail* because you can see in her piece where I was standing when I snapped the photograph that became my own piece *Beyond Swallowtail*. I only intended to make the technical observation that she portrayed the Swallowtail Lighthouse while I chose to face the other way. I wanted to simply cite this as an example of how two people standing in virtually the same place can choose such different, and equally valid, memories. However, the more Trish told me about her piece, the clearer it became that these two pieces are also a demonstration of how the artist's feelings for a subject will permeate everything about her work.

I had never visited Grand Manan before, and in all likelihood I may never return. I visited as a tourist and I had a fairly typical tourist experience. I met few of the people in any meaningful sense and though I purchased an interesting book about the sociology of the island, I didn't depart with any greater understanding of the island than I had had when I had stepped off the ferry a week before. My perspective, therefore, was more on the natural elements of the island, from its weather to its geology.

When I walked around Swallowtail lighthouse, I had no particular attachment to it and so I felt no real need to capture it. The tree, however, fascinated me. Others on the headland that day walked past it without a glance because, really, it was just another tree in New Brunswick, and not even a particularly large or noteworthy one at that. Its scruffiness and its solitude appealed to my Group of Seven instincts, though, as well as the fact that—even though dead—it still stood immovable against a wind that seemed intent on blowing everything and everyone else over the cliffs. Its stubborn persistence represented more than a little bit about how I see myself. Even today, on the days when I notice the piece as I walk past it in my house, it gives me a little pick-me-up.

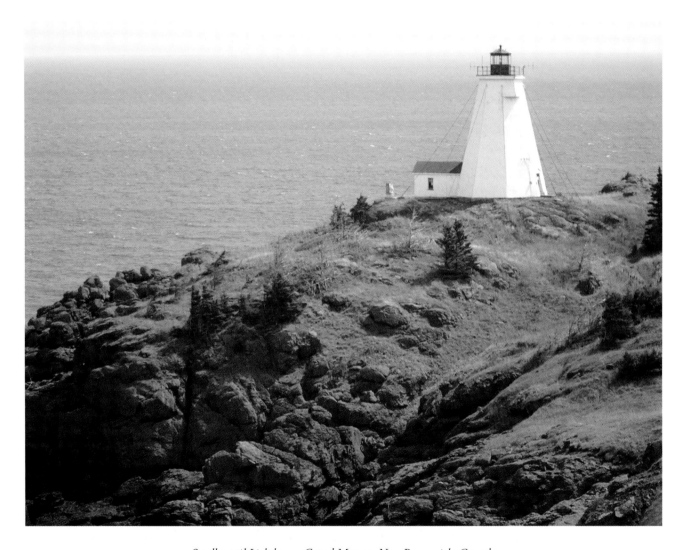

Swallowtail Lighthouse, Grand Manan, New Brunswick, Canada

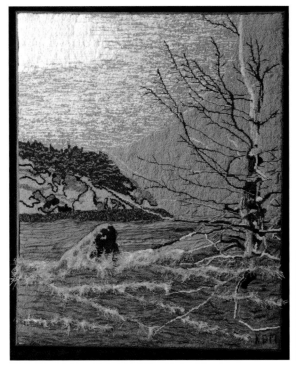

Beyond Swallowtail, *25" x 39", wool, acrylic, and novelty yarns and sari silk ribbon on rug warp. Designed and hooked by Karen D. Miller, Ottawa, Ontario, Canada, 2013.*

Douglas at Swallowtail, *35½" x 24", #8-cut wool on burlap. Designed and hooked by Trish Johnson, Toronto, Ontario, Canada, 1997.*

Douglas at Swallowtail, *Trish Johnson*

Beyond Swallowtail

Waiting II, *Patricia Winans*

By contrast, Grand Manan for Trish is a place of family roots. It is a place full of childhood memories, like lemonade and chocolate birthday cake on the beach and playing cards by the light of the kerosene lamps at the lightkeeper's house. Unsurprisingly, then, she feels a strong attachment to the island, describing it as a place where she belongs and as her favourite place to vacation. It stands to reason, therefore, that the Swallowtail Lighthouse has completely different meaning for her than it does to me. For her, the lighthouse represents the excitement of returning after so long away and the anticipation of the ferry soon rounding into the North Head ferry dock. Of course, it also represents the beginning of the next long absence as it and the island falls behind in the ferry's wake when she inevitably has to leave again. Trish revealed that this conflict is at the heart of this piece. She intended for it to be a memento of happy times on a summer vacation, and she intended to show her happiness at being able to bring her own son to the island, just as her own mother had with her. When she looks at the finished piece, however, she realizes that she actually captured a more complicated, pensive feeling. Just like the lighthouse prompts mixed feelings depending on whether she is coming or going, so too does the image of her son beside it. She is happy he is there, but seeing him there also makes her nostalgic for her own childhood. I like to think that two such different pieces coming from exactly the same subject is a fine lesson that it is the artist and her feelings that make the piece, not the subject.

Waiting II, 28½" x 15", wool yarn, mixed-fibre yarn,
linen thread, polyester velour, and mohair fabric on linen.
Designed and hooked by Patricia Winans, Riverview,
New Brunswick, Canada, 2013.

The story that Patricia Winans told me about her piece from Grand Manan completely changed my perception of it. The piece itself at first reminded me of Lismer's paintings of Seal Cove, not necessarily for the specific details, but certainly for the feeling. When I reached Seal Cove myself, even in a thick fog that made it a strain to see even from shed to shed, I felt like it couldn't have been anywhere else. Patricia's dories sitting still at their mooring ball in flat, grey water reminded me of the boats in Lismer's paintings.

It turned out I wasn't far off in feeling a similarity. Just as Lismer documented the fishing village as it was in his time, so too was Patricia documenting a particular practice of the local fishermen that drew her attention. In this case, she was observing a consequence of the peculiarly large tides in the Bay of Fundy. The fishing boats can't stay at the wharf after offloading their catch like they do elsewhere or they will be aground at low tide. Instead, they moor out in deeper water and the fishermen come ashore in their dories. When they are out at sea, of course, they leave their dories behind, tied to their moorings. When Patricia saw these dories tied to a mooring ball in Deep Cove, she knew that they were waiting for their owners to return, and so she had both her subject and also her title, *Waiting II.*

Seal Cove, Grand Manan, New Brunswick, when the fog briefly lifted

Also interesting, though, is knowing that Patricia came upon these waiting dories at the end of a day trip in a converted lobster boat out to Machias Seal Island, a lonely rock some ten miles out in the bay, home to a lighthouse and seabirds, including puffins. The trip wasn't blessed with the best of weather, and so she encountered fog and rough seas. At the island, she had to step into a dory rising and falling four feet in the swells, and then be ferried ashore. The return trip, obviously, was the reverse and doubtless as exciting. It goes almost without saying that as much of a fan as I am of puffins, I do prefer my expeditions to be placid and, preferably, grounded. Knowing the rest of her story now, and imagining my likely state of mind at the end of such a trip, it is the calmness of the water that strikes me when I look at her piece. The boats seem to me to be an expression of safety, almost asserting a calm confidence that for all of the wildness of the waters beyond the head of the cove, at the end of the day everyone will be home safe. It may not be at all what Patricia intended, but in that, too, there is a lesson. Art provokes feelings from those who view it, and those feelings are shaped by the viewer's own experiences and perspectives. As the artist, we make our best effort to say what we want to say, but sometimes how the viewer perceives it may be just as interesting.

Fishing weir off of Grand Manan silhouetted against a glowing sunset

LES ÎLES DE LA MADELEINE
QUÉBEC, CANADA

Part of the attraction of North Atlantic islands for me is that they always have two faces. For a few weeks in the summer, they are idyllic and life is unhurried. The winds blow gentle and warm, the sun shines hot, and though the water may never be truly warm, the sand can be scorching. When nature does stir and thrash the windows with rain in the night, it is a welcome excuse to do even less. As my worries fade, I catch myself believing that just maybe *this* place could be my escape from it all. I might start noticing the "For Sale" signs on the lawns and the real estate offices with their tantalizingly affordable offerings posted in their storefront windows.

Les Îles de la Madeleine is a different enough place that even though these islands also have an English name, once we visited them, it never seemed appropriate to use it. I will also confess that we didn't exactly fall in love at first sight because it isn't that kind of place. Its charms are a little more hidden—or at least they were the first time we visited, before the island began to tap into its tourism potential. Yet the islands still grew on us and we have now returned several times. It certainly possesses that end-of-the-world feel that we relish since you can turn off virtually anywhere along the main road and be alone with your thoughts and the birds. You quickly understand the island's nickname, "les iles des ventes" (islands of winds), and why the islands are a mecca for kite surfers, wind surfers, and even kite flyers. Nowhere else have we seen winds so constant that we could hoist a kite in the air, tie the line to a post, and leave it there to fly for hours. On every visit we haunt the seafood counters and clear the shelves of the locally-made honey, cheese and cider. In Les Îles, more than anywhere else we have been, the sea infuses all the senses and every aspect of life.

Although Les Îles still wear their hard-working existence quite transparently, an artistic bent is evident, too, that you don't need to look too hard to find anymore. As elsewhere in Atlantic Canada, bright, vivid colours are popular for the houses. Folk art is easy to come across, often featuring driftwood and lobster-trap pieces that have been worm-eaten and then polished in the tumult of sea and sand. Even the sand itself is glued and pressed into forms. There is a growing artisanal scene featuring bright glass and jewelry. One of the more popular local themes is the *pied-de-vent*, the ray of sunshine that occasionally shines like a beacon through otherwise dark storm clouds. It is a compelling motif as it makes the bright colours even brighter.

When I saw Patricia Winans's piece *Chez Madeleine*, I recognized the sunny face of Les Îles de la Madeleine. Formally part of the province of Québec, Canada, the most common way of getting there is actually by travelling by ferry five hours due north of Prince Edward Island. There, in the middle of the Gulf of St. Lawrence, you very much feel like you are somewhere really far away. The islands themselves are strung out in one long, almost contiguous, archipelago connected by long, empty beaches. Some of the beaches are bookended by cliffs of red sandstone that the sea shapes in a slowly evolving sculpture of arches, stacks, caves, and rock falls. When the waves rise, they funnel into the caves and slam into the bones of the island. You feel the thud as much as you hear the boom, and you understand through the soles of your sandals that, inevitably, the island must succumb.

Walking the trails along the cliff edges is at the same time one of my favourite, and most nerve-wracking, activities on the islands. Patricia noted the warning signs to stay back from the edge and a washout along her trail. Occasionally, I have also even seen taped-off sections but mostly you are on your own, trusting in the paths of those who have gone before you. The mothers out there will understand when I say that marshalling your little ones to stay back from the edge when they seem rather more inclined to walk obliviously off a cliff is scarcely relaxing. Patricia has captured why it is worth the trouble. She was drawn to the contrast between the cliffs and the carpet of green grass that crowned them, but I think that she caught the rest of the palette of the Atlantic summer colours, too. She caught the difference between the vivid red of the dry sandstone and the dark brown of the island's wet feet in the sea. She registered the play of the shadows across the cliff's crevices and promontories. She caught the bright colours of the houses, the light blue and white of a summer sky, and the darker blues and whites of the whitecapped water. In short, she caught the spirit of those days and those places that I wish could stay perfect, forever.

Colourful houses dot the landscape in Îles de la Madeleine, Québec, Canada

The cliffs of La Belle Anse, Îles de la Madeleine, Québec, Canada

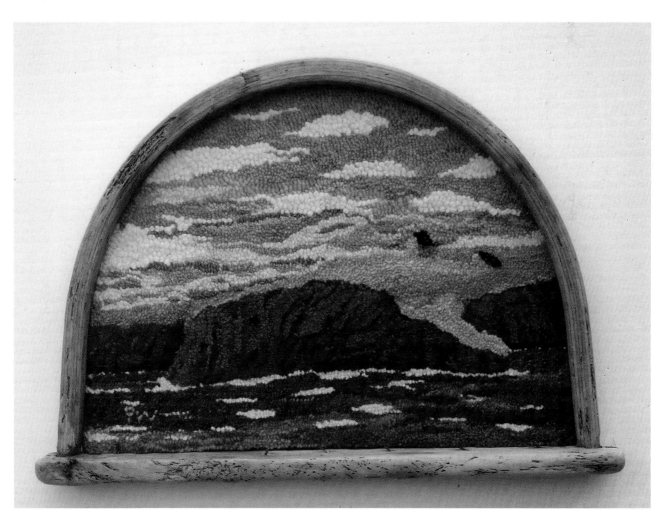

***Chez Madeleine,** 20" x 13½", wool yarn on linen.
Designed and hooked by Patricia Winans, Riverview,
New Brunswick, Canada, 2008.*

One of my earliest pieces was a study of the summer colours of Les Îles. When you drive south toward Havre-Aubert from Cap-aux-Meules, you cross along a long, narrow isthmus flanked by two beaches. Sandwiched in between the two beaches is a long, narrow marsh and shallow lagoons. The kite surfers flock to these lagoons on the windiest days, when the waves on the sea are too wild, and you can see their brightly coloured kite sails twisting and dancing together from far away. The marsh itself is colourful, too, in a more understated way. At the right angles, the sun reflects off of the water beneath the reeds, and pockets of water turn from brown or blue to brilliant shining white or yellow. The marsh plants vary from green to gold and, in season, they sprinkle the landscape with their flowers.

All that said, of course, a marsh is also relatively featureless, especially when backing onto the sea, so I didn't try to portray exactly what I was seeing. Instead, I took several photos and, when I got home, I distilled my favourite colours into an impression of the marsh.

Colourful marshes in Îles de la Madeleine, Québec, Canada

Colours of Îles de la Madeleine *(detail), 25" x 9", wool yarn, acrylic yarn, unspun soy silk, and wool roving on burlap. Designed and hooked by Karen D. Miller, Ottawa, Ontario, Canada, 2010.*

On our first trip, we stayed at the very north end of the archipelago, as far from anyone else as it is possible to get. Grande-Entrée is an unpretentious fishing community blessed with easy access to beaches and hiking trails. We even happened to be there when it was possible to buy lobster off the wharves, which of course made it even more wonderful in our estimation. Our view each evening overlooked the bay inside the fishhook so that we could see the ships loading at the salt mine on Grosse-Île, occasional houses and trees scattered along the road in either direction, and a tattered Québec flag flapping in the wind. In the west one night, the sun lit the sky in a kaleidoscopic farewell burst that silhouetted the last remnants of the day's storm. By the old saying, of course, the red sky promises a better tomorrow, so I like to think of the sunset as the new dawn. The two faces of a North Atlantic island are never far apart.

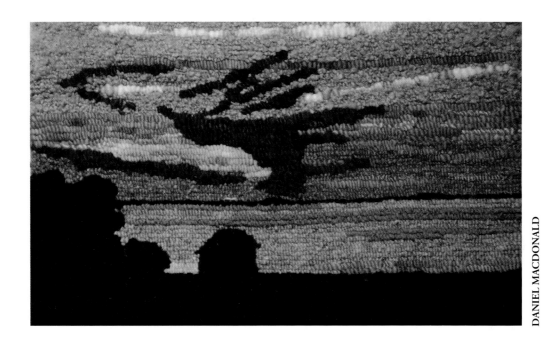

DANIEL MACDONALD

Sunset over Grande Entrée, 15½" x 10", wool yarn, acrylic yarn, and wool roving on burlap. Designed and hooked by Karen D. Miller, Ottawa, Ontario, Canada, 2010.

Chez Madeleine, Patricia Winans

Sunset over Grande-Entrée

She Will Move Mountains

Colours of Îles de la Madeleine

House on the Point

And then there is the island's other face, as all northern islands have. I was reading another writer's account of arriving on the islands for the first time, and I sympathized. Anywhere in the North Atlantic can be uninspiring in the half-light of a persistent, early-morning downpour. It can be a dull world, drained of colour and depth, made all the worse if you also happen to be cold. I felt the unspoken misery that I heard in his voice, and I recognized his feelings from our own pell-mell early morning dashes to airports and ferry docks in a state of half-sleep. Even in the most serene August days, the signs of October, and January, and even April, are plain to see. Trees are short, stunted, and twisted, as though wrung by giant hands. The grass is hardy rather than lush, and in conspicuous places, does not grow at all. All along the beaches and breakwaters, large pieces of beach junk lie where they finally fell from the ocean's grasp or were dropped by the winter ice, dozens of feet beyond the high tide mark. Even in August, after the warmest of days, the weather can turn to a freshness that is just a shade cooler than pleasant, a warning tendril of the winter that is only in remission.

It was one of those days when we piled out of the car at Dune-du-Sud in Havre-Aubert. When they happen, as they will, you just have to go for it and make of it what you can. Have your jacket, boots, and hat handy and have somewhere to tuck yourself away when the squalls hit, but you can't sit around waiting for perfect weather, either. We parked in the otherwise empty gravel parking lot overlooking the beach and considered things. Very little of the sea was visible through the fog and the rain, so we sat in the back of our van and ate our picnic while the rain poured down the windows. By the time we finished, the rain had stopped, so we pulled on our hats and coats and walked down to the beach. It was grey and foggy, and perfect. The tide was out and nobody else was about, so we walked all the way down the shore, ducking our heads into the sea caves and taking pictures wherever we pleased. We like this beach because it is divided by tall sandstone promontories that jut all the way from the cliff out to the surf. If the tide is in, the only way past is to wade around them through the waves. When the tide is out, they tower above you as tall as rusted ships' prows stranded in the sand. My daughter climbed up onto one of the smaller sandstone fingers and wandered out to the tip while I stood by the cliff and suppressed my urge to shout to her to come back. Beyond her, the grey sky was finally breaking up into subdued blues although, more than likely, it probably rained on us again as we walked back to the car. It is the North Atlantic, after all.

The beach at Bassin Est on Grande-Entrée

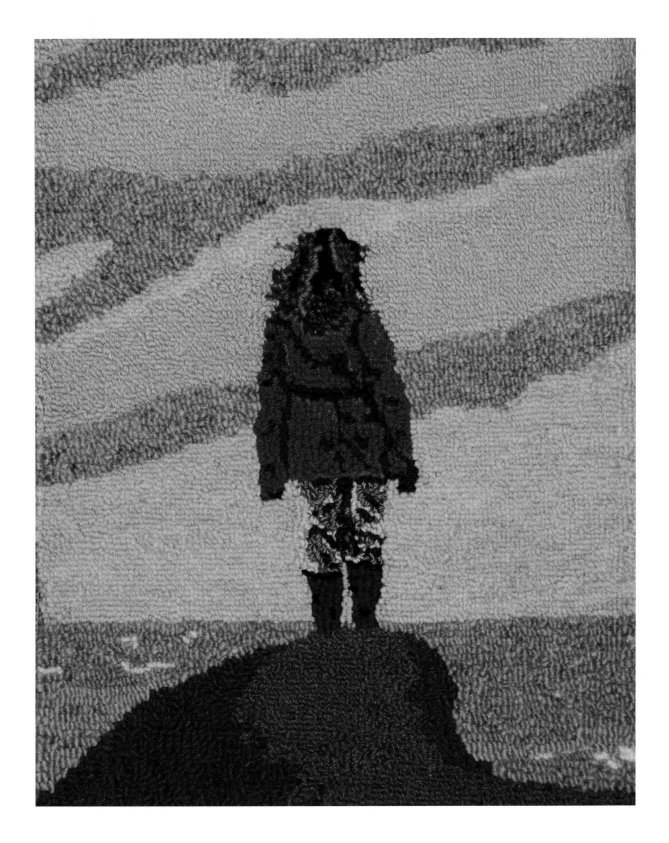

She Will Move Mountains, *11" x 14", wool yarn and acrylic yarn on linen.*
Designed and hooked by Karen D. Miller,
Ottawa, Ontario, Canada, 2015.

ICELAND

Iceland is the first place in the world that I truly fell in love with. Some places you go and you think you are in love but it is really about something else. If you return, it just isn't the same, like going back to your favourite school haunts now empty of your friends who brought them to life. While it lasted, Iceland wasn't like that at all for me. It is no stretch at all to say that it was in Iceland that I finally learned to see.

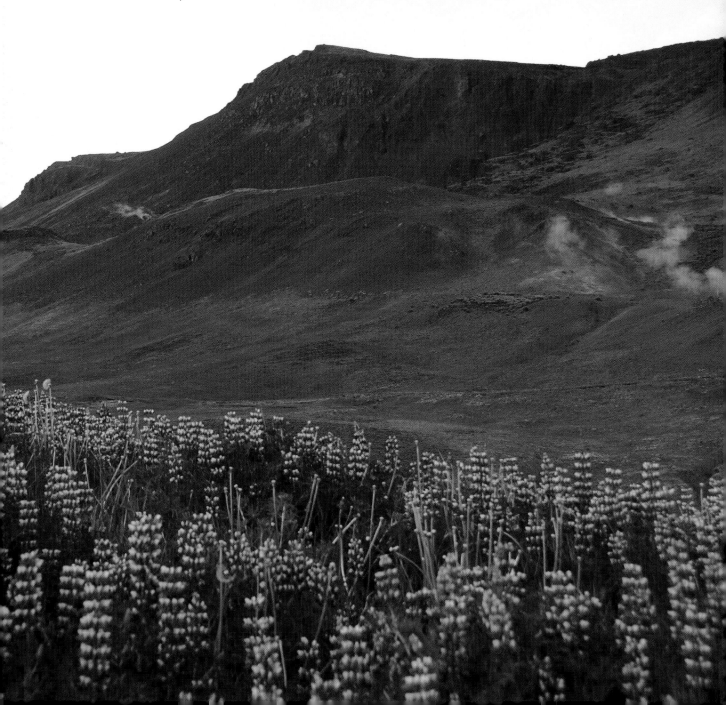

Van Gogh had Provence. The Group of Seven had northern and boreal Canada. Emily Carr had British Columbia. Each of these places has its own palette, and in Iceland I found mine. Vivid green, fathomless black, pastel blue and brilliant white; now I can only see these colours and their combinations as the fingerprint of Iceland. Golden yellow-green and blue remind me of wandering through the lush farms and vast open fields of southern Iceland, where the sky seems to stretch forever and empty above your head. To me, it is the freedom of space. And when the weather turns and the storms begin to gather on the horizon, it is the blue-tinged colour of the distant mountains beyond the sun-drenched fields where I still stand in carefree summer.

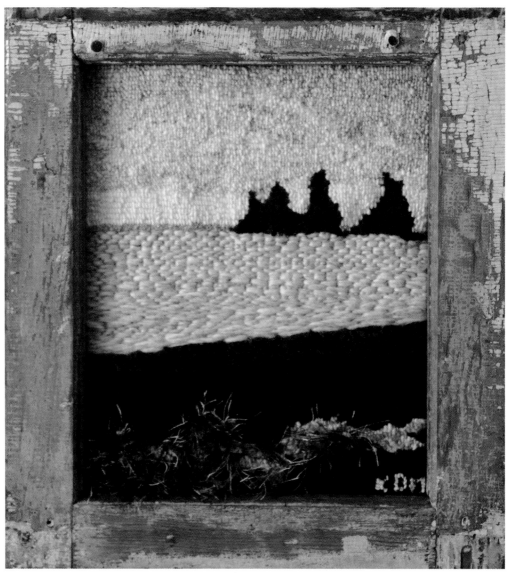

***Black Sand at Vik, Iceland,** 12" x 15½", wool, acrylic, and novelty yarns on rug warp in an antique window frame. Designed and hooked by Karen D. Miller, Ottawa, Ontario, Canada, 2013.*

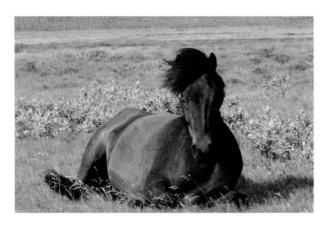

Near Gullfoss waterfall in Iceland. The blue of the sky was so dark and the grass positively shone against that backdrop.

Deep, pure green and strong black is, for me, a secret signature of Iceland. It takes me back to the black sand beaches girdling its shores, swept of all life by the sea's rages save for foolhardy pockets of grass that seem to glow in their world void of colour.

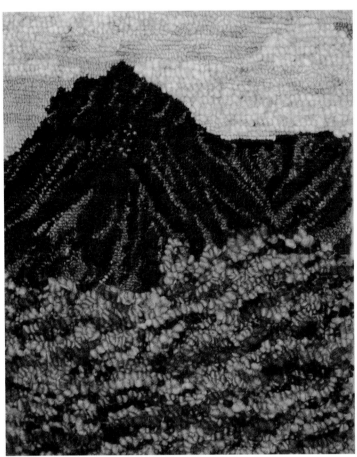

Moss Covered Lava Rocks, *12½" x 16", wool yarn, acrylic yarn, and wool roving on burlap. Designed and hooked by Karen D. Miller, Ottawa, Ontario, Canada, 2009.*

It is crowns of grass atop cliffs of volcanic rock. It is the carpets of moss so immaculate and thick over the jumbled fields of lava rocks that I begged to stop the car just so that I could kneel by the side of the road and press my hands into it.

DANIEL MACDONALD

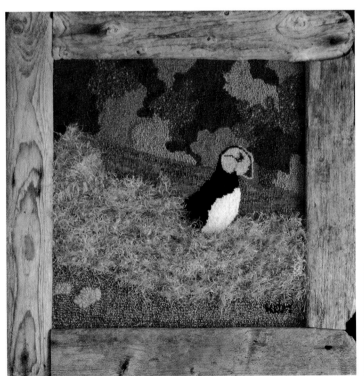

Atlantic Mascot, *21" x 21", wool, acrylic, and novelty yarns on rug warp in a custom driftwood frame by Daniel MacDonald. Designed and hooked by Karen D. Miller, Ottawa, Ontario, Canada, 2012.*

It is the shiny black backs of the puffins standing in front of their grassy burrows high above the sea, freshly returned from another ungainly simulation of flight.

DANIEL MACDONALD

White is made stronger for existing in a world of volcanic black. The boiling of glacial meltwater streams running to the sea is made angrier for having to course through barren flats of black desert rock and sand. Around the coasts, the feet of tall black cliffs are set in the white maelstroms of waves from all across the Atlantic endlessly crashing themselves to pieces. And looking up at night, the northern lights twist from white to purple to green and back again against a starry sky.

We watched white torrents of water fall in mesmerizing sheets between grassy banks. One rumbled hidden from view behind a curtain of green-clad rock, until we entered through a keyhole into an elven kingdom of splashing water and dancing light.

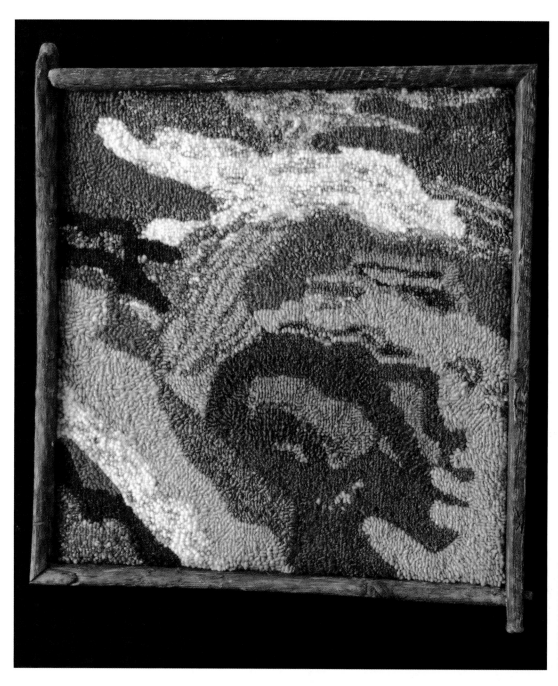

DANIEL MACDONALD

Colours of Mud at Hverir, *Iceland, 12½" x 12½", wool and acrylic yarns on rug warp in a custom driftwood frame by Daniel MacDonald. Designed and hooked by Karen D. Miller, Ottawa, Ontario, Canada, 2012.*

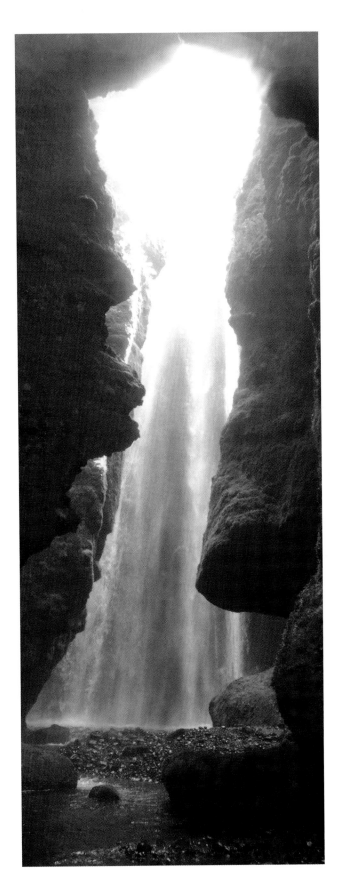
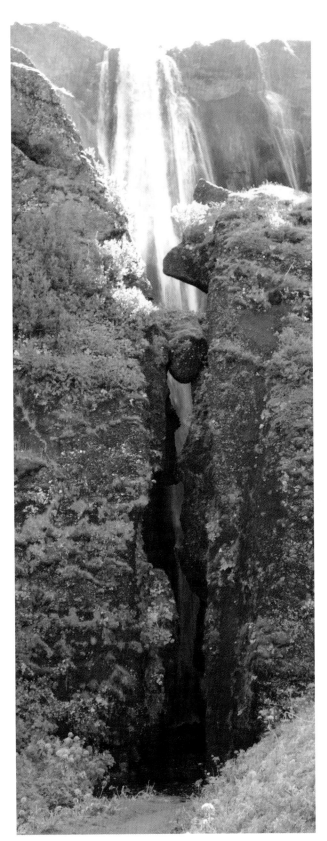

Behind emerald green-covered rocks there are often magnificent hidden waterfalls

All along the road, little white waterfalls tumble from such heights that they vanish into a mist as though watering the grass. When we first arrived, our welcome was driving down the steep hill into Hveragerði, sliding around the hairpins in the road and marveling at the pillars of white steam rising up from the fields to meet us.

Iceland's blues are not the brightest I have seen, but I find that they are richer for being so understated. I hesitate to call the blue in the thermal lagoons blue at all since it seems to be trying so hard to be white. There are almost tropical green-blues hidden away in the bottom of the craters, for those that go to look, and crystal blues in waterfalls concealed in awkward places. Beneath whistling fumaroles and in blurping, slopping mud pots there are unexpected blues as deep as midnight.

The colours of the Namafjall Hverir Mud Pots in northern Iceland

Þorvaldseyri farm on the South Coast of Iceland

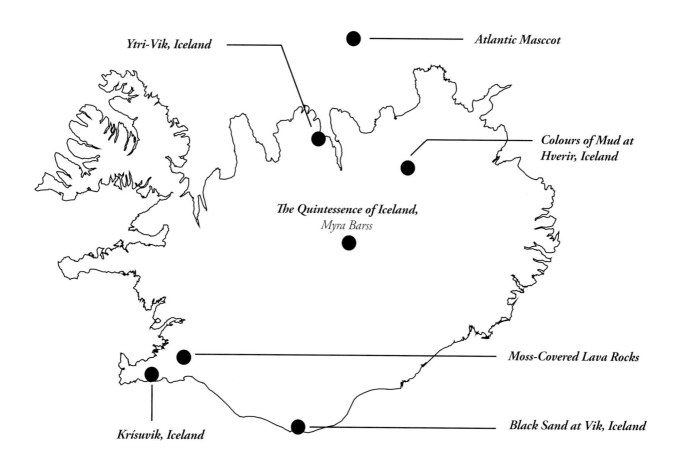

Ytri-Vik, Iceland

Atlantic Masccot

Colours of Mud at Hverir, Iceland

The Quintessence of Iceland,
Myra Barss

Moss-Covered Lava Rocks

Krísuvik, Iceland

Black Sand at Vik, Iceland

And, most spectacularly, Iceland pairs seasons as well as colours. In the fjords, the tops of the mountains wear their snowy caps well into summer, when their feet are well covered in rich green grass up to heights only reached by vertiginous sheep. In one of my favourite areas, the smooth dome of the Mýrdalsjökull glacier overlooks farmers' fields where we picnicked in the grass by the side of the road.

Iceland greeted us everywhere with fairy-tale lands and movie-set scenery. Often, it wasn't such a stretch to think that maybe elves did, and still do, live there. Each night, we lazed until dark in the warmth of the hot tub, impervious to wind or rain. It was magic. I fell in love. Sadly, we always think that we have more time and that things will always stay the same. But they don't, and sometimes slowly, sometimes quickly, everything changes and what we loved is gone. Iceland is still there, but it is different now with the sudden increase in tourists, and so, too, am I. Maybe we'll meet again, but maybe I'd prefer not. Maybe I prefer my memories of discovery and its gift of my rebirth.

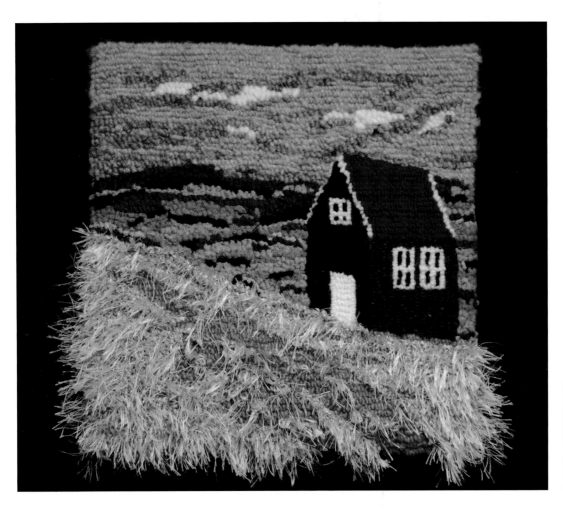

DANIEL MACDONALD

Krísuvik, Iceland, 12" x 12", wool, acrylic and novelty yarns, recycled wool and wool roving on burlap. Designed and hooked by Karen D. Miller, Ottawa, Ontario, Canada, 2009.

This piece was based on the small wooden church that had stood in Krísuvik for over a hundred and fifty years. When we returned a few years later, the church had been burned down by arsonists.

FAROE ISLANDS

We flew to the Faroe Islands from Reykjavik because it was so easy to do. Thinking we had found the root of all other-worldliness in Iceland, we were not prepared for the step into an entirely new other-world that awaited us when we landed at Vágar airport.

It simultaneously felt solidly European and yet so sparsely populated that civilization seemed to have cast only the thinnest of filaments over the land. Perhaps because of our timing, in the midst of a series of North Atlantic gales, the islands themselves seemed to be only blades of rock emerging from an enraged ocean. We stayed in a cottage among a handful of houses overlooking a cove and tried not to hit any sheep when we ventured out to drive. I remember fjord after fjord of green grass, rain, fog, and especially wind. One day, between the storms we went down to the small beach by our cottage and walked along the smashing surf in our rubber boots and raingear. There was nobody else around. I have never felt so close to the edge of the world; it was absolutely fantastic. When we returned, I watched the scene outside our window and revelled in the coziness we felt together inside.

Solitude

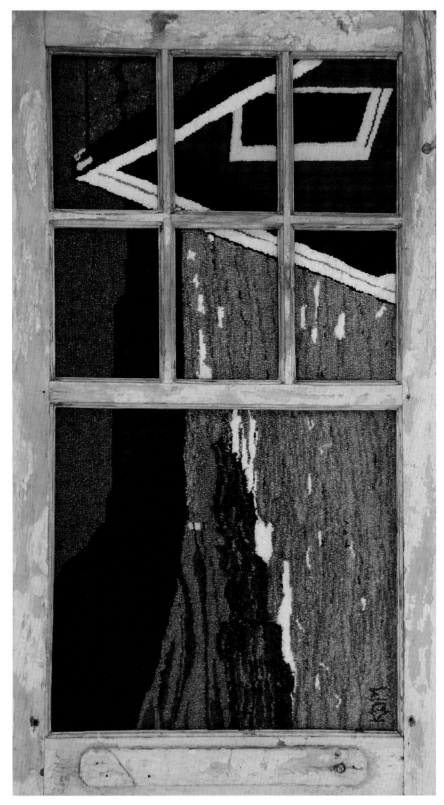

Solitude, *38½" x 21½", wool yarn, acrylic yarn, and novelty yarn, on rug warp in an antique window frame. Designed and hooked by Karen D. Miller, Ottawa, Ontario, Canada, 2012.*

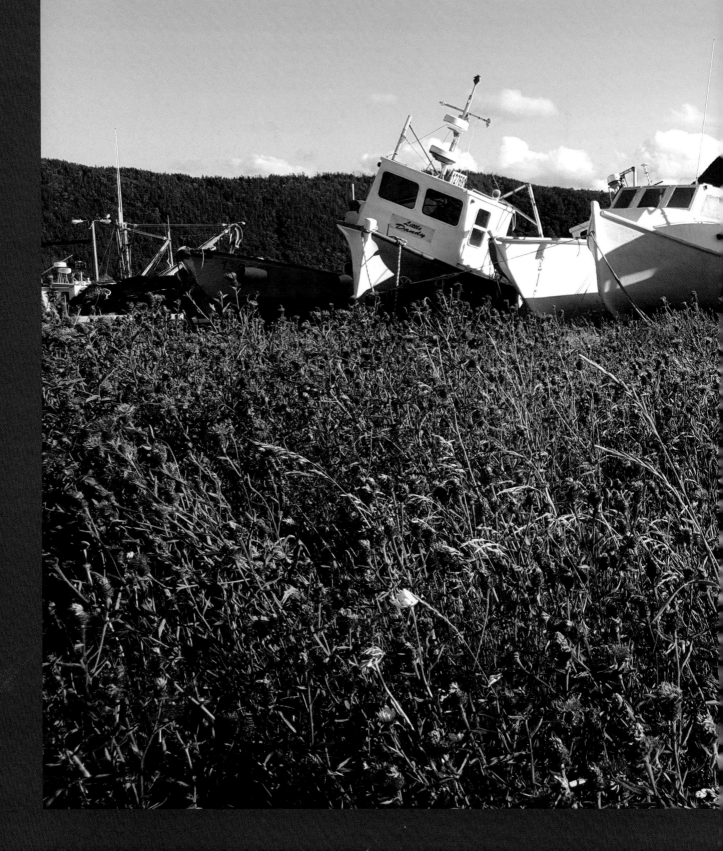

NEWFOUNDLAND
CANADA

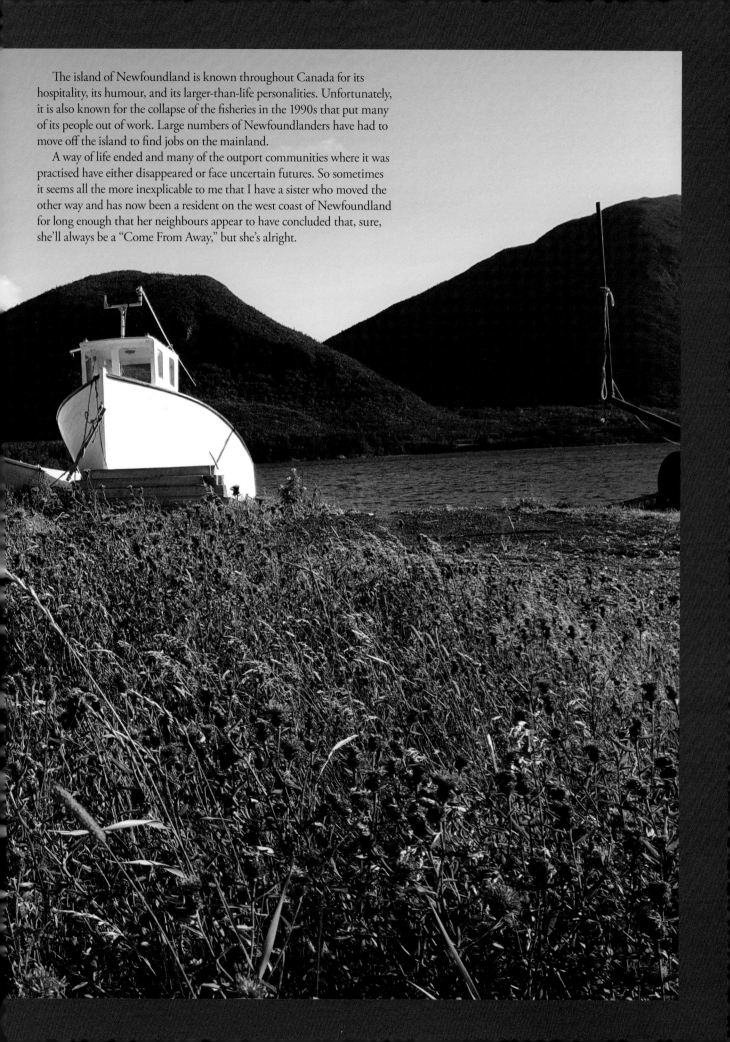

The island of Newfoundland is known throughout Canada for its hospitality, its humour, and its larger-than-life personalities. Unfortunately, it is also known for the collapse of the fisheries in the 1990s that put many of its people out of work. Large numbers of Newfoundlanders have had to move off the island to find jobs on the mainland.

A way of life ended and many of the outport communities where it was practised have either disappeared or face uncertain futures. So sometimes it seems all the more inexplicable to me that I have a sister who moved the other way and has now been a resident on the west coast of Newfoundland for long enough that her neighbours appear to have concluded that, sure, she'll always be a "Come From Away," but she's alright.

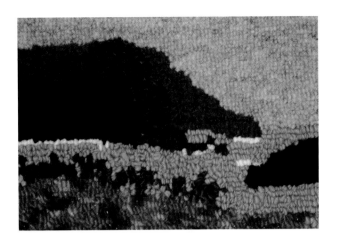

Bottle Cove, *7" x 5", wool yarn and acrylic yarn on rug warp. Designed and hooked by Karen D. Miller, Ottawa, Ontario, Canada, 2015.*

My sister's good fortune is also mine because her house is a well-placed base of operations within easy reach of some of the island's most spectacular scenery. We have had some wonderful adventures, like going up the northern peninsula where I saw the whitewashed trunks of entire copses of dead trees standing eerily rigid in the wind, roads detoured around sections collapsed into the sea, and rainbows in the spray thrown up from the wind-whipped waves.

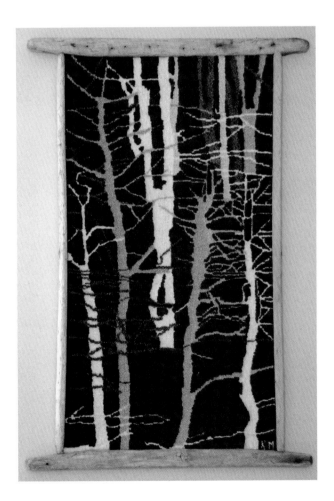

Along the Path, *16" x 26", wool yarn, acrylic yarn, and metallic yarn on rug warp in a custom Newfoundland driftwood frame by Daniel MacDonald. Designed and hooked by Karen D. Miller, Ottawa, Ontario, Canada, 2014.*

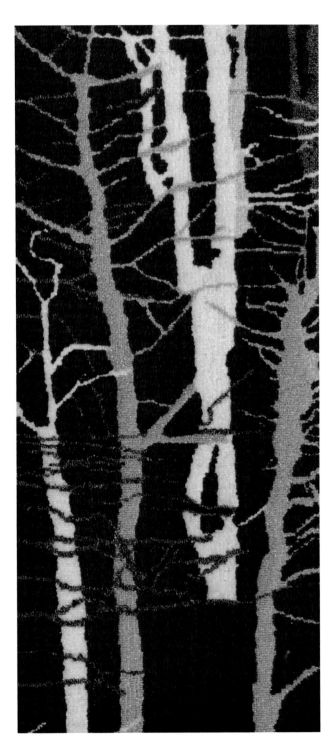

We drove far enough north that the trees gave way to a passable approximation of tundra. We visited L'Anse Aux Meadows on a day that would have convinced a Viking to stay inside by the fire, and we spotted moose tracks right outside our cottage door. On other trips we have travelled to the fjords of Gros Morne, and once the others somehow prevailed upon me to hike at least far enough to poke our noses up into the Tablelands. Elsewhere, we have awoken each morning to stunning views of our cove through enormous picture windows, been followed through town by a local author trying to sell us his books, and fallen asleep to the groans of melting icebergs. It is a varied land, alternately majestic and terrifying, and it, and getting to see my sister, keeps drawing me back.

No matter where we go in Newfoundland, excepting perhaps when driving through the endless trees of the Trans-Canada Highway, I have no trouble feeling inspired. It was Newfoundland that inspired me to work in smaller formats because I had so many pieces I wanted to make that I didn't want to spend months completing each idea. It was in Newfoundland that I finally figured out how to hook sunsets after the sky turned blood red over my head.

It was while walking up a random trail in Newfoundland— followed by a friendly wandering dog—that I looked down beneath my feet and realized how attractive the lichens could look. It was in Newfoundland that I hiked through mud and trees to scour beaches for driftwood for my pieces, and it was in Newfoundland that I understood what it meant to stand on a corner of the Earth.

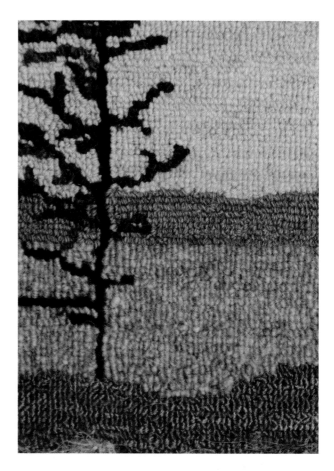

Northern Peninsula, *5" x 7", wool yarn on rug warp. Designed and hooked by Karen D. Miller, Ottawa, Ontario, Canada, 2014.*

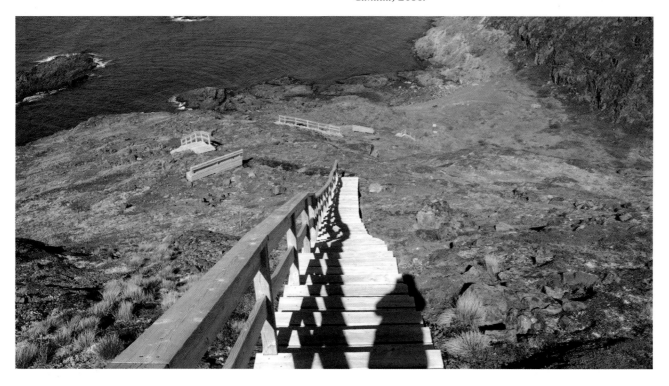

The hilly trails of Fogo Island in Newfoundland, where I learned to look down at what is beneath my feet.

Cedar Cove, *5" x 7", wool yarn, acrylic yarn, and sari silk*
ribbon on rug warp. Designed and hooked by Karen D. Miller,
Ottawa, Ontario, Canada, 2015.

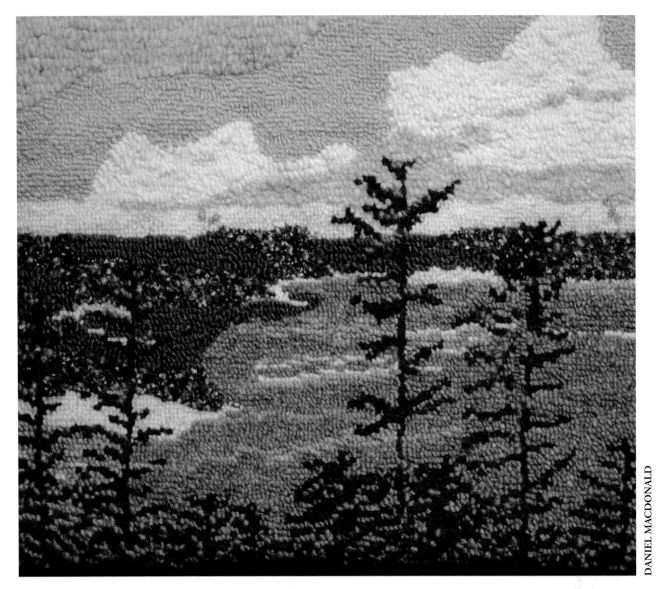

DANIEL MACDONALD

View from Captain Cook's Monument, 15" x 12½", wool
yarn and alpaca roving on burlap. Designed and hooked by
Karen D. Miller, Ottawa, Ontario, Canada, 2010.

Several of my Newfoundland pieces have already appeared earlier in this book. In this section, however, I wanted to show you a piece I did of a view from Captain Cook's monument in Corner Brook, Newfoundland. I do confess that I rather associated Captain Cook more with the Pacific than the North Atlantic, but he did survey the coast of Newfoundland in the 1760s. We visited his monument and, similar to my reaction to the lighthouse at Swallowtail, I was more impressed with the view around it than with the monument itself. In this case, it wasn't necessarily the view itself that struck. It is almost entirely forested coastline, of which there is no shortage in either Newfoundland or the rest of Atlantic Canada. What struck me, though, was the quality of the air. It was a fresh day, not necessarily with much of a wind, but definitely clear and sunny.

The light was the kind that you embrace as an artist because it transforms the land before your eyes. Evergreens, so often dark and dour under grey and rainy skies, now popped with lively green and the mountains were white-capped with snow. The sky, having cast aside its grey veil, fairly shone with a light blue so bright that it almost blended with the soft white of the high clouds. And the sea, liberated from the need to froth angrily, instead sparkled so idyllically that you could have been fooled into thinking it was far warmer than it actually was. On such days, it reminds you how vast the forests, the seas, and the skies are in this part of the world, and so you feel, just ever so slightly, a little bit smaller. It struck me as appropriate that there should be on that spot a monument to a man who sailed all of the seas.

When I saw Susan Murray's piece depicting three fish sheds, I thought I knew exactly where she took the scene from: Tilting, on an island off of the northern shore. That I was completely wrong only made it more intriguing, because it proved how well she had captured the spirit not just of her chosen scene, but of the island in general. When she revealed the story of the piece to me, it became an even more interesting study of the effect of unexpected influences.

The scene itself is of a place called Cavendish, in the south of the island, and therefore quite far indeed from the three similar sheds I thought she had depicted. Clearly, both of our eyes were drawn to the same symbol of the Newfoundland fishery and the hard work and resilience the sheds represented, but where I set my photograph aside for other projects, Susan carried on. Why? In part, at least, it turns out that the sight of these three sheds resonated with an earlier experience Susan had when she saw the brightly coloured houses of Muizenberg Beach en route to the Cape of Good Hope in South Africa. With her broader perspective on the practical and cultural importance of these colourful sheds for fishing cultures around the world, she recognized the greater significance of this scene and set about capturing it. Fortunately, given the realities of the weather by the sea in Newfoundland, Susan had many opportunities to pass by the three sheds in Cavendish and to photograph them in all light and weather conditions. The image that she chose was taken on one of those rare days in Newfoundland when the wind wasn't blowing, and the three sheds were reflected perfectly in the still barachois pond. It is a wonderful image and a great lesson about the fruits of patience, both in the practice of one's art and also in the harbouring of ideas for use even years later.

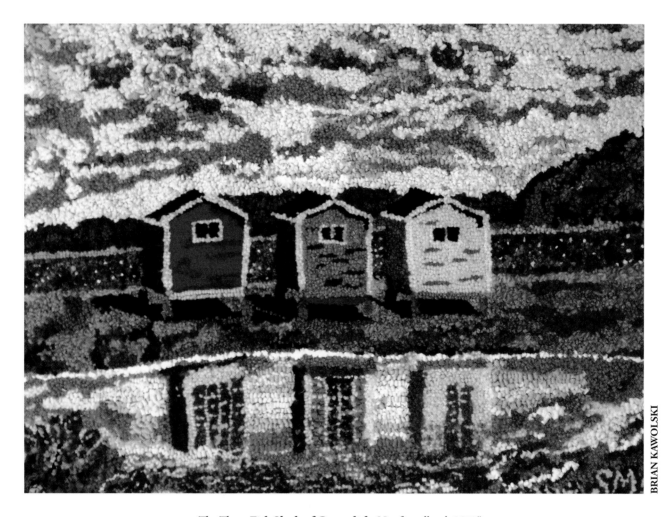

BRIAN KAWOLSKI

The Three Fish Sheds of Cavendish, Newfoundland, 30½" x 23", #7-cut wool, wool yarn, wool roving, and wool jersey on linen. Designed and hooked by Susan Campbell Murray, Portugal Cove, Newfoundland & Labrador, Canada, 2016.

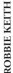
ROBBIE KEITH

Brigus Harbour, NL, 27" x 19", #3- to 7-cut hand-dyed wool
and wool yarn on linen. Designed and hooked by Dorinda Keith,
Elora, Ontario, Canada, 2011.

Sadly, bad times did hit Newfoundland and its people with the closure of the cod fishery. The livelihoods of a generation of Newfoundlanders were, at best, dislocated. Some of the isolated outport communities strung along the coasts lost their reason for being, their people, and eventually, their existence. Boats were hauled up and left to slowly collapse and rot in the grass within sight of the waters they once worked. Of course, the stories behind the boats are probably always more complicated, because the human experience always is. You can never know, without asking, what became of the families who owned those boats, whether they suffered or, if they did, whether they found new opportunity. Who is to say, in fact, if the boat was a casualty of the closure at all, or rather just stripped and abandoned at the end of a long life on the sea.

Dorinda Keith's piece *Brigus Harbour, NL* was borne of being confronted by this very ambiguity. She was walking through the community of Brigus, indulging her interest in heritage buildings, when she came upon this house with three boats hauled up in its yard. She saw the yard as being pregnant with stories that of course she couldn't divine without knowing more. Of the three boats, in particular, she wondered if they represented three generations of earning a living from the sea. Were the two older boats casualties of the collapse, and was the newer boat an investment to reach the fishing grounds now farther out to sea? She had no answers to any of these speculations, and she hooked her uncertainty into her work so that you can wonder along with her.

The other intriguing thing about Dorinda's work was that I, too, have wondered the same kind of questions when I saw the same kind of sights. Sometimes I squint at the boats when I pass them by, trying to figure out if they are derelict or merely done for the season. It can be difficult to tell. Sometimes they are propped up on makeshift wooden cradles, still sporting the antennae of their instruments, and you know they will be launched again next season even if other pieces, conspicuously missing, have been removed for refurbishing. Other times they are stripped of everything that can be unscrewed and left lying on the grass, greying along with the sky and waiting only for the day when their sides crack and cave in under their own weight. Then, though, there are the ones that you cannot place. One day in Prince Edward Island, there was a boat hauled up on the property next door, haphazardly propped up on barrels and uneven lumber and evidently being used to store surplus yard equipment. It even had an old barbecue screwed to the deck, from which I imagined the owners holding strange garden parties. When one day a trailer showed up to haul it away, I concluded that it was being taken for scrap. Imagine my surprise, then, when the boat turned up hours later tied up to a mooring ball in the bay across the road. So, I learned, sometimes you never can tell.

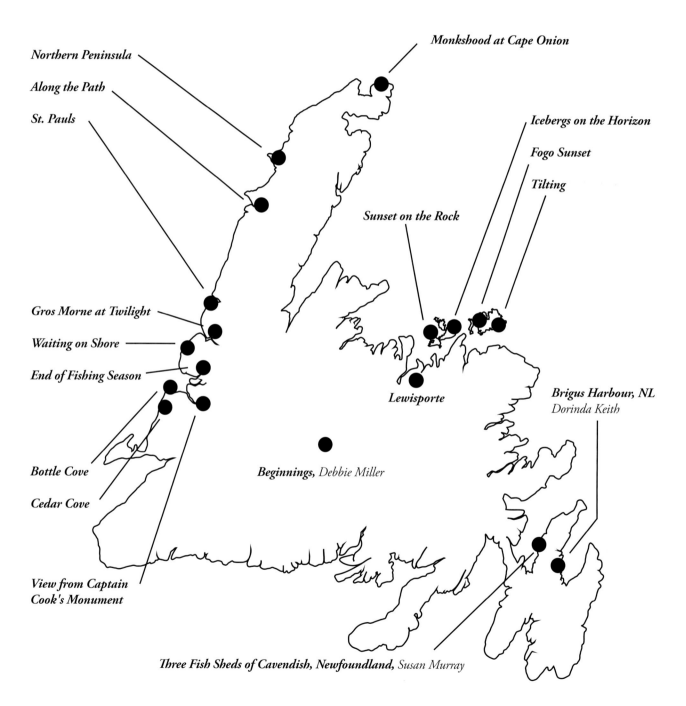

Northern Peninsula

Along the Path

St. Pauls

Monkshood at Cape Onion

Icebergs on the Horizon

Fogo Sunset

Tilting

Sunset on the Rock

Gros Morne at Twilight

Waiting on Shore

End of Fishing Season

Lewisporte

Brigus Harbour, NL
Dorinda Keith

Bottle Cove

Cedar Cove

Beginnings, *Debbie Miller*

View from Captain
Cook's Monument

Three Fish Sheds of Cavendish, Newfoundland, *Susan Murray*

In my own piece, therefore, I took a similarly ambiguous approach. The boat itself was one I saw pulled up for the season on the drive north to Gros Morne. It reminded me, though, of all of the other boats I had seen, like the ones hauled up in the service yard in Grande-Entrée or perched in the hills of Havre aux Maisons in Les Îles de la Madeleine, or even the wreck lying in the grass in the midnight sun behind our cottage in northern Iceland. I took the hopeful approach with my boat and called it *End of Fishing Season*, implying that it would have a next season. I cloaked the bottom of the hull in grass, though, and left the marks that could either be fatal breaks in the planking, or otherwise just marks. How you feel about it, I suppose, is up to you.

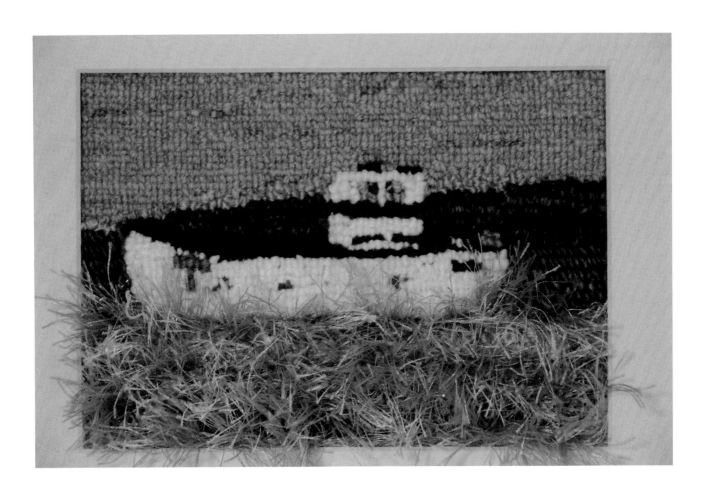

End of Fishing Season, *7" x 5", wool yarn, acrylic yarn, and novelty yarn on rug warp. Designed and hooked by Karen D. Miller, Ottawa, Ontario, Canada, 2015.*

4 BEYOND REALISM: BRINGING FEELINGS TO THE FORE

We fall in love with places that we travel to for all different reasons, of which beauty is only one. It can be the people we were with or who we thought of while we were there. It can be the destabilizing effect of the culture shock that first shakes our assumptions and then opens our eyes to the wonders of the different ways people live. It can be our own memories that the places trigger, or a particular feeling that they leave us with. For all of these reasons, there is no single correct way to capture your feelings about a place when you sit down with your hook. You are completely free to distort, falsify, crop, or magnify in whatever way speaks most clearly to you. The remainder of this book will demonstrate how different fibre artists have gone about capturing the feelings that they had in or about places where they travelled.

I have chosen six themes in which I will present 49 different pieces: mystery, the unknown and unexplored places; family and friends we travel with; discoveries we have made; keepsakes we make to hold onto our memories; symbols we use to explain our feelings; and ideals we strive for. Just like the feelings these artists felt, these categories are entirely subjective. It doesn't matter if they are "correct" or not, save for the purpose of showing different inspirations for art. What's important is that, whether you agree with them or not, they prompt your own thinking about your own art.

Reflections at the Water Temple, 57" x 45", new and recycled
fabrics on hessian. Designed and hooked by Gail Nichols,
Braidwood, New South Wales, Australia, 2016. **Colour and Light**

The artists in this portion of the book have chosen different techniques to highlight specific memories of their travels. While the main narrative of this portion of the book will concentrate on what the artist is conveying and why, some readers may wish for brief technical detail on how the artists composed their pieces and why. This information will appear in colour coded Technical Panels, like this one. These Technical Panels will highlight seven compositional techniques:

Each Technical Panel will give selected examples that I have chosen that illustrate the particular technique from elsewhere in this section of the book. For ease of reference, these highlighted pieces will also be identified by colour coded tags in their captions. Although many pieces could easily serve as examples for multiple techniques, I have assigned pieces to only one category.

1. **Colour and Light**

2. Altered Form

3. **Macroscope**

4. **Unconventional Media and Techniques**

5. Photography

6. **Magnification and Cropping**

7. Imagination

Mystery, the Unknown, and the Unexplored

For many people, the joy of travel is the anticipation of discovering a little pocket of the unknown. Once upon a time, when every inch of the Earth hadn't been mapped from space and previously walked by all manner of itinerant explorers and adventurers, this was actually possible. Nowadays, of course, we must settle for broadening our personal horizons. Fortunately, the world is such a bafflingly diverse place that turning almost any corner brings the promise of witnessing something refreshingly new.

Gunda Gamble is one who seeks out these adventures. She is an avid hiker who finds and follows new trails whenever she travels to a new place. For her, the excitement is in not knowing where it will lead and the anticipation of following it all the way to its unknown end. It is this sense of anticipatory adventure that she is portraying in *Unknown Destination*. She does not tell the viewer where

"Climbing into bed at night, my thoughts are finally my own. I travel to new places, meet new people, and create new art."
– Liz Alpert Fay

the trail in her piece is going because she does not know herself; she invented the scene from her own imagination. Her trail has no defining features, which almost invites you to see in it pieces of trails that you have hiked yourself. Which ones, and where they are going, of course, will always be a mystery. Even if you are returning to somewhere that you have been many times before, there is always something new to discover, and it is those unexpected surprises that keep travel fresh.

I, too, like hiking, but probably not nearly as much as Gunda. Instead, our family often does car trips. Travelling by train or airplane can also be an involved process, with all of the schedules to be adhered to and security checks to be endured. With the car, however, we simply throw our suitcases or our camping gear into the back and go. We stop whenever we wish and turn off to explore whatever catches our eye. Or we just push forward, putting as much distance as we can between ourselves and all the tasks and commitments waiting at home. The kids are quiet, ever since we discovered portable movie players, and oftentimes there is nothing for my husband and me to do to pass the hours but to chat, which we rarely have the time to do at home. And when the conversation runs out, there is pleasure to be had in simply reading the new place names on the signs as we pass them, and stopping for the guilty pleasure of terrible food. We relish this travel for the travel itself. Where we are going almost doesn't matter. Maybe there is something around the next bend, and maybe there is nothing there but more travel ahead. We're fine either way.

My other version of mystery is the yearning for places I haven't yet been.

Unknown Destination, 32" x 20", #3- to 7-cut wool on rug warp.
Designed and hooked by Gunda Gamble, Ariss, Ontario, Canada, 2015.

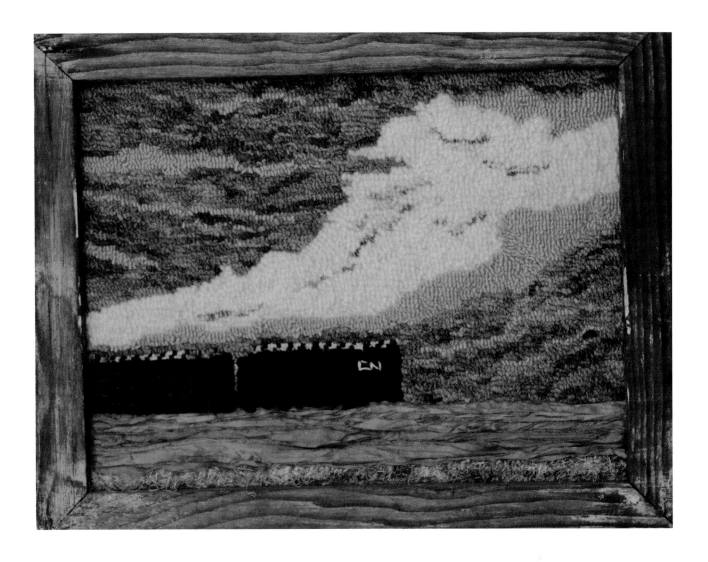

Heading West, 15" x 11½", wool yarn, specialty yarn, and sari silk ribbon on rug warp in an antique window frame. Designed and hooked by Karen D. Miller, Ottawa, Ontario, Canada, 2013. Imagination

While I have been so very fortunate to see many places in the world, and to fall hard in love with a few, I will also always be curious about what is around the next corner. Two places I think most about going are in my own country. This isn't an uncommon thing for Canadians, given that our country is so large and sparsely inhabited that the prospect and expense of travelling to other countries is often more manageable than travelling inside our own. This is why I have still never been to either central or western Canada. I have never seen the endless prairie road with nothing but grass and sky as far as the eye can see in any direction, for days on end. I have never seen our Rocky Mountains, against which I am told every mountain I have ever seen will pale in comparison. And I have never seen our Pacific Coast that I am told bears no similarity to our East Coast whatsoever. These were the adventures to come that I had in mind when I hooked *Heading West.*

Road to Akureryi, 7" x 5", wool yarn on linen. Designed and hooked by Karen D. Miller, Ottawa, Ontario, Canada, 2018.

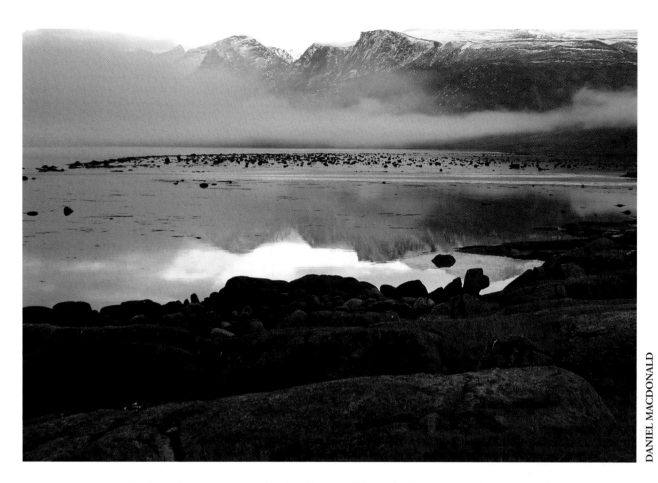

Another early morning captured in the still waters of the fjord at Pangnirtung, Nunavut, Canada.

Like Gunda on her hiking trails, however, I really have no idea what awaits me when I one day get there, and whether it will be worth the anticipation that I have created for myself. As I sat one day watching a train heading west, though, it occurred to me that the train cars would have seen many, many miles of western Canadian track in their lifetimes, and had probably seen everything that I wish to see. The train cars became an emblem for me, leaving me behind as they head away beneath towering clouds.

While heading west is easily done in Canada, heading North is a privilege. It is difficult to get anywhere that is truly northern in Canada without considerable expense and no little planning. It ususally involves tiny airplanes and rough living. My husband is one of the fortunate ones. He has travelled, if not to the truly remote locations, then at least as far as he has ever really wished to go. One trip took him by a small prop plane from Iqaluit in the northern territory of Nunavut to a community called Pangnirtung that was, at least at the time, basically as large as its airstrip. On his return, of course, he regaled me with pictures and stories of all the things he'd seen that I would have enjoyed, like fjords and barrens and northern lights. One picture, though, he took only for me. He was walking along the road in the morning and noticed that the rock wall of the fjord across the water had quite distinctly turned pink in the strengthening sunlight. Further, the mirror-flat water was doubling the effect so perfectly that it was difficult to tell where the rock ended and the water began.

I looked at this photo every which way, and I was so taken with its unusual colours and patterns that it became one of my first abstract pieces, without me having to change a thing. I share my husband's fascination with the north and I very much wish to see it, but unlike other parts of Canada, I won't make any more pieces about it until I do. It seems that it is one of those places in the world that truly does have to be seen to be believed.

Finally, beyond the unknown and the wistful hopes for future travels, there is the easiest and most unruly travel of all: the travel we undertake in our dreams. Think of all the travel that we do at night, and how easy it is when we are freed from the physical limitations of real travel. There are no boundaries and no limits, not even to our imaginations, since there is little that is so weirdly spontaneous in our lives as our dreams. In our dreams we are as fearless as we are free, and we explore our desires and relive our memories in chaotic and refreshing combinations. Liz Alpert Fay uses dreams as a fountain of inspiration for her art. Each evening for her is a journey into freedom, away from the demands of work and people. It is no surprise, then, that Liz herself wishes for a bedroom with a ceiling open to the stars. I confess to being somewhat envious of her success in having such interesting dreams. But I do completely understand the sense of mental escape that she describes, as it is the equivalent to what I feel when I am travelling on my next much-anticipated vacation.

DANIEL MACDONALD

Pangnirtung, Nunavut, 15" x 12", wool yarn, acrylic yarn, and alpaca roving on burlap. Designed and hooked by Karen D. Miller, Ottawa, Ontario, Canada, 2010. **Colour and Light**

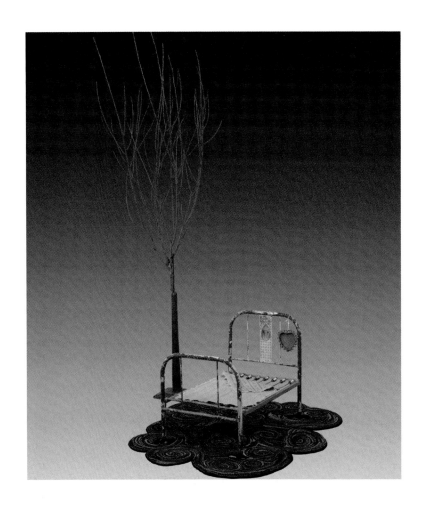

Collector of Words, I Dream in Color, *40" x 45.5" x 85". Recycled wool on linen. Antique hand-embroidered linen textile. Reclaimed metal bed, beaded picture frame, wooden base, ric rack, section of old map. Designed and hooked by Liz Alpert Fay, Sandy Hook, Connecticut, USA, 2011.*

Family and Friends

Some people like to travel to escape everything and everyone at the same time. They might hike into the wilderness alone, for example, or sail solo, or book a ticket for themselves to an exotic, faraway destination. Although I have never done it myself, I can appreciate the allure. Many others, however, travel to reconnect with friends and loved ones, to remember loved ones who have passed away, or to discover and appreciate their own past. Reconnecting with my family has always been very important to me. Especially after we had children, I found that travel was one of the only ways to drag our disparate lives back into one, if only for a short time, and recharge our bonds when they got too frayed by the monotonous demands of everyday life. I am so very happy when I am travelling and my family is laughing around me, and this is also why I am often so sad when the trip comes to an end. I know that all of the lists, demands, and routines of life that I left behind are looming once again, and that the fraying that we have just repaired will begin again immediately.

"My happiest childhood memories were of our holidays in New Brunswick."
– Trish Johnson

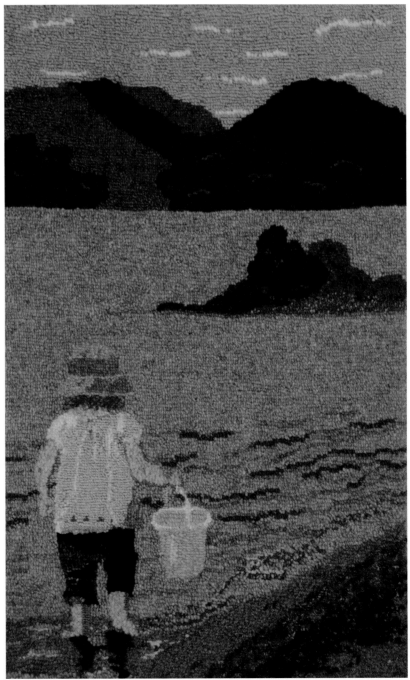

Girl with a Yellow Bucket, 17" x 27", wool yarn, acrylic yarn, and cotton yarn on burlap. Designed and hooked by Karen D. Miller, Ottawa, Ontario, Canada, 2010.

DANIEL MACDONALD

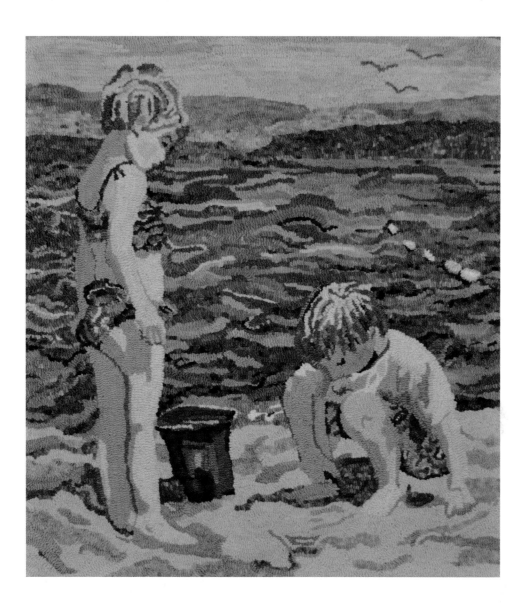

A Day at the Beach, *32" x 34", hand-cut dyed wool flannel on linen.*
Designed and hooked by Jane Bridgeman, Toronto, Ontario, Canada, 2017.

Looking back, then, it doesn't surprise me at all that *Girl with a Yellow Bucket* was one of my very first pieces after taking up hooking in 2008. We were staying at a friend's cottage and my daughter, very young then, was playing happily down at the lakeshore in the sand and mud with the other children. We had learned by then that kids don't care about history or exotic locales so long as there is something, anything, fun to do. It was a less stressful style of travel that we were happy to embrace. In fact, the only thing to do that afternoon was relax and let her play, because we didn't even have to cook dinner, which in those days was still an enormous novelty. The cottage was not far from home, but for an afternoon it felt like it, in a very good way.

I like to imagine that Jane Bridgeman was thinking similarly when she hooked her piece *A Day at the Beach.* As she recalls it, it was a beautiful summer day at a resort in Ontario, Canada. Just as I happily watched my own daughter playing with her bucket, she watched her children having fun building sand castles and moats in the beach. It doesn't even really matter to us as viewers which beach it was. This piece instantly transports us in our minds to memories of our own childhood or of watching our children having fun in the sun.

Similarly, Judith Lilley's depiction of her holiday at Lac Édouard in La Mauricie National Park in Québec, Canada, doesn't show anything at all of the area itself. Rather, the piece is quite evidently a celebration of the lasting affection between the artist and her two sisters. Not only is the fondness obvious, but we can even hear her husband's humour in the title *La Sainte Trinité* (The Holy Trinity), which he bestowed upon the piece as Lilley was completing it.

Although they stay in touch regularly, Judith and her sisters don't get to see each other very often owing to living a long distance apart. A rendezvous of all three, such as Judith captured, is a special occasion wherever it occurs, and so naturally photographs with all three of them together are rare. It is the same way with me and my own sister, although the necessity of travelling to Newfoundland to see her has obviously proved very inspirational to my art. Perhaps, though, one day I might take Judith's approach and document the real best part of Newfoundland, which is us two Ontario girls laughing over a bottle of wine about the strange turns that life takes.

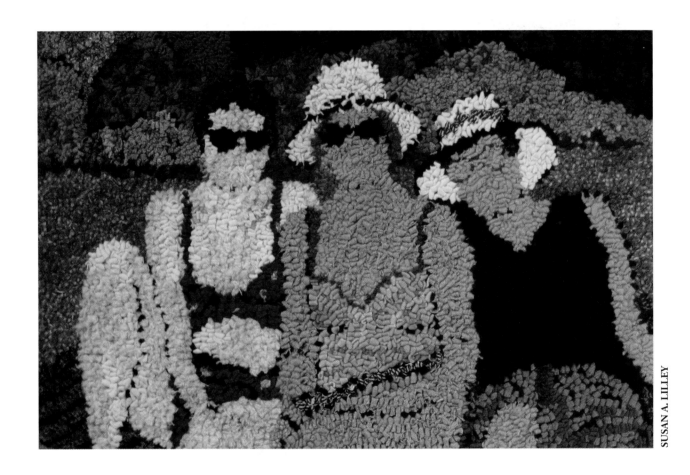

SUSAN A. LILLEY

La Sainte Trinité, 24" x 16", hand-cut recycled and overdyed wool on burlap.
Designed and hooked by Judith Lilley, Kamouraska, Québec, Canada, 2015.

"My husband called it this every time he leaned over my shoulder to see progress, and the name stuck." – Judith Lilley

"What a joy it was to finally be able to go outside in the fresh air again!" – Dana Psoinas

EILEEN HARITONIDES

Time, Prayers and Healing, 22" x 17", #2-, 3-, and 4-cut hand-dyed wool, wool locks, yarn, metallic threads, and hand-cut velvet on linen. Designed and hooked by Dana Psoinas, Woodbury, New York, USA, 2018.
Photography

Dana Psoinas was also inspired to create a piece that is a celebration of her love for her family, although the circumstances were grave. Caumsett State Historic Park Preserve in New York has long been a favourite destination for her and her family. The day that inspired her piece *Time, Prayers and Healing*, however, was anything but an ordinary trip to the park. Rather, it depicts a celebration of recovery and a documentation of a milestone in both physical and emotional

healing. Following a terrible accident, Dana's husband was hospitalized for several weeks and endured several surgeries. Just over a week after he was released, the family's first outing together was back to this favoured destination where the blacktop trail they used to bicycle over was instead perfect for his wheelchair. Together, the family appreciated the sun and the fresh air and celebrated how far they had come together.

Photography allows the artist to create new compositions by combining details taken from different angles, or even from different places or different times. This can either be done explicitly or it can be done seamlessly such that only the artist will ever know.

Trish Johnson is an experienced practitioner of the explicit approach as it complements her storytelling. *Memories of Oak Point* (p. 109) is composed of photographs and background elements, each carefully delineated and faithfully rendered, and yet coordinated effectively so that they all relate attractively within a single composition. Dana Psoinas takes the same approach with *Time, Prayers and Healing* (p. 107) as the individually faithful representations matched her documentary purpose.

John Flournoy commonly uses multiple photographs to create seamless compositions. In *Dolles Rehoboth Beach* (p. 134), he began with the straightforward task of selecting the picture of the building that he wanted to work with. He then took separate photographs of people on the boardwalk in the placements that he wanted. The effect is to create a realistic and technically sound scene that is in actual fact entirely his own creation.

Kay LeFevre's *Black Crowned Night Heron on Alligator* (p. 119) is a similarly seamless composition, but this time blending elements from different sources to create a reminder of a scene that she did not actually photograph at the time. She had her own reasons for wishing to hook a heron, and in developing her composition she recalled how they stood on alligators in Florida. The viewer of the resulting composition could credibly believe that Kay used a single photograph.

Trish Johnson has family roots in New Brunswick, where she has travelled often so as to keep her family in touch with its history. For close to 50 years, she visited Oak Point every summer to see her grandmother and her aunt, first as a child with her mother and then with her own children.

Memories of Oak Point is as much a documentation of this long and happy family tradition as it is art. For example, at the top left she has depicted St. Paul's Anglican Church. One summer, she and her cousin climbed up the church steeple, and she remembers the squeaks of the little furry bats that lined the inside. They had a treehouse in a tall oak tree a short distance away from which they could see the church and the graveyard. At the top right, Trish has placed her grandmother and aunt's house in Oak Point, and at the bottom left, her other aunt and uncle's house in nearby Greenwich, or, as she knew it then, Jones Creek.

She thought of both houses as old fashioned with their big kitchens, woodstoves, water hand pumps, and outhouses. The houses also had doting relatives who looked forward to their visits every year and ensured that the pantries were always full of food and, perhaps especially, cakes and treats. Finally, at the bottom right, Trish has depicted the lighthouse at Oak Point on the Saint John River. She swam in the river when she was a child, and her children did the same. If you look closely, you can see her children exploring the grounds around the lighthouse.

Trish uses her backgrounds to support her design, giving it an additional dimensionality that I have always admired about her work. The blue-sky backgrounds in each postcard are deliberate, emphasizing that her happiest childhood memories were of her holidays in New Brunswick. She remembers her mother being happy, picking raspberries with her cousin, bonfires and marshmallows on the beach, and later taking her own children to all of the same places.

The map in the background is of the Saint John River, taken from an old map that was used back in the days when there were still passenger ships on the river. By understanding the meaning behind all of these different elements in the design, it is obvious that Trish succeeded in her aim of showing her own children where their roots were and telling them about their grandmother, her own mother, whom they unfortunately never met.

Memories of Oak Point, *34¾" x 44¼", #2-, 3-, and 4-cut wool on linen.*
Designed and hooked by Trish Johnson, Toronto, Ontario, Canada, 2009.
Photography

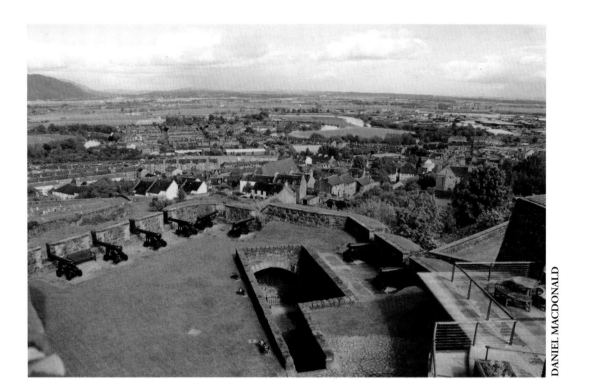

The precise geometry of Stirling Castle, Scotland

Jane Bridgeman was also paying tribute to her family history with her piece *Le Tour de la Gaspésie*, although this time going much farther back, all the way to the Port Royal Acadians and the *filles du roi* of the 1600s. She recounts that, because of her French family roots, she felt a connection with the food and beauty of the Gaspé and a sense for its history, when touring it with her family on a summer vacation. She took elements from two different photographs, including one of herself and her daughter wearing their similar sun hats, to develop her design.

I understand the feelings that both Trish and Jane are conveying with their pieces, and how their inspirations translated into their art. My own parents were the first, and so far, only, members of my larger family to emigrate to Canada from Scotland. We went back to Scotland several times during my childhood, and I even went back with my fiancé so that he could meet all of these characters that I kept talking about. I found, though, that it is a very

difficult thing to maintain such connections from a distance, even with all of the wonders of the Internet. I appreciate how both Trish and my own parents understood that difficulty and put in the effort that is needed to keep such family connections alive. Nowadays, though, I no longer think of Scotland as "home" as Trish does of Oak Point. It will always be a special place for me, and full of memories, but I think of it differently. I want to see different parts of it, parts that I have never seen, and I want to forge new memories with my own family, just like I want to explore the rest of the world. Nonetheless, I am sure that when the day comes, I will feel very differently about seeing the Cross of St. Andrews again than my husband and my children will, much as Jane feels in the Gaspésie. I am sure that they will see a new frontier and new adventures. I am sure I will feel like I am back, and maybe even like I never left.

Le Tour de la Gaspésie, 39½" x 32½", hand-cut dyed wool flannel on linen.
Designed and hooked by Jane Bridgeman, Toronto, Ontario, Canada, 2016.

The last three pieces in this section deal with the difficult subject of loss and, in a way, how travel can be used as part of the healing process. The first piece, by Tracy Jamar, relates to the loss of her horse, Fifty/50, after 18 years together. The image is of the dirt road in East Hampton, New York, that they rode many times to reach their riding trails. Riding Fifty/50 was more to Tracy than just the pleasure of riding through the woods, or of being with him, or even the friends that she met because of him. As she puts it, riding is an escape, and everything is better, even if just for that moment, when you are looking at the world from *Between the Ears* of a horse.

Between the Ears, 31" x 23½", hand-cut wool, cotton, silk, polyester fabric, yarn, and mixed fibers on monk's cloth. Designed and hooked by Tracy Jamar, New York, New York, USA, 2010.

Maine Gold, *14" x 11", #4-cut hand-dyed wool on linen.*
Designed and hooked by Lori LaBerge, Spruce Pine,
North Carolina, USA, 2017. Altered Form

Earlier in Lori LaBerge's life, York, Maine, was a family summer destination. Following her mother's passing, the family returned to York as a tribute to her and to revisit the sites that they remembered. They explored new sites, too, and they made one such discovery as they walked along Fisherman's Walk down by the seaside. *Maine Gold* is a stone entrance covered in golden moss, reimagined as a modern artwork using the colours of the surrounding sky and landscape and incorporating the motion of walking along the pathway.

This is my favourite technical subject because this is where I find that artists do the truly mystifying and magical. In altered form, the artist lets go of the form that she sees and replaces it with something else. This can be a mild distortion, the addition of new elements, and even altering reality to the point that the original subject is rendered unrecognizeable. Whatever the degree of alteration the artist chooses, understanding the work and its meaning is only possible if you understand that the artist is always in complete control of the image.

Two of Liz Alpert Fay's works in this book, *At the Water's Edge: Stones* (p. 139) and *Petoskey Stone: Memories of Michigan* (p. 140), are examples of mildly altering the form of stones and shorelines and the patterns made by fossils, to highlight an inspiration. Betty Calvert's *Galway Hooker* (p. 139) demonstrates how even abstract art can be used as inspiration for even further abstraction.

Melissa McKay begins to distort reality more significantly in her piece *Cherry Blossoms* (p. 145), an impression of actual streets in Vancouver, Canada, that she turns into wobbly towers, pinwheels and trees that could be cotton candy. She continues with *Lions Gate Bridge* (p. 141), also in Vancouver, and portrays them as a merger of what could be intergalactic expanses with almost Dr. Seussian symbols of Earth.

Lori Laberge's piece *Maine Gold* (p. 113) is probably the most extreme example of altering reality in this book, and it is worth examining how it was composed to demonstrate how all artists maintain control over the elements of their composition, even as they depart from what they are actually seeing. Lori's work is very conceptual, meaning that she deliberately uses altered forms and colours to represent her subjects rather than accurately depict them. As documented by Lori in her blog, the idea for *Maine Gold* came from a stone wall that she observed while on a walk along Fisherman's Walk in York, Maine. The wall was made of stone covered with an orange-gold coloured moss.

Lori LaBerge's photo of a stone wall along Fisherman's Walk in York, Maine. This wall sparked her idea for the piece Maine Gold.

There were at least two distinct steps in the evolution of this design. The first sketch is easy to interpret, as it retains all of the core features of the original photograph, including the basic shape of the wall as the focal point, the backing wall, the grass turf and pavement, and the building to the right.

However, Lori was dissatisfied with the lack of balance between these elements, particularly on the right hand side. Therefore, she introduced a large circle on the left, and simultaneously introduced new diagonals in the lower and background sections that gave more of a sense of movement along the walkway. She then planned her colours, blocking sections so as to emphasize the forms.

Clearly, the most significant departure from "reality" in this design is the white circle, which simply isn't there at all, in any form, in the photograph. Looking at the final design next to her original photograph, this step appears as magic. By breaking down her process, though, it is apparent how Lori proceeded quite logically, first identifying the main elements from her photograph, and then setting aside her photograph and introducing the "missing" element that was required to complete her resulting composition. It is a useful lesson in how an artist can fruitfully draw from, but not be bound by, reality.

Sketches for Maine Gold, Lori Laberge, Spruce Pine, North Carolina, USA, 2017.

I will close this section with Gail Nichol's piece *Cape Liptrap Beach*, which is a piece about travel that life events turned into a memento of a friendship. The piece itself is the colours of rocks, sand, seaweed and lichen that she found on Cape Liptrap beach in Australia while she was camping at Cape Liptrap Coastal Park. On the way to the park, however, she first visited a close colleague from her ceramics work who was then in the late stages of cancer. Her friend expressed an interest in trying some hooking, so Gail gave her some hessian and an embroidery hoop for her to try. After Gail returned from her camping trip, she kept in touch with her friend and even shared a photo of her progress on this piece before she departed on an overseas trip. Sadly, her friend passed away while Gail was travelling. Now the piece has taken on a new significance as more a reminder to Gail of her friend than of the beach.

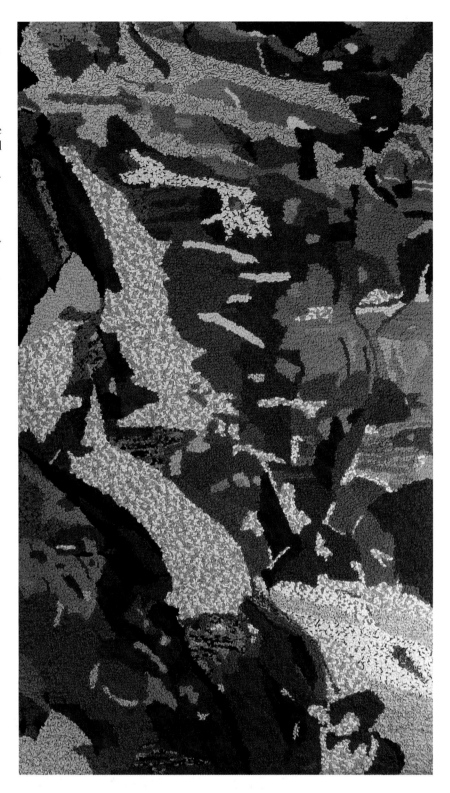

Cape Liptrap Beach, 37" x 63", new and recycled fabrics on hessian. Designed and hooked by Gail Nichols, Braidwood, New South Wales, Australia, 2016. **Colour and Light**

New Frontiers

Perhaps the most obvious reason to travel is simply to see and feel something completely different. It can be the invigorating, if somewhat shocking, experience of venturing to a distant land with a culture and language that you barely comprehend, if at all. Or it can be visiting a familiar place and finding something new or noteworthy that alters your perception. **Either way, we are personally enriched by our travel, being changed by the differences that we see and reflect upon.** Such reflection upon our new experiences is a wonderful source of art.

One of the most exotic foreign locales to my mind is the fabled Orient, Southeast Asia. Just about everything about it is so intimidatingly different from my everyday that one day we will probably go. Val Flannigan travelled to Vietnam and visited the UNESCO World Heritage site of Halong Bay. Her piece, of that same name, is from a photograph that she took on their early-morning boat tour before the mist burned off. Although the bay is world renowned for its limestone karsts and islands, typically photographed in radiant sunshine and saturated with vibrant greens and lively blues, Val chose the opposite approach. Her treatment is almost monochromatic, with only a lonely splash of colour, to convey the sense of mystery that she felt that morning.

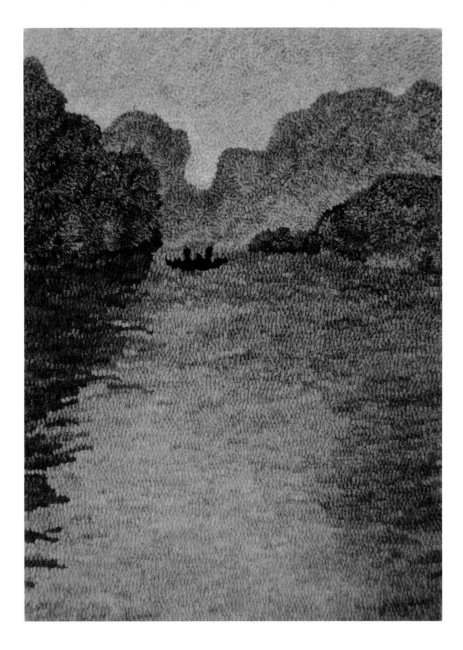

Halong Bay, 11" x 17", *#4-cut hand-dyed wool on linen. Designed and hooked by Val Flannigan, Kelowna, British Columbia, Canada, 2014.* **Colour and Light**

Laura Salamy's travel to a new locale is different than most in that it eventually became permanent when she moved from New England to New Mexico after years of vacationing there. It is also different in that, as she freely acknowledges, the first-time visitor to New Mexico would not be exactly overwhelmed by the range of colours on display. However, for those with the patience to stay awhile, to make the effort to hike into the surrounding area, and to appreciate the understated, the desert reveals a surprisingly colourful side. Laura hooked *Desert Gone Wild* while she was still in New England, between her last trip to the area and moving. The colours were from her memory of her soon-to-be new home, of the large blue sky and the different hues it takes on depending upon the time of day, of the reddest sunsets she'd ever seen, the pink of the Sandia Mountains, the golds of the trees in the fall, and even the pinks, blues, and purples in the desert flowers.

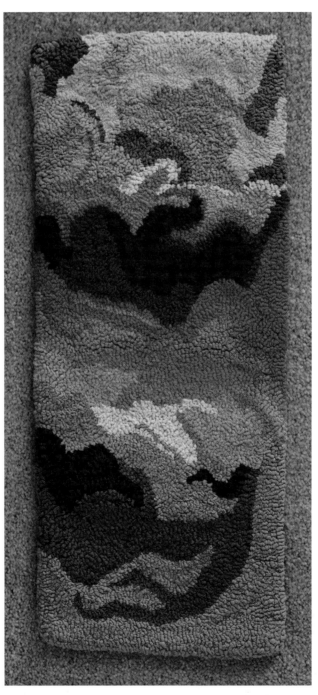

GARY LAMOTT

Desert Gone Wild, *9½" x 25", hand-cut recycled t-shirt strips on monk's cloth. Designed and hooked by Laura Salamy, Albuquerque, New Mexico, USA, 2015.* **Colour and Light**

Black Crowned Night Heron on Alligator, 30" x 45", various
yarns on rug warp. Designed and hooked by Kay LeFevre,
Oshawa, Ontario, Canada, 2017. Photography

Kay LeFevre's *Black Crowned Night Heron on Alligator* is, to my mind anyway, a lightheartedly understated look at the strangeness that we can encounter while travelling. The scene is from an RV vacation in Florida, when they stopped at a place they'd driven past many times before. She chose the night heron as the subject for her piece because it had personal meaning to her. Also, she was fascinated by the behaviour of the bird, or, perhaps more accurately speaking, of the alligators that weren't eating it. She thought it was amazing that the herons could stand right next to, or even right on top of, an alligator without fear. Accordingly, she portrayed her heron standing on top of an alligator, but to show just a bit of the alligator as a dramatic addition so that you have to look closely to see what it is. It is another interesting demonstration of how artists will see different things in the same scene. Had I been in Kay's shoes that day, I'm not certain I would really have noticed the birds as I remained focussed on knowing where the teeth of the alligators were at all times.

Los Angeles, for Lori LaBerge, was a powerful and sophisticated city full of activity and fast-moving people. Lori's compositions are inspired by reality without being constrained by it. This approach gives her the liberty to select from and alter reality in order to clarify her meaning. In this case, *Urban Blush* was composed to portray the modernity of the city.

Normally, I would be wary of proceeding any further in "explaining" a work such as this lest I inadvertently imply that there is only one universal way of interpreting, and therefore only one universal way of expressing, any given idea. In this case, however, Lori explained her thinking to me so clearly that it is readily apparent that she selected her elements by the meanings that she attached to them, not as anybody else defined them for her. Therefore, I think it is valuable to share some of her process in developing *Urban Blush* to demonstrate to everyone the full extent of the artistic freedom inherent in her approach.

Lori began with the knowledge that strong, geometric shapes were an important element of mid-century modern design. The colour pink came from a bright pink building that she had photographed. The combination of pink with liberal amounts of red that she added suggested to her the power and liveliness of the downtown area. She took grey from the ubiquitous exteriors of modern office buildings, and she employed the combination of black and white, each neutral on their own, to convey sophistication. She combined and repeated all of these elements, and added others such as the multiple half circles of differing sizes and the diagonal lines, until she judged that she had achieved a cohesive and balanced composition. There is no recipe for this process; balance is determined entirely by Lori's own judgment.

Urban Blush, *14" x 11", #4-cut hand-dyed wool on linen.*
Designed and hooked by Lori LaBerge, Spruce Pine,
North Carolina, USA, 2017.

Looking East, *50" x 32½", steel wool on metal mesh, salt water*
from Troon, pine frame. Designed and hooked by Jane Walker,
Bonavista Bay, Newfoundland & Labrador, Canada, 2017.
Unconventional Media and Techniques

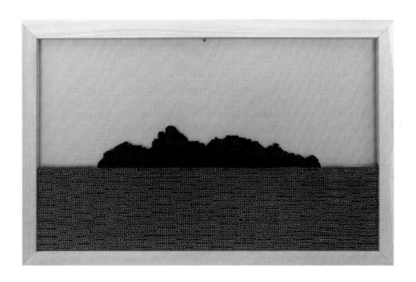

Looking West, *50" x 32½", steel wool on metal mesh, salt water*
from Bonavista Bay, pine frame. Designed and hooked by Jane Walker,
Bonavista Bay, Newfoundland & Labrador, Canada, 2017.
Unconventional Media and Techniques

Finally, I will conclude this section with three pieces by Jane Walker. The first two, a pair of compositions called *Looking West* and *Looking East*, depict two island outlines rising from the sea, much as though you were approaching by ferry.

These places don't actually exist; they are from Jane's imagination. Just like Lori LaBerge, Jane embraces the freedom of imagination and experimentation. She had Scotland in mind when she was hooking *Looking East* and she had Newfoundland in mind when hooking *Looking West*, but such specifics are only incidental to her purpose. The real purpose of these works was as part of a larger composition that depicted her feeling of being "in-between" and of a love of more than one place.

The island forms are made from hooking steel wool on metal mesh. Her original plan was to use different grades of steel wool to create tonal differences, but then serendipity intervened when she noticed how a piece of steel wool left on her front step had rusted into an iron-like colour. This led to a successful experiment in which she decided to rust her island forms on purpose rather than leave them their original dark grey. She rusted them by spraying them with ocean water from a spray bottle over the course of several days until she judged that the effect was right.

Fibre artists are fortunate because we have so many different techniques that we can take advantage of to increase the effective range of our expression.

Jane Walker's pieces *Looking East, Looking West* (both previous page), and *islandness* (p.123) all demonstrate the possibilities of using different media to hook, including non-fibre. Even though I didn't push the boundaries nearly as far as Jane, I have experimented with leather, beach rope, various plastics, and many other synthetic fibres. Jane also demonstrates how the backing can be unconventional by using a wire mesh. I, too, have experimented with different backings, such as metal meshes of various grades and, in the case of *Suspension* (p.128), tulle. As Jane's work and techniques amply demonstrate, when your focus is on artistic expression rather than technical perfection, there is no reason whatsoever to deprive yourself of unique looks by combining your skill with anything that can either be bent around a hook or hold a loop.

Even conventional hooking with wool or yarn can be fertile ground for alternative techniques. My piece *Lewisporte Shore* (p.iii) demonstrates the use of driftwood attached to the piece as one example. Much has been written on the subjects of accents and ornamentation, some of which I have included as suggestions for further reading at the end of this book.

Susan Feller's work demonstrates some of the possibilities of combining different fibre-art techniques, even to the point of reducing the hooking to a minor share of the total composition. *Valley View* and *Seneca Rocks #2, Travel Series* (both p.150) use combinations of embroidery, appliqué, and hooking to achieve striking depth and texture.

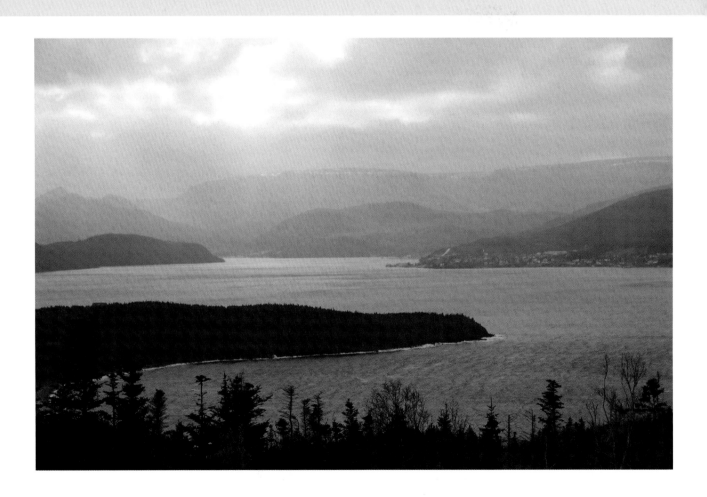

The sun breaking through the clouds at our favourite picnic spot overlooking Norris Point in Newfoundland.

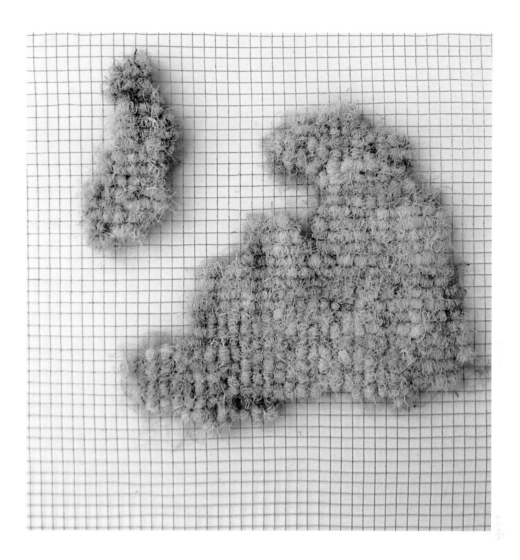

***Usnea,** 11" x 12 ½", preserved lichen on metal mesh.*
Designed and hooked by Jane Walker, Bonavista Bay,
Newfoundland & Labrador, Canada, 2017.

The third piece from Jane, *Usnea*, continues the theme of imaginary islands. This idea is one that Jane has explored extensively owing to her own identity as an islander. She thinks often about the relationships between land masses, such as islands and the mainland and islands to each other, and how these relationships will often dictate connotations of place and people.

In the case of *Usnea*, Jane wanted to explore a number of themes simultaneously, including the relationships between island places, creating a sense of place with very limited resources, sustainability, and the intensive labour required to use whatever is available to make what is needed. As such, her choice of materials is an essential part of her composition. I can only imagine how laborious it must have been to make a viable hooking material out of lichen, and how focused she had to have been over the shape and direction of every loop to control the texture of her design.

However, the resulting braids created a sculptural, almost topographical, effect when hooked into the backing. To control the texture of the design, she had to pay attention to the shape and direction of each loop, far more so than in the case of regular hooking. Finally, in keeping with her overall themes, I appreciate how she left the rest of the wire backing exposed, as though showing exactly how she had used what she had available to create what she required without any unnecessary embellishment.

INCLUSIVENESS IN THE WORLD OF ART:
A DISCUSSION WITH JANE WALKER

Q: Many people who have interesting ideas are intimidated by the artistic process. They imagine that true artists never make mistakes and therefore that if they make a mistake, it somehow delegitimizes what they were trying to do. Do you ever look at one of your own pieces and think that you would do some element of it differently if you were to do it again?

A: There is not a single completed piece of mine that I feel 100% satisfied with. There are always ways it could have been better. But I learn through making, and that's really what matters. When I first started experimenting with steel wool, I realised that I needed high quality, oil free, steel wool to create the effect that I wanted. My first steel wool pieces are imperfect and have a different look than my recent work, but I still like them. They track an evolution of my progress. If you don't make some bad art first, you'll never make good art. I make bad art all the time. Frustrating? Absolutely. Do I start over? Absolutely. Learn through failure.

Q: When you include community interactiveness as part of your projects, do you consider this a method of uncovering ideas, or do you consider these interactions to actually be part of your art?

A: I think that it's both. My relationships in my community inform my ideas and my practice, but I'm a strong believer that art isn't only made by self-proclaimed artists. I like exchanging with creative people in my community because I want people to know that I value their knowledge and ideas, because I do. For *Main Lands and Long Winters*, my body of work hooked with steel wool, I would bring my work with me to the Monday night sewing group and work while others worked on their own projects. To me it's important for people to see that I'm hooking in a different way, and to encourage others to think outside the box. How can we push materiality further within our creative work? Why do we have to hook on burlap or linen? I like having those conversations and I like sharing new ideas.

Q: The term artist *sometimes seems to be a strangely exclusive title. What do you think determines whether someone is an artist?*

A: I find it difficult to tell people that I'm an artist. I have an exhibition record and a formal education in art, and I am definitely an artist, but for some reason I find that I constantly compare myself to other artists and oftentimes that leads to self-deprecation. I think this is natural but also problematic. The hierarchies within the field of art are intimidating, the "art world" is daunting, but at the end of the day if you're in the studio (or wherever; I make art in my kitchen) making things that have meaning, you're an artist.

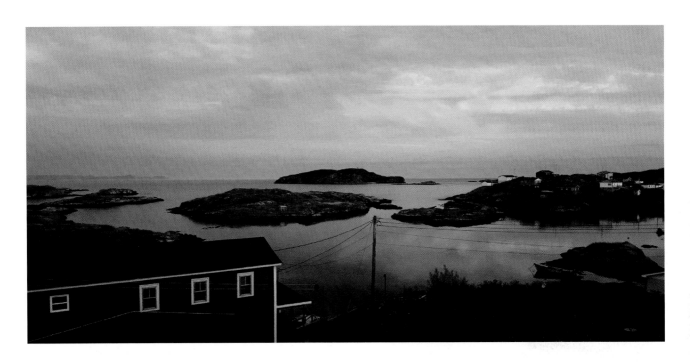

One of Mother Nature's grand illusions: islands seeming to hang in the sunset in Burgeo, Newfoundland.

Discovery

Discovery is probably my favourite aspect of travel art. I don't mean personal discovery in the sense of seeing something wonderful and world famous with your own eyes for the first time. I mean true discovery in the sense of seeing something that others have overlooked or dismissed. It amazes me sometimes that anything at all can be still be undiscovered in this age where everything and anything can be photographed and shared instantly with the world over the internet, but it is true. It just requires having an open mind, looking where it isn't necessarily obvious to look, and appreciating what is hiding in plain sight. Betty Calvert was visiting Blue Rocks in Nova Scotia, Canada,

with a friend when curiosity about the colours and varieties of seaweed in the water led her to lie down on the wharf and take pictures. Perhaps this curiosity is at least partly explained by her background in biology, and perhaps by her happiness hiking along the seashore and peering into the tidal pools, but it is also obvious these pictures from the wharf prompted some very artistic thinking. The resulting work, *Low Tide at Blue Rocks,* is faithful to the original detail, and yet opens our eyes to the extraordinary world that Betty saw when she looked into something so ordinary as a bed of seaweed.

TECHNICAL PANEL: MAGNIFICATION AND CROPPING

Imagine you are suddenly tiny and you are dropped into the world. How would it look? What would a flower look like to you if it stood as tall as your chest and its blooms spread as wide as your arms? What would a leaf look like if it stretched over your head and blocked the sun?

The technique of magnifying and cropping is straight-forward to teach: point your zoom lens, fill your frame until it looks interesting and nothing unattractive remains, and shoot. It is the mindset that takes the time to learn, because it is the mindset that shows you where to point your camera. Betty Calvert's *Low Tide at Blue Rocks* (p.126) is born of the curiosity of a biologist and a beachcomber,

but neither of those facts explains why her piece is compelling. When I look at it, I could be a parachutist high above, but sinking fast into, a strange jungle. About to be involuntarily immersed into it, I study it differently. Where might I be about to land? Where looks foreboding? Where looks safe? I look for, and see, different details. That, to me, is the beauty of the technique of magnification and cropping. When people say to me "I never looked at it that way" or "I never would have guessed that was a _____," I take great pleasure from having shown them a piece of the world that they've never seen before, and yet at the same time, have seen hundreds of times before.

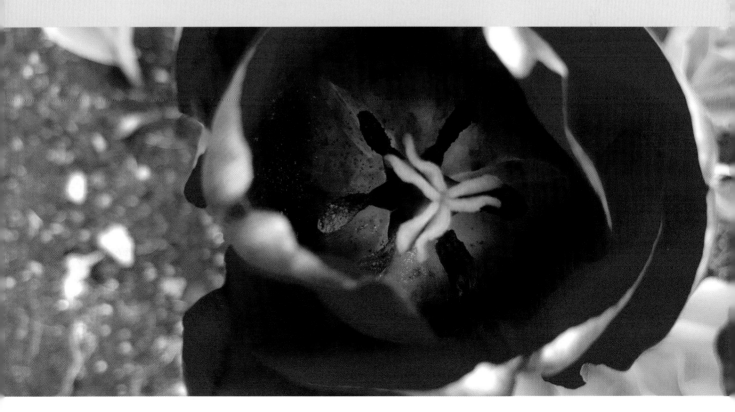

Low Tide at Blue Rocks, *37" x 23", #3 and #4-cut new, recycled*
and overdyed wool on linen. Designed and hooked
by Betty Calvert, St. Catharines, Ontario, Canada, 2013.
Magnification and Cropping

I find the combination of lichen and the textured surfaces it grows on an ideal subject for art by magnification and cropping. Zoomed in close, the roughness assumes new proportions, turning cracks into crevasses and bumps into promontories. Adding the greens of the lichen overtop reminds me of the mosses and plants growing in the tortured, broken fields of lava rocks in Iceland.

In my interpretation of tree bark, I wove a dark grey background to represent the voids in the bark and hooked in the colours of the lichen over top. When using this technique, you are helping the viewer see mysteries they wouldn't otherwise observe, so it is important that you don't show anything that would betray the "correct" scale of the piece.

A small section of bark on a tree that I saw on a walk up Mont Royal in Montreal, Canada

Underfoot V, *7½" x 11.5", cotton warp, wool yarn weft, wool and acrylic yarns. Designed, woven, and hooked by Karen D. Miller, Ottawa, Ontario, Canada, 2018.*

The inspiration for my own piece, *Suspension*, is similar to Betty's, with the exception of the biology background that I certainly don't have. My family is used to my fascination with lichen and fungi now, and don't even stop walking anymore when I step off of a path to photograph a rock, a tree, or a stump. I've probably taken pictures of them on every recent trip we have taken. There is little that is more ordinary and nondescript than lichen, but I love to see the shapes and colours in it. For *Suspension*, I wanted to emphasize these shapes by taking away the background entirely, so I hooked their forms into tulle. This left the lichen looking more like drops of oil floating in clear water, which is exactly how I perceive it when I photograph it.

Cherry Hill Beach is about discovered colours. As Melanie Perron describes her local beach where she goes

to walk and escape, it is nothing but grey. It is at the edge of a large bay that is frequently windy, with tumbled rocks extending for almost a mile. When the tide is out, some smoother rocks are exposed, but they are still wet. As a frequent visitor to the Maritime provinces of Canada, I know what she refers to when she describes grey sand, grey rocks, and grey sky. It can seem dreadfully uninspiring. Just like Laura Salamy in New Mexico, however, Melanie notices the subtle colours that are apparent if you have the patience to take a second glance. Besides the different blues that the ocean shows, the colours of the wet pebbles on the beach can be surprising when set against the dark grey sand. Melanie included all of these elements to portray her times spent walking Cherry Hill Beach at low tide.

Suspension, 31½" x 20", cotton yarn on tulle in an antique window frame. Designed and hooked by Karen D. Miller, Ottawa, Ontario, Canada, 2015. Unconventional Media and Techniques

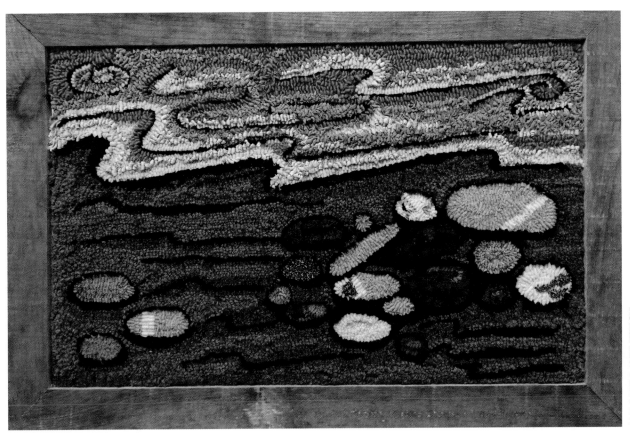

Cherry Hill Beach, *16" x 25½", hand-cut recycled wool and silk clothing, silk sari, wool yarn, and yak yarn on monk's cloth in a custom wood frame by Ian Walker. Designed and hooked by Melanie Perron, Liverpool, Nova Scotia, Canada, 2014.*
Colour and Light

Jean Ottosen also took a similar inspiration with her piece, *Northern Exposure.* While on a drive through Victoria, British Columbia, Canada, she was taking photos on a grey and dreary day when she noticed how the moss grew in one of the stone walls. As she was thinking about this, and taking some more photographs, she noticed especially striking bright moss growing all down one side of a dead tree. When she studied her photos later at home, she noticed both different types and different ages of moss on the tree, making for an even more complex subject. The final composition is about the surprising greens that jumped out at her on that grey day from the north side of the tree, where shade-loving moss grows.

Northern Exposure, *8" x 42½", #6-cut wool, silk, nylon fabric, silk yarn, wool yarn, mohair locks, and mohair roving on linen. Designed and hooked by Jean Ottosen, Regina, Saskatchewan, Canada, 2017.* **Colour and Light**

VICTORIA SKOFTEBY

*Let the Light In, 26½" x 29½", wool yarn and wool blends on
burlap. Designed and hooked by Denise de José,
Tappen, British Columbia, Canada, 2016.*
Colour and Light

Denise de José's *Let the Light In* is a depiction of the optical effects that are apparent when light is filtered through trees. In this case, she depicts the way the light appears when it shines through a mix of deciduous and evergreen trees, looking, as she puts it, almost ethereal and definitely delicate. She demonstrates how light can transform ordinary objects into special subjects, and in doing so lets us all share in this walk. Forests are challenging, I find. Often, they are dark and closed to the light, but in the right conditions they are quite bright and alive with dancing spots and streaks of light. Denise's piece brings back some of my own favourite memories of summer camping in the forests of Ontario, when I have sat looking up through the trees towards the sun and watched the forest sparkle.

We should never discount the role of fortune and serendipity in discovery. We should always resist the temptation to bury our mistakes. Instead, hold them for a moment and look at them with an open mind. It is certain that mistakes are not what we intended, but by virtue of being unexpected, they might also be the door to new vistas. For example, *Through the Trees* was born from a mistake. I was intending to catch the play of sunlight in the trees when looking through the trees and over the lake from off the back deck of a cottage we had rented for a long weekend outside Picton, Ontario. I took a couple of photographs before I realized that I hadn't readjusted the

settings of my camera. Fortunately, I didn't promptly delete my mistakes to save space on the memory card, as I usually do. Instead, in my haste to catch the photo while the sunrise was in the right place, I just changed my settings and proceeded with my photography. It was only later when I was reviewing my photos that I realized that my mistakes were far more interesting than the correct photos. Whatever my incorrect settings were, they smeared the light and broke it apart, almost as a prism would, and silhouetted the trees as a frame. Quite accidentally, I took what may forever be my best sunrise photo.

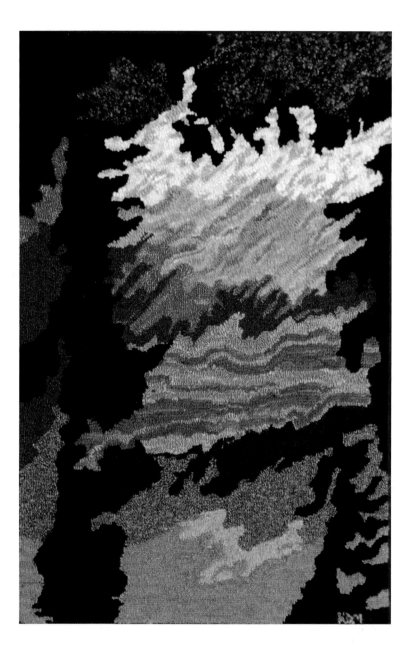

Through the Trees, 17" x 30", various yarns and wool roving on rug warp. Designed and hooked by Karen D. Miller, Ottawa, Ontario, Canada, 2014. **Colour and Light**

Keepsakes

One of the oldest traditions of travel is collecting souvenirs. The idea, of course, is that the souvenir will act as a reminder of the trip once you have returned home, ideally bringing back memories of the wonder and happiness you felt. My husband and I subscribed to this theory for the first years that we were together, and we assiduously bought mementoes from each place we visited for ourselves and our families. These were usually the things that you were supposed to buy from a given place. We carried this on until we realized two things. First, people didn't really care for souvenirs from places that they themselves hadn't been and they soon became just unwanted clutter in their houses. More importantly, after the flush of the trip wore off (and excepting certain souvenirs that my husband still inexplicably insists on collecting in quite baffling quantities), we found that we didn't really care for our own souvenirs either. They never did extend the enjoyment we felt on the trip itself, and in time they just became clutter in our own house. Even photographs ended up in binders and boxes, carefully labelled and rarely looked at again.

Art provided the answer for me, after I learned two things. First, I had to understand what it was that I really wanted to remember about a trip. It took me some years to realize that it wasn't the history of Greece or the ruins of Italy that I wanted to remember. It was the sense of wonder I felt looking out over Athens spread out as far as I could see every which way from the Acropolis, or the happiness I felt dangling my feet in a brightly lit pool in the cool Siena evening. And the more that the demands of career and life pulled at us, the more I came to value the moments of family togetherness. Then, I had to realize that it usually just isn't possible, unless it is a truly special and meaningful object, to simply acquire something and be teleported back to a special time merely by looking at it. **Catching and holding on to the special memories required me to actually grab hold of them and preserve them in a way that made sense for me.** This, above all else, is how travel came to guide almost all of my early art, and why my house is now full of keepsakes that really do transport me back to happy places and happy times every time I glance at them.

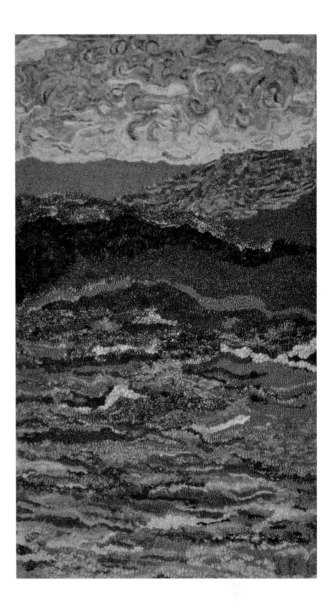

Purple Hills, 27½" x 47", *wool yarn and dyed wool flannel on linen. Designed and hooked by Jane Bridgeman, Toronto, Ontario, Canada, 2014.* **Colour and Light**

I begin this section with the most familiar interpretation of the keepsake, which is as a direct substitute for a visual memory, like a photograph or a postcard. The flexibility that this affords the traveller is obvious. The act of creating the piece in the weeks, months, or years following the return home, like a postcard, can remind the artist of the best that there was to see or her own favourite spot. In either case, the unnecessary and distracting details can be edited out leaving only the best of the memory.

Dolles is a candy store on the boardwalk along Rehoboth Beach in Delaware. John Flournoy recounts that the store has been in place for so long that it is considered an icon, and he stays faithful to reality in his portrayal. What I enjoy most about this piece, though, is the relaxed, summery feel that he gives it with his careful depiction of a summer crowd. I like that he captures so much enjoyment. The casual feel reminds me of similar places that I have been, where I felt completely relaxed because it felt like everyone else around me was there on vacation, too, without the industrialized vacation feel of a true resort. I most appreciated stepping off of the boardwalk in the early evening and walking along the beach that was still warm from the sun while the lights of the boardwalk twinkled behind me. I always appreciate those bubbles of separation from reality, and John's piece makes me feel like I would find another one at Rehoboth Beach.

Dolles Rehoboth Beach, *34" x 20", #3-cut wool on linen.*
Designed and hooked by John Flournoy,
Lewes, Delaware, USA, 2006. Photography

Image credit (rotated, right margin): GUY BOUDREAU

Cap Gaspé, 31" x 22", #4-, 6-, and 8-cut recycled and new wool,
various yarns, and hand-dyed roving on linen. Designed and hooked
by Judith Lilley, Kamouraska, Québec, Canada, 2017.
Colour and Light

Judith Lilley's work *Cap Gaspé* is another direct example of a personal keepsake from a trip to Forillon National Park on the tip of the Gaspé Peninsula in Québec, Canada, where she was hiking and camping with her husband. This work shows a beautiful day. The blues of the sea and sky were striking and the August wildflowers were well evident, from the milkweed and goldenrod to, especially, the fireweed. Interestingly for a piece that is so plausibly realistic, Judith did not have a camera that day and so the entire scene is drawn from her own observation. She designed the composition as a keepsake of the brightness and liveliness of all of the colours that she saw and remembered.

I daresay that imagination is the point of art. It would be misleading of me to suggest that there is any technical approach required to use your imagination, or to suggest that any of the pieces in this book can be identified as being specifically the product of imagination. Every piece in the book could – and should - be classified as being the product of the artist's imagination.

That said, I wanted to highlight a few pieces where imagination played a large role in the artist's composition.

Myra Barss selectively identified and assembled disparate memories of Iceland accumulated over multiple trips into a single composite feeling of a place. Brigitte Webb's *Highland Tranquility* (p. 148) takes the same approach with the Scottish Highlands, as well as with *Lochcarron* (p. 142). They both show their individual personalities and imaginations through their processes of memory-driven, selective composition. Even what we forget, and so inadvertently omit from our creations, is a reflection of our individuality.

Similarly, Debbie Miller imagines a whole composition for the sole purpose of creating a feeling in *Beginnings* (p. 149). Like the previous examples, *Beginnings* portrays an imaginary place that, while nowhere, could plausibly exist. But the imaginary place exists only as a frame conjured up by the artist to hold up the colours that she wants to use to describe her relationship with the place in her mind.

My own piece, *Heading West* (p. 99), is also a composite of the imaginary and the real, which I combined into my best guess about a place I very much want to see one day. The train that prompted my daydream about the Canadian Prairies was actually passing through a marsh in Ontario, Canada. I remembered the towering sky from a summer day in Ohio. Together, with a couple of other elements, they made my best guess as to what Canada's Western provinces will feel like when I finally get there.

Myra Barss departs from the realistic portrayal of an observed reality to create her keepsake. Instead, she created a compilation piece by amalgamating several of her memories into a single representation of a trip. She and her husband twice rented a camper van and drove around the country of Iceland, taking many side trips along the way. Her piece combines glaciers, mountains, perhaps a concealed volcano, waterfalls, and sheep into a single view. Of course, Myra will have known from her travels that the view she has created is also completely plausible, which enhances its effectiveness as a keepsake.

Once the artist has taken control of the composition, she can begin to alter the reality of what she saw to suit how she remembers it. Dawn Cruchet embraced this opportunity when depicting her memory of seeing the aurora borealis, or northern lights, just outside of Yellowknife in Canada's Northwest Territories. This is a notoriously challenging subject that Dawn acknowledges she designed, hooked, pulled out, and redesigned many times to get right. Part of the challenge with the northern lights is that a realistic depiction of a moment in time would be unjust to their majesty in the same way that one snapshot of fireworks in the sky will understate the impressiveness of the show. Even smaller shows of northern lights move in graceful twists and streaks across the whole

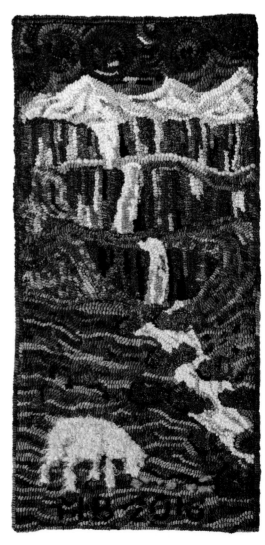

The Quintessence of Iceland, 14½" x 29½", #9-cut recycled and hand-dyed wool, wool yarn, and novelty yarn on linen. Designed and hooked by Myra Barss, West Dublin, Nova Scotia, Canada, 2016. *Imagination*

PETER BARSS

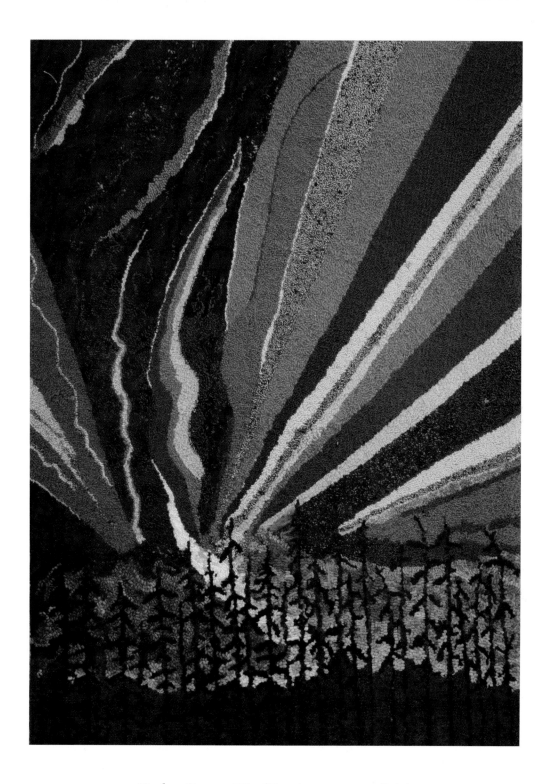

Northern Dancers, *36" x 48", various yarns on monk's cloth.*
Designed and hooked by Dawn Cruchet, Palmer Rapids, Ontario,
Canada, 2016. ***Colour and Light***

sky in ways that suggest mesmerizing patterns of dance. Some even say that you can hear them, though I can't say I have. Artists trying to adequately capture the majesty of the lights have adopted various techniques for altering reality. For one example, as Dawn observed, the camera catches more intense colours than what you actually see, since the exposure times have to be longer to adjust for the low light.

Dawn's depiction portrays the lights filling the night sky with an array of greens that she enjoyed playing with. What I especially enjoy about her composition, though, is how she rooted it in the thin trees and robust landscape that are characteristic of the area. It not only enhances the northern feel, but also gives a sense of awesome scale to the lights themselves.

Macroscope is simply the complementary technique to magnifying and cropping an image. Instead of tightening an image to eliminate extraneous detail, a macroscopic approach instead uses distance and an all-encompassing perspective to both obscure detail and reveal patterns that are visible only on a grand scale.

Mapping is a common example of this technique. Inch by inch, detail is deliberately sacrificed in order instead to comprehend the full breadth and width of a large area and the patterns within it. Tracy Jamar's *Land Parcel Quads* (this page) and *Road Map* (p. 151) are both examples of using an aerial perspective to replicate the feel and detail of a map. Both abstract away the detail to focus on topographical patterns and the signatures of human occupation on the landscape.

Another, more common, application of the macroscopic perspective is in the use of wide-angle, panoramic photography to take photos of wide landscapes and cityscapes.

Tracy Jamar's subject was grand in scale and much too large to render in honest detail. She wanted to depict all of the "fly over land," as it is known, that she passes over each time that she flies home to Minnesota from New York City. Her approach was to create a series of impressions of the views that she sees from out her airplane window during the flights. The result, *Land Parcel Quads*, is four separate abstractions of aerial landscape views. The coherence of the complete piece is achieved by linking the composition through the river or stream that passes through each quarter. Being abstracted, the piece is inspired by and reminds her of her journeys, without actually depicting any specific feature or aspect of them.

Land Parcel Quads, #3 in Fly Over Land Series, four pieces, each 18" square; wool, cotton, silk, polyester fabric, yarn, and mixed fibers on monk's cloth. Designed, hooked, appliquéd, and machine stitched by Tracy Jamar, New York, New York, USA, 2009.
Macroscope

Betty Calvert also uses abstraction, but her approach differs from Tracy's in that she has taken a specific and identified subject for her inspiration. *Galway Hooker* is inspired from the statue of the same name that stands in Eyre Square in Galway, Ireland. A Galway hooker was a local fishing vessel, and she and her daughter sat beside the statue one happy morning while waiting in the park to take their next bus on to Donegal. Betty liked the presence of the statue, especially its abstract design and the rustiness of its metal. When she sat down to turn her sketch of the statue and her memories into a piece, however, she elected against accurately replicating its form and colour. Instead, she decided to abstract even further from the original statue. Inspired by cubism and the work of Georges Braque, she further rearranged its shapes, added colour and a new setting, and so transformed it into an almost fanciful reinterpretation of a boat sailing the open sea.

The first of two pieces by Liz Alpert Fay, *At the Water's Edge: Stones*, is an interpretation of the concept of keepsakes themselves, as best explained by Liz's own poem:

STONES
They come into my life on many excursions.
Slipped into a pocket or the back of a car.
Bits of energy gathered from the corners of the earth.
Their powers add strength. Their ages tell many stories.
I watch them a bit disappointed as the color begins to fade as they dry in the sun.
I admire their beauty as the water washes over them and intensifies their colors.

 -Liz Alpert Fay

RON CALVERT

Galway Hooker, 17" x 19", #4- and 6-cut wool on linen. Designed and hooked by Betty Calvert, St. Catharines, Ontario, Canada, 2014. *Altered Form*

BRAD STANTON

At the Water's Edge: Stones, 53" x 18", hand-dyed and recycled wool and metallic novelty yarn on linen. Designed and hooked by Liz Alpert Fay, Sandy Hook, Connecticut, USA, 2006. *Altered Form*

More prosaically, *Petoskey Stone: Memories of Michigan* is similarly inspired. In this piece, Liz created patterns based on the fossilized coral that is found in stones along certain beaches of Lake Michigan and surrounded them with a border inspired by the lake's waves. Liz also added a black center to represent a particular black rock that she saw from the edge of the water, and an orange center that was actually cut out of the rug and mended with orange silk to represent the sunsets.

I collect little keepsakes, too. I prefer to take a little scoop of sand from different places that I go, but I have also taken little stones from places, too. I have put some of the sand in small jars and been surprised through the years at how different sand colours can be across different parts of the world. Stones, though, are a little different. Sometimes I'll pick up pretty beach stones along with seashells, and like Liz, I'm disappointed when they dry and fade. Sometimes, though, I'll pick up unremarkable stones that just fit nicely in my hand. I'll play with them, absently enjoying their shape in my hand and their smoothness under my fingers while I think or idle away the time. Later, when I get home, playing with the stones again reminds me of where they came from, and it makes me happy.

This statement from Melissa McKay about the process of hooking her piece *Lions Gate Bridge* summarizes the very point of making keepsake art, however you decide to approach it. The act of working on this piece brought her back to the day she walked along the seawall around Stanley Park in the heart of the city and looked at this view of the bridge across the Burrard Inlet. It was raining that day, as it often does, but far from dampening Melissa's spirits, it seems rather to have ignited her creativity.

BRAD STANTON

Petoskey Stone: Memories of Michigan, 73" x 56", hand-dyed and recycled wool on linen and silk organza, hooked and stitched on linen. Designed, hooked, and stitched by Liz Alpert Fay, Sandy Hook, Connecticut, USA, 2010. *Altered Form*

Melissa mentioned that it is the combination of skyscrapers and nature in Vancouver that inspires her, and specifically that *Lions Gate Bridge* is about celebrating human achievement while remembering the nature around you. What fascinates me about her design, though, is the subtlety with which she expresses her vision of Vancouver within a composition comprised of very bold choices of both form and colour. For example, the depiction of an immense and precisely engineered bridge as a wobbly structure seems to me to be quite unconventional—and also perfect. Any coastal city is defined by its waterfront. Its awkward contours define its development, and its people clamour for access to live, work, and play by it. How appropriate, then, that Melissa seemingly lifts the wavering reflections of the bridge and the hills from the surface of the inlet and stands them up in their places.

Vancouver is famous for many things, and infamous for at least one: its rain. I enjoy how Melissa portrays not just the rain, but the feel of that rainy day. I find that rain is an artistic challenge even after spending many of my own vacation days being soaked in it. Obviously, it alters the light, shrouds subjects, and cools the air. Just as importantly, though, it envelops the world in white noise and chases away distractions, like fair-weather tourists without umbrellas. It quite effectively leaves you in peace to escape in your thoughts. I sense this in Melissa's choices of colours. The aggressive use of cool and dark colours brings the damp,

chilly feel of a properly rainy day. The bright greens in the hills and the stark reflections on the water, though, acknowledge the tricks that light plays in these circumstances. The water, so often flat after a good rain, is a perfect mirror that shines surprisingly bright even without sun, and trees can brighten under even the faintest rays of sun. Inclement weather is tricky because it is so unstable, and I admire how carefully Melissa must have studied its dynamism. I can see how working through the complexities of this piece must have drawn her back to all of the feelings of that day on the seawall, and I hope that every day felt like living that day of vacation all over again.

The final two stops in this spectrum of keepsake art are examples of the artist taking complete control of the scene to reproduce a feeling rather than any specific details. Jane Bridgeman's inspiration for *Purple Hills* (p. 133), like Monika Kinner-Whalen earlier in the book, was memories of looking out the car window at the passing landscape. In her case, the trips were across southern Ontario and Québec in midsummer. The colours of the scene are drawn from her memory and what she felt like using; they are not true colours. Instead, she worked with the typical golden yellow colour of ripening fields, and then added purple in the distance as the complement, which is what we often observe in the distance in Canada's boreal forests. She draped these colours over features drawn from her imagination.

Lions Gate Bridge, *19" x 25½", #5-cut wool, various yarns, and hand-cut fabric on linen. Designed and hooked by Melissa McKay, Stettler, Alberta, Canada, 2017. Altered Form*

The second piece, and the final stop in this section, is Brigitte Webb's *Lochcarron*. Like Judith Lilley, Brigitte had a place in her mind when she made her composition. Lochcarron does exist in the Highlands of Scotland, and Brigitte's piece is inspired by the view of it from across the loch. However, unlike Judith, Brigitte didn't attempt an accurate representation of a particular time or a particular day, or even a precise spot. Instead, she set out to recreate her positive feelings about Lochcarron and Highland towns and villages in general. The piece is what Brigitte wants it to be rather than what is, right down to the colour choices. In this way, she expresses her feelings about the history and hardships of the land, and her love and happiness to be a part of it.

HEATHER MEAD

Lochcarron, 36" x 12", #3- to 8-cut wool, various yarns, and hand-spun fleece on linen. Designed and hooked by Brigitte Webb, Dingwall, Ross-shire, Scotland, 2012.
Imagination

Symbols

Many of the western world's most famous paintings make extensive use of symbols to convey meaning beyond what is plainly evident at first glance. I associate this most with paintings from the Renaissance era that are full of symbols pregnant with Christian meaning, but of course it was common in many other areas and eras, too. Sometimes the artist's purpose was to surreptitiously convey an alternative meaning, and sometimes it was simply to reinforce the already plainly evident message. Nonetheless, I found both approaches sapped my enthusiasm for art. Correctly "interpreting" art meant understanding a code of established symbols, starting with a dictionary of western Christian religious symbols. I was well familiar with many of these from both my own background and my extensive study of the world of Western classical music, but as a visual artist I felt that they just weren't relevant to the kinds of things that I wanted to explore. To me, they were little more than another extension of the suffocating body of rules that governed "correct" artistic expression, and so they hindered rather than helped my interest in exploring my own artistic inclinations.

It took me many years to appreciate that a symbol is nothing more than a visual motif that stands in for an idea. It is just an efficient form of visual shorthand. Of course they can be cultural, such as the colour white standing in for virginity or the dove standing in for peace, but they can also be personal. This latter discovery was very liberating for me; symbols can be very useful artistic devices if you just make your own. In this way, symbols become a flexible tool of expression rather than a straightjacket imposed by 16th-century western thought. They can even be a secret code, if you wish, known only to you and to the people who know you best.

Dana Psoinas's *Nature's Treasures* is a personal symbol. Superficially, it is simply a mushroom, even if it is executed with a great deal of skill. This mushroom, however, is a symbol of a great day in the Greenbelt Trails on Long Island, New York, walking with her husband a year after he suffered an accident. On this day, her husband's recovery and improvement in strength had progressed to the point that he was able to walk ahead and leave her to enjoy nature. She found this mushroom and felt not only that it was an example of one of God's perfect compositions in nature, but that it was also one more gift to her that day to have been able to find it. While it is a very personal symbol that won't otherwise be evident to many, it is clear that it holds multiple levels of meaning for Dana.

TECHNICAL PANEL: COLOUR AND LIGHT

Visual artists have a choice when they work with colour and light. They can choose to accurately portray the true colours of what they see, or they can alter or falsify what they see for some artistic purpose.

A common trigger for a visual artist is a particular colour. For example, Judith Lilley recounts that she really wanted to include the colour of fireweed when she designed her piece *Cap Gaspé* (p. 135). As we have already seen earlier, Gail Nichols composes by staying faithful to the vibrant colours that catch her eye, but she chooses to increase their predominance in her works to emphasize their impact. Her works *Reflections at the Water Temple* (p. 96), *Temple Fish* (p. 146) and *Cape Liptrap Beach* (p. 116) are all further examples of this approach. Similarly, Dawn Cruchet replicated the ephemeral colours of the Northern Lights, but intensified them as the camera does in order to create her striking composition (p. 137).

In a variant on true colour work, some artists alter a scene or a composition entirely to emphasize colours that are either unconventional or that aren't so apparent until a second or third look.

For example, Laura Salamy's composition *Desert Gone Wild* (p. 118), my own pieces *Through the Trees* (p. 132), *Colours of Mud at Hverir, Iceland* (p. 80) and *Pangnirtung, Nunavut* (p. 101), Melanie Perron's *Cherry Hill Beach* (p. 129) and Jean Ottosen's *Northern Exposure* (p. 130) are all about colours that aren't normally associated with an area but that emerge either in special circumstances or that you will see if you are particularly attentive. Val Flannigan's piece *Halong Bay* (p. 117) uses a morning mist to show a popular destination in a way that is completely different from the typical sun-soaked tourist photographs. Finally, Denise de José's piece *Let the Light In* (p. 131) is the result of studying the effect that changes in light have on an object's colours. Just like John Flournoy's realization about the complexity of portraying water, de José studied what the light was actually doing rather than accepting assumptions about what it should look like.

Quite the opposite of staying faithful to the colours that you see is to falsify them. While perhaps counterintuitive when you are trying to capture a memory of what you actually saw, falsifying can also be understood as paying attention to the relationships between colours and exaggerating them to artistic effect. For example, Jane Bridgeman's piece *Purple Hills* (p. 133) uses purple as the complement to golden yellow to balance the composition.

"I love the fact that Mother Nature doesn't make mistakes with colour." – Jane Bridgeman

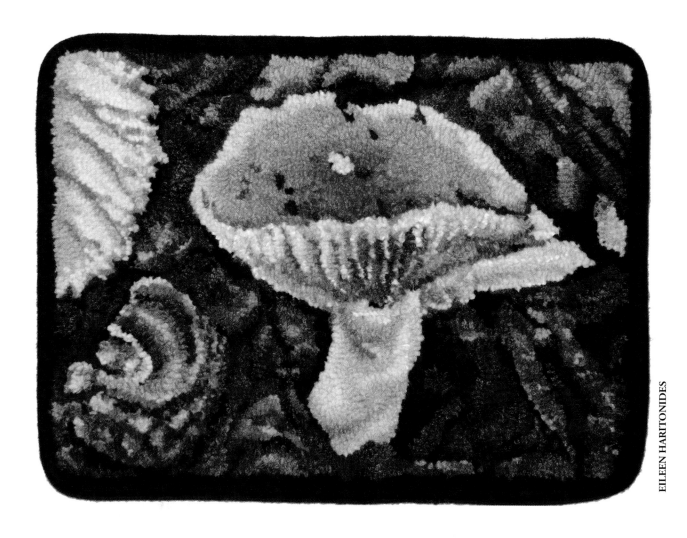

Nature's Treasures, *11½" x 8", #2, #3 and #4-cut hand-dyed wool,*
metallic wool, metallic threads and organza on linen.
Designed and hooked by Dana Psoinas, Woodbury, New York, USA, 2018.

My pieces inspired by lichen shown earlier in this book are examples of a personal symbol. Although I have seen some fantastic examples from nature photographers, lichen is not a typical subject for studies of beauty as compared to, say, the more brazen beauty of flowers. That unexpectedness appeals to me. Like many people, I have been underestimated at various points in my life, which I have found to be both frustrating and motivating. It is tremendously validating to witness the moments of revelation that she who was overlooked, namely me, should perhaps have been paid more careful attention. While I am accustomed by now to seeking out these little pockets of colour and beauty on every walk that I take, it still amuses me to think about how many people, even only moments before me, failed to see what was right in the open and, oftentimes, right under their feet or inches from their eyes. The metaphor for the judgments we make every day about the people around us is straightforward.

Melissa McKay's *Cherry Blossoms* is about a fresh start after everything has been washed clean. As we have already seen, Melissa loves to travel to the city of Vancouver, Canada, for its mix of natural and urban landscapes. On this particular day, the cherry trees along Robson Street were in full bloom and still glistening from an early morning rain.

I enjoy how Melissa chose to portray this effect by giving her trees the appearance of cotton candy in a land of Dr. Seussian buildings. Melissa used the temporary glistening of the trees as an observation about friendships and how they change over time.

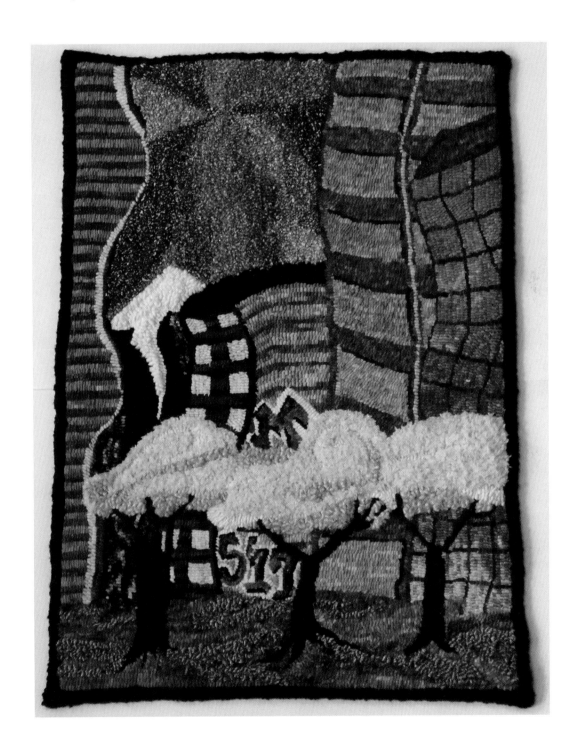

Cherry Blossom, *19" x 26", #5-cut wool and various yarns on linen.*
Designed and hooked by Melissa McKay, Stettler, Alberta, Canada, 2017. Altered Form

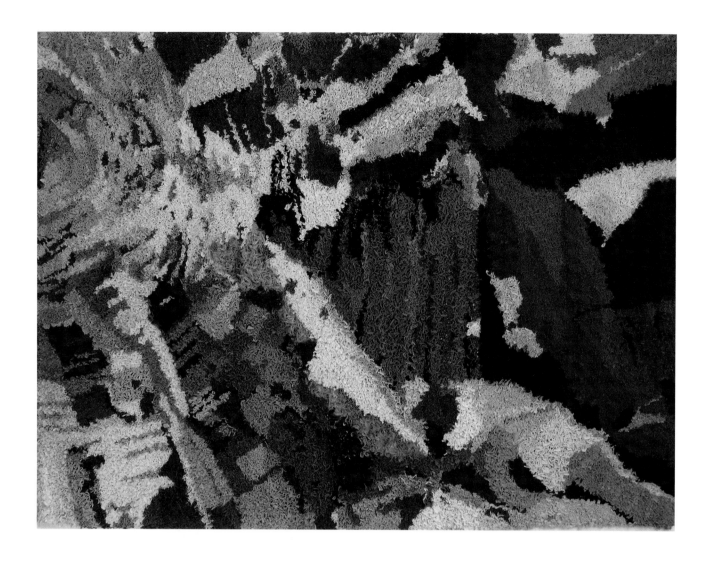

Temple Fish, *65" x 45", new and recycled fabric on hessian.*
Designed and hooked by Gail Nichols, Braidwood, New South
Wales, Australia, 2017. ***Colour and Light***

Temple Fish and its companion piece *Reflections at the Water Temple*, on (p. 96), symbolize physical and spiritual refreshment. Gail Nichols visited the Tirta Empul Water Temple on the island of Bali in Indonesia when she was in the area leading a ceramics workshop. After the last firing was complete and the kiln was cooling, the local staff took the class to the temple for the day. There, they learned about the spiritual significance of the site, donned sarongs, and stepped into one of the pools, paying respects to the spouted figures adorning the edge. Gail saw the colours of all of the nearby banners, saris, and sarongs reflected in a pool of brightly coloured koi fish. Her composition depicts a chaotic interplay of colours in which forms are still intriguingly discernible.

Finally, Anne Shaw Hewitt shared how her piece *Swaledale Sunlight* was inspired by an almost spiritual experience that she had with the sun. Her intention when visiting Swaledale in England that day was to portray the walls that cross the dale. However, there were heavy rainclouds--and then the sun broke through. To symbolize the striking effect and spiritual impact of that moment, Anne chose to impose a geometric pattern over the colours of the landscape. The effect of this distortion is to give her sky the lustre and character of a diamond, intriguingly mimicked through the grass of the dale to bolster the impact. I admire how she leaves the walls in the composition. Where they were originally intended to be the focus of the piece, they are instead used to convey the enormous scale of the shaft of light arriving as a gift from the heavens.

"I enjoy looking at maps… even maps of places I will never be."
– Tracy Jamar

Swaledale Sunlight, *6½" x 24", hand-spun wool yarns on hessian. Designed and hooked by Anne Shaw Hewitt, Reeth, North Yorkshire, United Kingdom, 2016.* **Colour and Light**

Highland Tranquility, 29" x 20", #3- to 8-cut wool, various
yarns, natural fleece, and silks on linen. Designed and hooked by
Brigitte Webb, Dingwall, Ross-shire, Scotland, 2010.
Imagination

Ideals

The true liberation of travel artistry is that we are free to travel without moving. As we have seen already, art allows us to travel in time and to cross barriers. We have seen depictions of places that we yearn to go. We have seen places we once were, stored forevermore in capsules of our own creation. We have even seen how we might leave the physical world and explore the limits of our dreams and make-believe.

The last power of travel artistry is to take us to times and memories long past, and even to places that have never existed at all except in our own feelings. We have already seen how Brigitte Webb played liberally around the edges of Lochcarron to develop a piece showing her feelings for the place. In *Highland Tranquility*, Brigitte takes the next step and creates her own imaginary place built from all of the elements that she loves about the Highlands of Scotland: "the mountains and hills; the ever-changing scenery; the open, quiet spaces; the farming lands and local homes; the forests, rivers, and lochs; the richness of the colours—heathers, wild flowers, sheep; and the overall sense of peace."

We are all familiar with the concept of travelling home and returning to the comfort of where we belong. Debbie Miller's *Beginnings* arises from the act of discovering and falling in love with a home she had left behind before she really knew it. Debbie was born in Newfoundland, Canada, but left soon thereafter with her adopted family. In adulthood, Debbie was transferred to Newfoundland. As it was years before the troubles with the fisheries, she had—and took—the opportunity to travel to many of its small outport communities. *Beginnings* is an imaginary composite of her memories of those remote outports. The depiction of the components common to all of them, from the dories and the fishing stages to the colourful houses and the church, means that the piece is designed to be any outport, and so represents them all. Just as importantly, Debbie has also used personal symbols to represent her own journey. The sailboat leaving the harbour is not a vessel typically seen in Newfoundland, which is how Debbie chose to represent herself being adopted away from the province. Debbie also acknowledges that a sunset is usually used to depict the end of a day, but she chose this design element to remind us that the end of one day is also just the beginning of a new day, as it was for her.

Beginnings, 60" x 36", #4- to #8-cut wool and yarn on linen.
Designed and hooked by Debbie Miller, Mermaid, Prince Edward Island, Canada, 2017. Imagination

Where Susan Feller grew up, she had a large forest and fields as her playground. Though she owns a smaller such playground today, it looks out over valleys and creeks that run far away to the Atlantic. *Valley View* and *Seneca Rocks #2, Travel Series* are about walking these trails and recalling her childhood explorations.

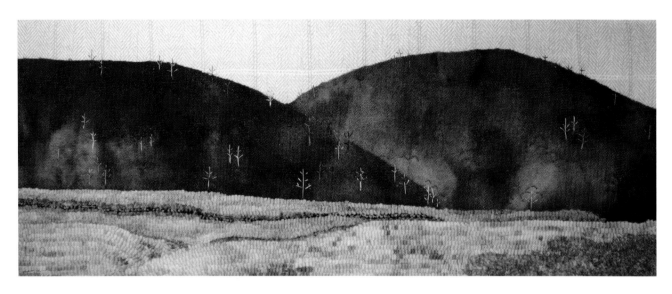

Valley View, 24" x 9", #5- and 6-cut wool, hand-dyed wool appliqué, and silk and cotton thread embroidery on linen. Designed, hooked, and stitched by Susan L. Feller, Augusta, West Virginia, USA, 2016. **Unconventional Media and Techniques**

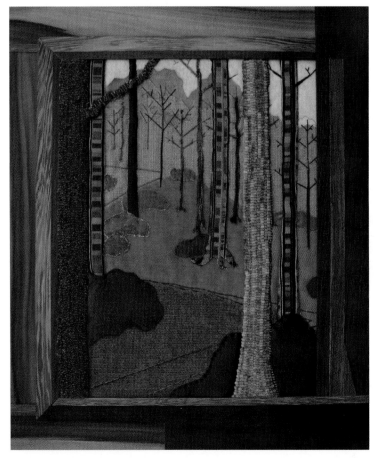

Seneca Rocks #2, Travel Series, 20" x 16", textured wool, upholstery fabric appliqué, and silk and cotton thread embroidery on linen in a custom frame by Jim Lilley. Designed, hooked, and stitched by Susan L. Feller, Augusta, West Virginia, USA, 2017. **Unconventional Media and Techniques**

Tracy Jamar's *Road Map* is the ideal work with which to conclude our journey together exploring travel as an inspiration for our fibre art. It is of no particular place, and yet it instantly evokes the idea of travel. It is apparent that it is countryside and that it is criss-crossed by some roads, or even tracks or paths. But where are they coming from and where are they going? You can only speculate. Tracy adds to the intrigue by making the piece interactive. The four pieces are not connected, and the pathways across them are designed so that the viewer can arrange them together however she wishes, whether in a rough square, in horizontal or vertical lines, or even three in a row and one out of line. However they are linked, the aerial viewpoint gives the viewer a sense of place and context beyond the roads, which we often miss in today's digital world when we rely upon our GPS for directions. Tracy has even embedded some humour in the composition by ensuring that the roadways don't always link to provide continuous pathways from one end of the work to the other, bringing to mind the puzzling expression, "You can't get there from here."

Perhaps you can't, but you can still get somewhere. And isn't it the curiosity about where that might be, and the optimism about what we might find there, that prompts us on to our next travels? Happy trails, wherever those travels may take you.

Road Map, *four pieces, each 10" x 11" to be arranged in flexible formations; cotton knit on monk's cloth. Designed and hooked by Tracy Jamar, New York, New York, USA, 2013.* **Macroscope**

5 DREAMS OF TRAVEL

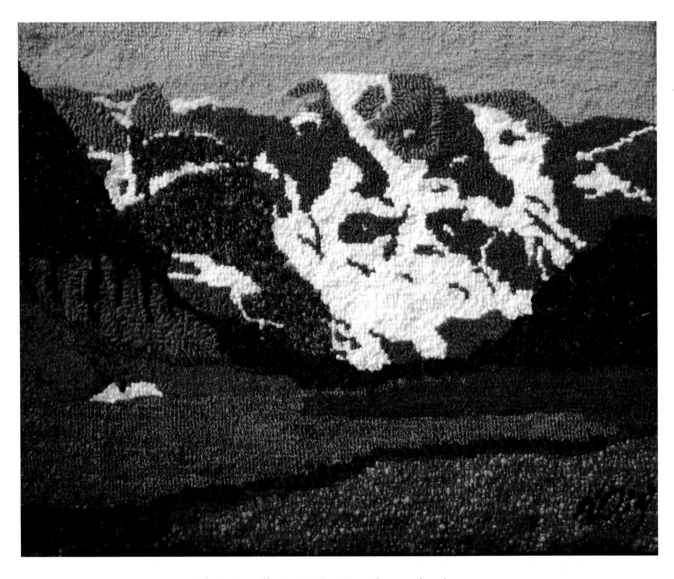

Lake Louise, Alberta, 13½" x 14", *wool yarn and acrylic yarn on
burlap. Designed and hooked by Karen D. Miller,
Ottawa, Ontario, Canada, 2011.*

One day, soon, I will get there...

SUGGESTED READING

PLEIN AIR

- Albala, Mitchell. *Landscape Painting: Essential Concepts and Techniques for Plein Air and Studio Practice.* New York: Watson-Guptill Publications, 2009.
- "Plein Air Hooking Artists: Rug Hooking Technique, Outdoor Inspiration," www.pleinairhooking.com

APPROACHES TAKEN BY FIBRE ARTISTS

- Jane Walker's website, https://janewalker.ca
- Lori LaBerge's website, https://lorilaberge.com
- Susan Feller's Year Study, https://artwools.com.

INSPIRATION FROM NON-FIBRE ARTISTS

- Barson, Tanya, ed. *Georgia O'Keeffe.* New York: Harry N. Abrams, 2016.
- Fillmore, Sarah, "Vanitas" in *Mary Pratt.* Fredericton, New Brunswick: Goose Lane Editions, 2013, 41–65.
- "Mary Pratt: A Love Affair with Vision", interview with Jonathan Shaughnessy, National Art Gallery of Canada, April 1, 2015, https://www.gallery.ca/magazine/exhibitions/mary-pratt-a-love-affair-with-vision
- Murray, Joan. *Tom Thomson: The Last Spring.* Toronto: Dundurn Press Ltd., 1994.
- Shadbolt, Doris. *The Art of Emily Carr.* Vancouver: Douglas & McIntyre Ltd., 1979.
- Silcox, David P. and Harold Town. *Tom Thomson: The Silence and the Storm.* New York: Harper Collins Publishers, 2017.
- Suh, H. Anna. *Van Gogh's Letters: The Mind of the Artist in Paintings, Drawings, and Words 1875-1890.* New York: Black Dog & Leventhal Publishers, 2006.

INFORMATION ON ART GENRES

- Gilbert, Colin, et al. *The Daily Book of Art: 365 Readings that Teach, Inspire & Entertain.* London: Quarto Publishing Group, 2009.
- Sanna, Angela. *Impresionismo.* SCALA Group, Florence, Italy, 2011.

ADDING EMBELLISHMENT TO HOOKED FIBRE

- Hrkman, Donna. *Creative Techniques for Rug Hookers.* Northbrook, IL: Ampry Publishing LLC, 2015, 77–80.
- Pavich, Tamara. *Designed by You: Ideas and Inspiration for Rug Hookers.* Northbrook, IL: Ampry Publishing LLC, 2017, 104–105.

Your Free Trial Of

R·U·G HOOKING

MAGAZINE

Get a Free No-Risk Issue

Join the premier community for rug hookers! Claim your FREE, no-risk issue of *Rug Hooking* Magazine.

Sign up to receive your free trial issue (a $9.95 value).

Love the magazine? Simply pay the invoice for one full year (4 more issues for a total of 5).

Don't love the magazine? No problem! Keep the free issue as our special gift to you, and you owe absolutely nothing!

Claim Your FREE Trial Issue Today!

Call us toll-free to subscribe at (877) 297 - 0965
Canadian customers call (866) 375 - 8626
Use PROMO Code: **RRTY18**

 -

Discover inspiration, techniques & patterns in every issue!

Yes! Rush my FREE issue of *Rug Hooking* Magazine and enter my subscription. If I love it, I'll simply pay the invoice for $34.95* USD for a one year subscription (4 more issues for a total of 5). If I'm not satisfied, I'll return the invoice marked "cancel" and owe absolutely nothing.

SEND NO MONEY NOW-WE'LL BILL YOU LATER

Cut out (or copy) this special coupon and mail to:
Rug Hooking Magazine Subscription Department
PO Box 2263, Williamsport, PA 17703-2263

First Name Last Name

Postal Address City State/Province Zip/Postal Code

Email Address

* Canadian subscribers add $5/year for S&H + taxes.
Please allow 6-8 weeks for delivery of the first issue. RRTY18